Praise for *Glory Guitars*:

"A synesthetic fireball of beauty, a gut punch in every line, this is the kind of memoir full of gorgeously drawn characters and the wild passion of youthful misdeed that spawns a thousand attempts to live halfway up to the thrill of the original. Germaine has recreated the world of young, alternative women of the '90s and their bonds with a grace and fury that it's never had until now. If you grew up young and female-identified in the '90s, you'll recognize every word of it—and if you didn't, you might find yourself wishing you did."
—**Alex DiFrancesco**, author of *All City* (Ohioana Awards finalist) and *Transmutation*

"With grit, heart, and punk spark, *Glory Guitars* is a seething anthem of teenage sex and explosive youth. Gogo Germaine is a voice of her generation, a shriek of darkness and life you never knew you needed ... but won't ever forget."
—**Jason Heller**, author of *Strange Stars: David Bowie, Pop Music, and the Decade Sci-Fi Exploded*

"*Glory Guitars* is a vulnerability manifesto that refuses to be ignored. Whether we're witnessing an adolescent, spontaneous hand job or experiencing the high of breaking boundaries in Teenageland, the visceral realness of kids bordering on adulthood will hit you square between the eyes. Heartbreaking and hilarious, all with the perfect soundtrack of sorrow and rage to

boot, Germaine is brilliant at masterminding the art of storytelling from each endearing character's point of view, telling us, it's not going to be okay, everything isn't alright, but somehow we'll make it through."
—**Hillary Leftwich**, author of *Aura, a Memoir* and
Ghosts Are Just Strangers Who Know How to Knock

"So good it hurts. Gogo Germaine's voice is witty, gritty, and flat-out addictive."
—**Emily France**, author of *Zen and Gone*, a *Washington Post* Best Book for Young Readers and *Signs of You*, an Apple iBooks Best Book of the Month

"*Glory Guitars* is a multi-sensory, tilt-a-whirl fun house adventure of guiltless teenage rebellion that formerly puritanical readers can live vicariously through, retro-actively experiencing every school-ditch drunken escapade with the memoir's cast of blighted yet self-re-newing characters who you end up convinced were responsible for your coming-of-age as well as Gogo's."
—**Amanda E.K.**, author of *The Risk it Takes to Bloom*

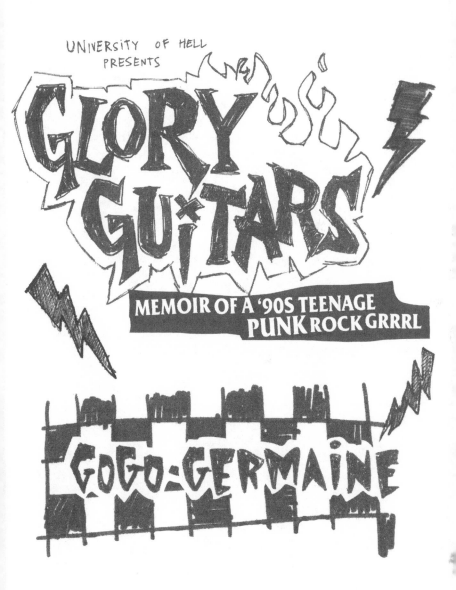

UNIVERSITY OF HELL
PRESENTS

GLORY GUITARS

MEMOIR OF A '90S TEENAGE PUNK ROCK GRRRL

GOGO-GERMAINE

UNIVERSITY OF HELL PRESS | PORTLAND, OREGON

This book is published by University of Hell Press
www.universityofhellpress.com

Cover Art and Interior Illustrations by Joel Amat Güell
joelamatguell.com

Cover Photos by Carri Lawrence

Gogo Germaine bio photos by © Glenn Ross
@glennrossphoto | www.glennrossphoto.com

Interior Design by Gigi Little
gigilittle.com

Published in the United States of America
ISBN 978-1-938753-45-9

"PUNK ROCK IS JUST ANOTHER WORD FOR FREEDOM."

—PATTI SMITH

TABLE OF CONTENTS

PROLOGUE

TORRIDORIGINS

SOUNDTRACK "AWED SILENCE"

I SAW HER SPINNING around a silver pole, her platinum hair alight as it splayed against the emptiness of the bar behind her, blue-lit flashes of breast, white light illuminating the long lines of her darkly oscillating limbs like chrome.

The fringe of her hair and diaphanous costume gilded her like a prize pony. Her clear heels clacked the stage triumphantly; and for a moment, I forgot this was my best friend that I rode bikes with in sixth grade. Someone who didn't know any strippers might assume they're all destitute or damaged. I knew that

she was neither; she was plucky and she was too clever for moral pretension.

Right now, she was indistinguishable in her beauty. She was the blazing concentration of the secrets whispered all around us. She was everything I was simultaneously encouraged and warned not to be. I envied her, and I felt bad for her. She was the most primitive desires elevated to the highest holiness. My gaze fixated on the V that her legs made, and I followed inward from her clear-glinting heels. I followed the waves of her sculpted calves to her soft thighs to the crux of the V, the convergence, the softest place in the universe, the only place of real magic, the torrid origins of our species, a tiny universe that holds prisoner every woman in the world. This world of sex.

I took a sip of my pint, but the gulp was too big, the soft liquid of the beer felt hard as I swallowed it. My eyes watered.

"How important is it, really," I wondered aloud to Nico, the new boy that I had brought here to impress, "how you enter into this world?"

"What, the Hunt Club?" he asked. "You're seventeen. I thought you were only able to get in because you know her," he nodded his dark messy hair at the girl on the stage. "Er, what's your connection to this place again?" Nico was also a teenager; the black band tee he wore couldn't mask the fact that he was an innocent. He was both thrilled and intimidated by this first date.

What does it matter what you do once you're in this

world? I went on thinking to myself. Does any of it matter? What is purity but something humanity invented for us to torture ourselves? Or is this sacred? Sex is not sacred like the saints; sex is only holy like nebulae and amoebas multiplying.

"Gogo?" asked Nico.

My best friend on the stage did a backbend so her tits were at eye level of the man sitting next to us. His gaze was soft, but his posture was tense in a way that betrayed the precarious containment of an internal squall.

"How did I get here?" I mumbled to Nico. This place had become a fixation for me. A place to find out why.

"Time to take you home, Gogo," he said. He never called me again.

SOUNDTRACK "CRAWL!" by IDLES

1

DITCH MANIA

IF YOU'VE EVER WONDERED what it feels like to rob a bank, take a sprint across the field of Fort Collins High School when you're supposed to be in Geometry. The freefall of possibility unfolds before you, the fear of being caught burns your heels, your drumsticks hang from your left side and a bottle of vodka sloshes against your right. Such contraband was previously stashed at strategic points throughout the field, waiting to be plucked like fat little video game jewels.

On this flat plane, you're as conspicuous as a lone giraffe in the desert, but far less graceful galloping

in cherry red vinyl pants. If one teacher glances out one window in the ten excruciating minutes it takes to cross the field, your day is ruined. This could cost you a hefty detention or, if you escape, a pint of sweat when you finally peel your pants off to jump in the pool you'll break into later.

Ironically, there is an innocence to your corrupt behavior. Here are the specific burdens your 15-year-old self is still blissfully ignorant of in this moment:

1. The garbage world. You're comfortable enough to hurdle the rules because the world of the late-'90s offers a safe space to land. You're just at the precipice of the Columbine shooting, which will launch the country into a decades-long-and-counting epidemic of AR-15-fueled terror where school children are regularly annihilated. Reports of celebrity sexual misconduct are not so frequent as to be banal. No children have yet been locked in cages by the President while the country did nothing to help. No sweeping pandemics have devoured the world yet. Plus, you're under eighteen, so nothing here will go on your permanent record, baby.

2. A sense of propriety. Even four years from now, meeting friends to drink vodka in the morning would be downright depressing. For a 15-year-old punk rock girl, it's called *experimentation*. Everyone knows that getting morning-drunk is fun; guilt is the only thing stopping them from starting the day with whiskey-O's.

You feel no guilt because breaking norms is what teenagers are inherently designed to do. You're unfolding the world, smoothing it out like a map, and then fucking the shit out of it.

3. Your garbage brain. You don't understand what you're running from at this very moment, besides Geometry. Your 15-year-old self might say you don't need to explain what's cool about ditching class, playing the drums, or subsisting on a diet of coffee, cigarettes, malt liquor, Lester Bangs, and smashy guitars. It's a natural predilection. The only reason people assume it's indicative of emotional trauma is because you're expected to like pink and cheerleading. The truth is that some people are happiest wearing black and listening to fucked-up music, and you're one of those people. It doesn't necessarily indicate a deeper emotional trauma, it's simply the tendency to dig deeper and burn harder.

And yet, there may be some pesky truths you're not copping to yet. Perhaps you're wired a little bit differently than the rest of the world. Perhaps your lack of awareness about it is setting you on a thrill-seeking trajectory that will only end in the bleak drama of after-school specials.

Or maybe you're just a teenager.

The irony in your lack of self-awareness is that you think you know everything about

yourself. That's what teenagers do. By all appearances, you look and feel like a normal girl who grew up singing every word to *The Little Mermaid*. A normal girl who plays percussion in the school band. A typical girl who takes pottery classes at the community center in the summertime … and uses the opportunity to make clay pipes to sell to her druggy friends. Maybe a little more enterprising than the next.

You wouldn't even realize you were drawn to the blankness of fresh air, let alone why, unless you were able to look back upon the entire landscape of your life and realize just how many doors you've swiftly exited. The spit-encrusted black doors of squalid punk rock dens. The bedroom doors of near-strangers. Even the breadbox-sized window you squeeze out of at night as your parents slumber.

Right now, you only see the micro-landscape of your current geography, and you mistake it for the whole picture. You don't understand how the field you traverse, which feels endless now, is going to merge into a gargantuan reverse Pangea someday. Now, here are the micro-landscape elements you're familiar with:

School hurts. Outside feels good.

Hypomania, synesthesia, anxiety, sensory processing disorder—these are all foreign concepts.

You don't understand why you keep ditching out on everything. You just consider yourself a connoisseur of fresh air. This particular field air has an expansive, frenetic piquant with bottom notes of car exhaust-infused pointillism.

Speaking of which, your senses are all fucked up. They're mixed at random, like the suicide-style concoctions your friends dare each other to eat at IHOP: things that don't belong together, like jelly with ketchup and creamer. As it applies to your brain, this is called synesthesia. You see all names, letters, and numbers in color. You see and feel songs. A certain guitar riff might cause a floral arrangement to bloom cream-colored in your mind's eye, but the beat of another song strobes pleasurably black through your chest. Five years later, when the electro-duo Air releases their album *Talkie Walkie*, embarrassingly, you'll be brought nearly to orgasm after listening to it several times in a row.

You don't know what synesthesia is yet, that you have it, or that it's a gift. If you had known you possessed anything special at all, maybe you would've been more careful with yourself.

All that you know right now is that you sneak out into the raucous night air not because you're bad but because you are drawn to feeling each molecule as inevitably as a deer

is drawn to a creek to drink. That's why it's so confusing when people accuse your actions of being dark or bleak. You're rapt, trembling in love with the world.

You wonder things like, "If I were crazy, would I know that I was crazy?" Sometimes, you wonder if you're an alien. Your teen crush, Kurt Cobain, also thought he was an alien. Before he blew his brains out. The prognosis isn't good. You don't know which junk in your mind is normal and where neurodivergent begins and let's just wash this down with some vodka.

4. Personal boundaries or sense of safety. We're still talking about things you're blissfully unaware of here. You're drawn to open fields because you are boundary-less. That's what this memoir is about; it's about the freedom of innocence when you haven't yet been torn apart by the world. It's a burst mainline of effervescent gratitude that you ever did feel safe, even for a short time. It's about the unsavory business of building those jagged boundaries for yourself: examining those moments when fun turned to danger, asking why it was so easy to sell your soul, figuring out where you started to tear off vital organs and hand them to grinning people with shady intentions and hate in their hearts.

5. The future. Right now, you're joy-sprinting

towards the fun of a morning buzz, but in less than a year you'll be tearfully running to the back of a courtroom after a life-altering sentence is delivered. Would you continue along this path of boundary-less exploration if you could see ahead to the blood, the courtrooms, the shame, the hurt you've inflicted on your family? That's the million-dollar question.

SOUNDTRACK
"TOO DRUNK TO FUCK"
by Dead Kennedys

THE LONELY SUBURBAN ROAD you run towards is the finish line in this race for misfits. A shiny black 1998 Mitsubishi Eclipse drives past on the road, *NSYNC wafting from its window. It's filled with girls from your grade, probably leaving school during their off period to study. You catch the smile of the blonde sitting shotgun—but as her earnest and breezy expression lands on your sweaty visage, it contorts into a smirk. In one instant, such a stark comparison with your normal peers tangibly drains all the joy from this jog.

You sneer at them with haughty music nerd indignation. *Fuck *NSYNC*. At the time, you believed your musical tastes to be eight worlds above any of your peers.

What is it that spawns the Mitsubishi Blondes

eclipsing your fun with their societally acceptable joyride, and your vinyl mess of a person hurtling towards the haggard sun of some a.m. drinking?

There is the sad breaking of norms, like the clear sting of vodka that singes your throat when you'd rather not feel feelings. There is the rule-bending of regular people who commit small atrocities when no one is looking. Then there is the hopeful kind of trouble, like this. It comes from being a little bit hurt by the world. It comes from wanting to transgress it.

This maximalist air all around you, it's degenerate-grade freedom. A freedom of deviants. You can physically feel the lack of math, or walls. It's like when you're stumbling home from a party in the morning twilight, clutching your friend, and you spot the speed-walking neighbor in front of you. Seeing adults going about their routine when you're flying so far above it hits a deeply gratifying chord; you finally understand why movie villains won't fucking stop laughing.

Just then, something happens to elicit that exact feeling of outlaw smugness; it jolts you like a lightning bolt doodled on a Trapper Keeper. Your friend's beater car caterwauls around the corner, Dead Kennedys' "Too Drunk to Fuck" stomping out the *NSYNC like a steel-toed boot. Your people. This momentary relief is usually the part in the movies where the protagonist gets caught. Better hustle now.

For the last ten seconds of running, you're sprinting up clouds. Those last ten seconds always feel like your hammering heart is on the brink of shattering. If you

like to collect potential band names, like I do, might I suggest getting a pad of paper? Because this memoir is full of 'em. Write it down: Last Ten Seconds. Not to be confused with the Last Ten Seconds of Life, a real band that lists its genre as "pain," Last Ten Seconds is a sonic celebration of that breathless "almost there" feeling, as filtered through deranged, fast-paced polka.

Everyone is here, I mean too much everyone[1] crammed in one car, and the side door is broken so you have to dive through the window. You squeeze past the scrum of bodies onto someone's lap. The sunroof shuttles open as the car speeds away from campus. Getaway breakout elation. The party in the car forces your head out of the sunroof, and it is exactly where you want to be. Emerging from the dingy container of the everyday to gaze into the fierce blast of uncertainty.

But this memoir isn't about you. Clearly, it's about me. Not just any me. Not mid-20s me, working at a record label for manipulative men who think they're the shit but their ponytails whisper otherwise. Not 36-year-old me, a married writer and mother of two. I'm talking about Teenage Gogo, the Degenerate. There are some others that you need to meet, too.

SOUNDTRACK "SUMMER OF '81" by Violators

1 Too Much Everyone: The solo emo project of a former grunge rockstar.

2

GIRL GANG

SOUNDTRACK
"SABOTAGE"
by Beastie Boys

Boltz Junior High Lip Sync Competition, 1996.

A guitar revs and machine gun drums attack the peaceful junior high audience of the Boltz auditorium. These are the stabby opening notes of the Beastie Boys' song, "Sabotage." The pace is quickening and I know it's about to get hectic in here. I look at my beanied-up backstage brethren.

First, there's Dar: the foul-mouthed, angel-eyed blonde devil of a thing. She's vibrating at a higher frequency, pretending to punch the air like a boxer. While I'm questioning why we signed up for this lip

sync, she's actually excited for this bullshit.

Dar is the party superstar. Blue-eyed and breasty, Dar can talk to any person on this planet and is as easygoing as sunshine. Aged thirty more years, Dar could be the waitress who calls you "Sugar." Dar is the person you want in the room to break the silence when something awkward just happened. She'll say something perverse and make it worse, but at least you'll be laughing.

Dar's my first-ever partner in crime. Throughout the sacred chronicles of our teenage photo collection, Dar's devout smiles imbue our misdeeds with a deliciously ironic piquant: rolling joints on our yearbook, looking up at the camera, her smile that of a glove spokesmodel. Affecting pouty eyes in drunken photos, like her crush just told her he wouldn't go with her to the dance. Every first of mine was likely committed by Dar's side.

Dar isn't the typical dating type; she's forward, she gets what she wants, and she's open to everything. In high school, this is evidenced about once a quarter when she periodically tries to fuck me. It's just Dar. Her sexual heat only makes her more lovable.

Dar is filled with stubborn pride. When Vice Principal Squires catches us smoking one cigarette, Dar vows to quit smoking, just so the bitch would have nothing on her. Years of staunch resistance, shivering outside with us smokers in the cold, gulping our secondhand smoke.

Dar is slouching like a rapper right now. She's

hamming it up. Getting gussied up like Beastie Girls means we're wearing our typical uniform: polyester old man pants from Savers, baby barrettes, and vintage tees featuring a randomly benign phrase like "Dale" or "T H E B A H A M A S." This is back in the days when you can find real vintage clothes for cheap at the thrift stores and you know they actually came from a dead grandpa, instead of a pathetic recycling of last year's Target merchandise with pit stains.

Dar maddogs my other friend Corinne, and Corinne nods coolly like she's at a drug deal. Corinne is our third Beastie Girl for the performance. Corinne pulls her beanie down over dark flames of bleachy orange hair, a smile escaping her deceptively shy demeanor that's both fierce and determined. Corinne is my idol in feminism, fearless owner of her own sexuality. Her mom is an astrologer, which gives her life a witchy, Tarot card feel. I feel like I'm in a much cooler world than Fort Collins when I'm hanging out at Corinne's house, like Seattle. Corinne plays electric guitar and wears slips as dresses with red eyeliner. Her fashion is loud, leopard print, and in your face. She loves Sleater-Kinney, Hole, and Bikini Kill, and it's her idea for us to start a Riot Grrrl chapter together. We make one flier, which I illustrate with a cartoon Beastie Girl with pigtails and a fierce grimace. Not a single person shows, and we immediately give up.

Then, there's me. I'm about to put on a show, but the truth is the performance has already begun for me. Pressure-filled situations like these make me forget

where to hold my arms like a normal human, let alone perform an engaging lip sync in a competition in front of the entire school.

On the cue of Ad-Rock's freefalling "Iiiiiiiiiiiiiiiiii iiiiiiiiiiii can't stand it," it's our time to burst upon the scene. Here it comes.

Dar, Corinne, and I swarm the stage like a super dope mirage. We're gonna set straight this Watergate. We're holding invisible mics and we're crouching low for an imaginary camera that would've likely been on the fisheye effect. We're schemin' on a thing. You know. It's sabotage.

We're each going to take turns being Ad-Rock the front man, and I'm the first. As I charge the front of the stage, my brain clicks off like a dead lightbulb; thankfully for me, my neurological system is hooked into the music and providing the accurate gestures to impersonate a rapper. People even cheer in delight. But my performance Zen is short-lived.

"Boooooo!" calls a strange voice from the crowd. This "boo" is particularly cruel sounding. The bright roar of the crowd tinges dark, my fear rising like the "ding!" of a carnival high striker.

I make a concerted effort to keep gesturing in a rappy manner, occasionally crossing my arms and grimacing, as I scan the crowd for my heckler. "Boooooo!" the voice taunts again, louder this time. I follow the sonic harbinger of shame directly to its source, across the bobbed heads of the audience to two silhouettes standing ominously in the back. I follow

the lines of their bodies down to where I can just make out some ripped bell bottoms that I recognize, and it clicks. The "boo" was especially cruel sounding because it was the parody of a "boo." It was an ironic boo that only an adolescent best friend could deliver. It's Tana R. Williams, Dar's older sister and my other best friend.

Tana is in the grade above us. Her golden hair is parted down the center and glides luxuriously to her waist. Bell bottoms reach her sandaled feet, ripped and frayed at the bottom from too many summer stoner parties. Her complexion pale and freckly like a ginger, her hair the color of brushed sand. A fairy comparison comes to mind, but she laughs that you just said that. She's way more fucking cynical than that. She's Tana.

If one were to picture Tana as a decade, it would be the '70s. Bright blue eyes and an almost wholesome appearance, if it weren't for the lighter that she's absentmindedly flicking, as if subconsciously readying herself for something. Something to smoke, something to fuck up. Tana is literary, passionate, dirty-minded, and big on snuggling. She isn't the typical dating type, either; she collects guy friends and they fall in love with her.

Tana is my soul-friend. Our favorite activity is leaving the party together, knowing we'll have much more fun on our own. Staying up late, chain-smoking, chain-drinking, chain-philosophizing. We're better one on one. And Tana's the one sitting back-to-back with me on the ground of the parking garage, linking

elbows so I don't twitch in pain while I'm getting inked on my chest at age fifteen.

Tana and I earnestly promise each other that if one of us dies, the other will gain access to her diaries, as if they're sacred texts. My diaries are of the written variety, and Tana is the in-house photographer. She keeps immaculate photo albums detailing the vivid spectrum of our misbehavior: grainy photos of us stealing signs from the small town of Niwot, grinning with idiotic pride. A particularly saucy drunken photo shoot with just Tana and me, with a Christmas theme and some light bondage. Corinne holding Dar with a fierce look on her face, an imaginary gun to her head; Dar looking totally content, dreamy even, to be faux-murdered (she's really blitzed). Rolling on the floor while stoned in vintage tees like a '90s album cover. Julian, Jones, Lucky, Bob, Micket, Jonny, Armstrong, all the best guy friends and lost loves.

Tana's photo albums ooze voodoo. Deep down, we think we're going to be famous for something contained in them. Do all teenagers secretly feel, like an instinct, that they're going to be famous? What would we be famous for, partying?

Sisters hold an energy between them that's always on the verge of exploding into mischief. I know because my sister Genevieve and I share it; but she's four years older than me, so our social lives are often separate. With Tana and Dar, I'm in the midst of the blast.

I'm nearly done with being Ad-Rock, at which point I'll probably try to imagine I'm invisible until

the whole thing is over. I peace out to the back, as if coming to after a blackout night of boozing. I congratulate myself for having passed my internal bar for everything: getting through it without falling and being as agreeable as possible.

It's Dar Williams' moment to shine right now, and she's so convincing as Ad-Rock that I can barely tell she's Dar. When the song ends, we exit the stage like heroes, and four people clap really emphatically.

"Booo," Tana adds again, as a postscript. Lexi, standing next to her, lets out a supportive "wooo!" Lexi is probably the least sarcastic one of us all, and the most mainstream in style. She even listens to R&B on the mainstream radio.

Lexi is Tana's real best friend. She's tall and skinny and tan, and at a certain point her mousiness will blossom into svelte beauty. Lexi has that maternal confidence that lets her get away with calling people "babe," and the ability to charm popular boys. She will become the first of us that I know of to give a boy a blow job, or to be desired for such an honor. It's no surprise that I don't remember the first of our kind to receive cunnilingus.

Next up on the lip sync stage is Brock Walker, one of the jocks. You can't even hate him, because he has the nerve to be popular yet not a dick. I immediately identify the tiddly keyboard plinks of another Beastie Boys song, one that talks about girls like they're a side dish to be enjoyed at different times of the day, rather than people. It's called "Girls." Fuck. Another Beastie

Boys song, and so soon after ours.

Talk about sabotage. My pride plummets like a Beastie Boy off a concrete parking garage, as exemplified 1:50 into the "Sabotage" music video.

While our lip sync was a gender-defying explosion of awesome, I surmise this perkier number is bound to go over better with the docile consumers of Top 40 that is Boltz Junior High. It's happier, it's simpler, and it's the appropriate level of sexism for these environs.

Fuck. Drea Lee, the most popular girl in school, is Brock's special cameo, playing the crucial role of "girl" in "Girls." Drea is everything that I am not: blonde, petite, demure, preppy, tan, normal, wearing of pink. She is skipping around the stage while Brock chases her. There is no art here. They exit the stage casually, like this is the least cool thing they will do all day. Now that's what applause should sound like. So hearty and full-bodied.

No winners are declared because no one cares about who wins the artistic contest. But we all know who the winner is.

The auditorium begins slowly emptying its contents into the afternoon sun, students shuffling out wearing Gap and Lucky jeans. These are not my people, not the people our Girl Gang parties with. Our people can be found slinking around downtown at very specific blackened coffeeshops filled with smoke, teenage haunts that Drea would never set a Skecher in. Our people are made up of a different stock: heavily eyelinered girls, slouchy girls, willowy blonde stoner

girls named Anna and Ana, punk girls with pixie cuts who belong in the '80s, hot sociopathic hippie girls, scene girls, future fire twirlers, large-breasted funny girls, larger-than-life girls.

There are boys in our scene, too—bass players in shitty punk rock bands, wastoids and skaters who drive blue Chevy Malibus, bisexual shy guys named Dorian who hang out at the goth coffee shop downtown, longhair metalheads, heshers, and amicable hip-hop heads. There are plenty of ska bands and exponentially more ska band members. There are slimy dudes who sell acid, Ian Curtis-looking dudes who love Skinny Puppy, dudes who ask me to say strange things on their homemade electronica recordings ("I want you to take me to a warehouse and fuck me so hard, over and over again, until there's blood and cum everywhere." I can't believe I took that recording request at face value, *Spencer*). There are too many people for just one story, important and unimportant, interactions that are cringeworthy and nostalgia-inducing all the same. You'll meet more of them along the way.

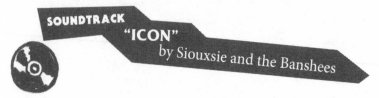

SOUNDTRACK "ICON" by Siouxsie and the Banshees

3
TOO COOL FOR SCHOOL

SOUNDTRACK "REBEL GIRL" by Bikini Kill

THE MOMENT LIFE TOOK a rebellious swerve for the Girl Gang is forever etched into my memory, like tires peeling out. Before this moment, I got good grades, danced ballet, took French, and played classical piano. I won the D.A.R.E. essay contest, as did Tana the year prior. We might've penned impassioned essays about zero tolerance towards drugs because we knew that was what was expected of us. But behind our sweet devotion to D.A.R.E. was a rock-hard, secret boner for drugs.

My private moments featured a lot of crying in my room to Nirvana's *In Utero* while seizure-inducing

Christmas lights flickered around me. The tragedy
that I would never meet Nirvana's lead singer Kurt
Cobain was too much for my teenage heart to bear. I
spent hours gripped in synesthesia-induced elation as
Nirvana's guitars and drums blasted me open, laying
me out backwards onto my bed, eyes gazing towards
the ceiling in heavy-lidded ecstasy. The brash sloppy
guitars of "Serve the Servants" didn't just satiate my
teenage angst with style points. I tangibly felt the
sounds exploding in searing white mushroom clouds
across my chest, in film negative contrast much like
the album cover of their debut album, *Bleach*; my
synesthesia didn't care that I was actually listening
to *In Utero*. Nirvana was my gateway to loud, smashy
guitars. From there, I started going to punk shows.

Punk is the gateway to all other music. It's acces-
sible, it's easy to play, the shows are affordable, and
it's cathartic enough for teenage hormones. Pretty
soon we were into Green Day, then NOFX and Rancid.
Eventually, we'd be thrust into the scene that birthed
the Descendents and Nobodys, where Jello Biafra
frequently popped in. One day, I'd look around and be
surrounded by people who only hung out with other
punks and only listened to Guttermouth, Pinhead
Circus, Pennywise, The Vandals, and the Bouncing
Souls. There were the diehard fangirls like Bea, one
of the Varsity Skater Girls, the scene queen who knew
everything about local punk. She collected all her ticket
stubs and fliers and bought all the local punk releases.
She made the scene go 'round. In comparison to her, I

was just kind of ... *there*. Plus, I was okay with hippies and listening to Led Zeppelin, so I never fully fit in. And my heart always belonged to Kurt Cobain.

Just imagining a lock of Kurt's hair tucked behind one ear, or a ratty oversized sweater hanging over one wrist as he strummed a guitar, kickstarted my brain on a passionate trajectory with questionable destinations. I sometimes made Fantasy Kurt cross the room and back me up against a wall to ravage me, kissing me passionately, his imaginary tongue unleashing a waterfall of real-life tingly nerves. Despite the fact that I'd never touch him, I felt the attraction tangibly like echoes of sexual sonar throughout my body. This was as far down the sexual path as my teenage mind traveled before the landscape turned foggy, unimaginable.

SOUNDTRACK
"BEAT ON THE BRAT"
by Ramones

SIXTH GRADE WAS A PIVOTAL TIME. It was the year I started playing drums. It started with unglamorous paradiddles on the baby drum pads and dorky solos on the timpani drums in band class; eventually, I got a secondhand sparkly drum kit that I blasted with noise. Then it was onto glorious drumrolls, then "Wipeout," and finally Dave Brubeck's "Take 5" in 5/4 time. I know, jazz. But I was never confident enough to play

in bands.

Sixth grade was also the year that I learned about drugs. In seventh grade, we began doing them. The rest was the stuff of *Reefer Madness* reels. We were moving to harder drugs (psychedelics, ecstasy, cocaine) and regular habits (smoking, drinking, smoking weed) by fifteen. I was barely playing my drums by that time anymore. We had a liquor store that sold to us regularly by sixteen and fake IDs by seventeen. My mom sold my drum set around then. Our twenty-first birthdays were entirely obsolete.

In the sixth grade, D.A.R.E. served to teach us which drugs were which and inject grand levels of irony into our later drug use as we wore D.A.R.E. jackets. I think every teen worth their weight in weed performed some unspeakable act of insobriety wearing D.A.R.E. merch. It was a rite of passage.

SOUNDTRACK
"I NEED SOME BRAIN DAMAGE"
by The Lillingtons

THE DAY WE WERE INTRODUCED firsthand to the seedy drug trade was an unremarkable day. It was pizza day in the lunchroom, which meant greasy Black Jack Pizza, orange grease and ennui. I had an embarrassing lunch my mom had lovingly packed for me.

Dar looked at me with her big blue doe eyes and

whispered over our lunch, "Greg Keilman has some weed. He's looking to sell it." She put her pizza down and looked at me.

"Ugh," I uttered in response to the name of Greg Keilman. Greg had called me a ditz. This was a criticism I received often, because of my tendency to space out in the middle of conversations. Little did they know, it wasn't a deficiency in intelligence but just excruciating awkwardness.

But Greg Keilman be damned, Dar and I were looking for adventure, and honestly anything would suffice.

The following is a list of our favorite pastimes at that tender age—I recall these times with pristine, sun-kissed, white confetti nostalgia: Rolling loose tea leaves into cigarettes, hacking on the spiky smoke of it, just to have something to smoke. Pressing our palms to our necks until we fainted, the world dimming inwards. Piling pillows in my entryway, plunging off the second-story banister to land, sometimes, on the pillows. The world flies up around you when you're plunging down, reaching towards ascension in that backwards teenage way. Unadulterated girl mayhem.

The truth is, we were bored shitless. Today, Fort Collins is a college town that has the trappings of a big city—a cool music scene, microbreweries, and art house theaters—without the traffic. When I was a teenager, the main form of entertainment was when the entire town swarmed Old Town Square for Thursday night concerts. Other than that, there were sporting

events; for those who had interests besides sports, there was drinking and drugs.

SOUNDTRACK
"SUBURBAN HOME"
by Descendents

THE SUBURBS WERE DESIGNED to be inoffensive, but they're not for everyone. Some people see a beige home with a two-car garage, an American flag and a hefty truck out front, and that's their base level of normalcy. These symbols of widely shared comforts make them feel a part of something larger: sports, Christianity, America. To a kid with weirdness in her soul, the frequency of its shrill banality is as offensive as waterboarding. These symbols felt anti-other, anti-creative expression. Hostile to anyone who wants to share anything new, telling everyone to shut up and be the same, *We Are Americans.* In the suburbs, bald white men often stand in front of their houses with their arms crossed, phone in hand, surveying the area for anyone different.

Our communities are the foundation from which we build our lives. If you're going to suck the humanity from my neighborhood, you deserve to have drunk teens dry-humping in your yard.

Perhaps that's why Dar and I had already kick-started our degenerate career the year before. We were

already elementary ditchers. I say this to mean we were ditching school at a beginner's level, but also that we were the only people I knew to have successfully ditched elementary school.

SOUNDTRACK "ADVENTURES CLOSE TO HOME" by The Raincoats

IN SIXTH GRADE, Dar and I made a plan to go into the nurse's office, staggering our arrivals, claiming to be ill. We each proceeded to call Time and Temperature, instead of our parents, and hold a fake conversation making plans for our moms to pick us up. And then we met at Dar's house, jubilantly gorging on pickles. Drinking black coffee from the still-hot carafe. Melting American cheese on corn chips and dipping them in Costco salsa. Then dipping giant pickles straight into the salsa because why fucking not. A dessert of ramen noodles, sprinkling just a tad of the granular MSG on the tip of our tongues. Consumed all at once before jumping on the trampoline, no digestive consequences whatsoever. Stretching out on tan lumpy couches that melded to our bodies in a cool basement. The kind of laughter that makes you curl up on your back and kick your feet into the air like a little bunny.

Sure, it only took a few hours for our sixth-grade homeroom teacher to realize how suspicious it was for

two best friends to go home sick at the same instant. Late in the afternoon, Dar's dad Jack returned from his bus driving shift and sat down on the lumpy comfy couch next to us.

"So, didja have a good day?" asked Jack. He had a sticky John Wayne drawl that got even slower when he was being mischievous. The super-slackened manner in his delivery led me to believe he was positively savoring this moment.

The Williams parents were hyper-literate blue-collar folks. Jack was of a rare breed: soft spoken, yet he might gleefully shoot a squirrel in the backyard with a BB gun, then say something witty about the whole endeavor. Smart, yet unrefined. Being Evangelical, Jack and Barb never let the Williams children participate in Halloween; instead, ole' Jack Williams hid in the shadows to scare the shit out of trick-or-treaters. The only thing more surprising than the mix of crass humor and earnest morality was that it came from someone so mild-mannered as ginger-haired Jack. You could call him dry. And it's worth taking note that if you're going to make your kids opt out of the candy holiday, you should make up for it with something highly entertaining.

Barb was the quintessential television mom: she perfected an outward condemnation of our shenanigans, while betraying an inner smirk that let us know she'd be making fun of us later.

A well-watched grainy family film featured the Williamses in their front yard, their youngest child

Grant asking the camera in toddler speak for "oranth juith." Jack was behind the camera, capturing the smile of his loving wife, Barb, then zooming in on her derrière as she bent over to do some yard work. This is the all-American, conservative, yet wickedly humored family from which the Williams girls were spawned.

Dar rolled her eyes at Jack. He was fond of giving long speeches in the middle of our hangouts, and they always had an angle that became painfully and repetitively clear very early on and for far too long. These speeches triggered Dar's teen angst at a razor-sharp click.

"You didn't answer me," Jack continued. He wasn't letting us off the hook. "How was your day at school?"

"Good," she spat out, as if it were an insult.

Jack smiled. "What'd you do at school?"

"I don't know, learning?!" Dar yelled in frustration. "Geez, Dad, why are you so nosy?"

"How are you feeling?" he asked, putting his hand on her forehead as she swiped it away. He was stifling laughter now.

"I'd be fine if you stopped violating me!"

"Oh," he held his hands back as if in surrender. "Hey, I'm sorry. It's just that I got a call from the school nurse today," Jack continued, "she said you went home sick today. That was really funny because I could've sworn you were at peak health this morning."

When getting in trouble with Jack, you never quite knew if you were truly busted. That's because he was always so clearly amused, it made you wonder if real

punishments would ensue, or if the delicious "gotcha" moment would satiate Jack.

"Come on, Gogo," he said, his voice turning serious. "I'll take you home and have a talk with your parents."

This indiscretion forever changed O'Dea Elementary School's standard operating procedures. Children going home sick had to call their parents on speaker phone from that moment forward. Dar and I didn't feel bad for ruining it for future ditchers. We were the only elementary school ditchers we knew. We grinned with toothy pride at changing elementary school policy.

But even our previous ditching held a sweet innocence to it. In the seventh grade, we were becoming aware there were far more interesting things to gorge oneself on than pickles.

SOUNDTRACK
"GIMME DANGER"
by The Stooges

BACK IN THE LUNCHROOM over the wafting scent of pepperoni, I considered Greg's weed, and a beatific smile warmed my cheeks from within. Both fear and excitement ignited the oven of my ribcage.

"Let's do it."

Dar nodded and said she would arrange the drug deal.

An hour later, Dar caught me in the corridor between classes and told me to meet Greg outside the music hall with $5 after the next period.

My fingers tingled for the entirety of a monotonous, infinitely dragging biology class. When the bell rang, I ran to the drug swap rendezvous, my heart working overtime to pump liquid fear through my veins. There were many possible outcomes, all of them scary. Would he not show up? Then I would feel like a loser because he probably didn't want to sell to a ditz. Would he show up, but then a teacher would catch us? That would almost be better than him not showing up. Would he show up, and then sell me drugs? The best-case scenario would involve me possessing illegal drugs.

There he stood, in the middle of the hall. Throngs of kids meandered around the small-statured island of Greg Keilman. Greg wore gobs of hair gel. He was the fast-talking sarcastic type who hung out with the jocks, but could cross over into other, less wholesome cliques. He was the perfect person for a first drug deal: someone who might grow up to sell used cars that implode the second you drive off the lot.

I approached Greg, towering over him as I did many boys at school, which had the opposite effect of making me feel small. He nodded at me, a half-smile on his face. At least he was acknowledging my person-hood. This was a good start. Greg opened his pants pocket and gave me a glimpse of the baggie rolled up. Feedback raged in the pit of my stomach.

"I want it, but I don't have the $5 today," I said.

Five whole dollars. It must've been some really good weed. "I can get it tomorrow."

"It's okay, you can pay me tomorrow," he said, slightly miffed. He looked shifty, like he wanted to get rid of it. We made the exchange, fingers burning as I stuffed the baggie into my pocket, walking away briskly without saying adieu.

The sprint to my next class was exhilarating. It's easy for a feelie like me to become addicted to the distinct feeling of conspiracy. The tension of holding in a secret feels so fucking good, like an inside-out carwash squeegeeing your viscera.

I passed Dar on the way, our wide eyes connecting with enhanced meaning. I nodded once, and her face burst into a smile so bright, as if we had finally made the cheerleading team. We grabbed elbows and danced around in circles for a dumb minute.

"After school?" she yell-whispered as we parted ways.

"I have volleyball tryouts, so later!" I called.

SOUNDTRACK "SPORTS" by Viagra Boys

AH, SPORTS. It's funny to think of a time, as brief as it was, that I believed the trajectory of champions to be my course. My older siblings had faked their way

through sports, never really excelling, but never truly embarrassing themselves, either. Participating in sports was just what was expected of you in Fort Collins secondary education. The only book written about the local high school, Fort Collins High, was entitled *Home of the Champions*. The school's previous location was a charming historic building in a neighborhood filled with old-money mansions turned frat houses. It had a tower, which became the school's emblem, e.g., the dance troupe calling themselves "Tower Dancers." The school then moved to a brand-new angular building, designed by an architect who normally designs prisons. It came complete with a ridiculous spike to honor the original, more charming tower, pointing skyward like a football player thanking God for his touchdown.

Sports.

Sports.

Sports.

Sports.

Sports were just what you did and, thus, I figured I could at least pass for athletic. Together, my parents and I had decided I should try out for the volleyball team. If it could be played on the beach in bikinis, with balls soaring delicately through the air, surely it was to be the least intimidating of the sports.

After school in the open gym, the balls that seemed to soar gracefully in MTV beach volleyball situations now aggressively divebombed my face, fluorescent lights blinding me. "Kneel!" yelled the board of varsity players and coaches lined up behind a

table and tasked with the unfortunate duty of judging my athletic prowess. I ungracefully dropped to a knee on shaky ankles and tried to bump the swiftly approaching volleyball with limp wrists. Then, I tipped over. I shook it off, laughing to myself. Silence from the board. The cruelest thing one can do, when witnessing a catastrophe of coordination, is to refrain from laughing.

After a good five minutes of lunging after balls and grasping empty air, the tryout board thanked me for my time and told me I could move on to the locker room. I tried to brush off the embarrassment of failing at the only thing that mattered to anyone in my town. It was a little easier to brush off because it was balanced by the excitement of what secretly beckoned from my locker: that beautiful baggie of motherfucking weed.

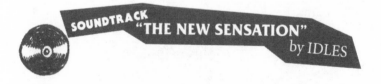

SOUNDTRACK "THE NEW SENSATION" by IDLES

DAR IMMEDIATELY FOUND ME on the path outside school, flanked by our neighbor boys, Micket Thompson and Rat Woozle, in ratty shirts with rattier skateboards. Micket was medium good-looking and sky-high levels of sarcastic. His caustic nature was balanced by quirky endearments, like the time when he buzzed all his hair but for one protuberance that stuck straight up, which

he referred to as his "quail feather." Rat, Micket's side-kick, was shifty and his shoulders bounced when he laughed, as if he was letting out bursts of air with each chuckle. Micket and Rat clearly smoked weed all the time. Dar had presumably brought them for the paraphernalia and the know-how. We made clandestine plans to meet later that night in Rat's treehouse.

In the treehouse later that night, cool stars glittered from the cerulean twilight. We stuffed our bodies into the tiny wooden spacecraft that would surely carry us to horizons unknown. Micket brandished a pipe, which looked like a gnarled Christmas ornament, so foreign and strange. He packed my weed into the bowl and flicked a Zippo to it, sucking in for an eternity and exhaling an expansive plume of skunky smoke. Then, he handed it to me. I sparked the embers, pulling the smoke into my mouth and immediately blowing it out. Micket laughed. "Dumbass, you have to inhale," and it sunk in cleanly as the greatest embarrassment of my young life to date. He took the pipe back and demonstrated that after sucking the smoke in, I needed to open my mouth in an "O" shape. This time, I tried again, making the "O" shape. The tangy smoke bit sharply in my lungs, then coughs sputtered out of me. But it was a good burn.

Just as the lighter stoked the pipe's contents into blooming embers, this ritual, and the knowledge that we were doing something explicitly wrong, warmed my innards. Rat looked around at us with slanted eyes, sizzling with laughter. "Sss-sss-ss-sss-sss."

"You feelin' it, bud?" said Micket, a Jack Nicholson smile on his face. He already knew something that we didn't.

"Yeah, I think I feel it," Rat Woozle said.[2]

"It's fucking oregano, Rat-tard," said Micket. "I can tell. This isn't real shit."

No wonder Greg had deigned to sell to us untouchables. The weed was fake. We had been officially ripped off. Except … we hadn't actually paid for it. That amateur gel-encrusted sleazelord.

When Greg demanded his money the next day, Dar and I laughed at him and kept walking. "Nice oregano, GREG."[3]

It was at that moment we decided not only that we were going to be bad—I wanted the real thing, now—but that we were also going to be good at it. Sure, being sold fake weed in junior high hurt our pride a little, but at least we hadn't fallen for it. Thanks to Micket. We were ready to take our degenerate careers to the next level.

SOUNDTRACK "OH BONDAGE UP YOURS!" by X-Ray Spex

2 "Rat Woozle": A punk song about that one guy who always fakes being stoned.

3 Oregano Greg: A really shitty white guy blues guitarist.

THE NEXT DAY WHEN I CHECKED the volleyball sheet that was posted, to my horror, I had made the team—simply because I was tall, I assumed. Simply because I stood at the height of 69 inches and three-quarters. (I refused to refer to my height in feet, nor would I round up to 5′10″, lest a sex joke opportunity be missed.)

"Good job," said a plain-looking jock girl who had never spoken to me before. Even though she bored me desperately, it felt good to be addressed by someone who was so much higher in the school caste system than me. But I was terrified of what would happen when the time came for me to perform. I hadn't yet bothered to learn how exactly volleyball worked, or how to avoid diving into the periphery when a ball came towards me.

After school, Dar and I decided to celebrate my newfound acceptance into the popular world by trying drugs again. This time, our "friend" John Robinson said he'd smoke us up. I say "friend" in quotes because the fucker tried to charge us money for it. It's not like he was charging us for a baggie of weed. He was smoking his own shwag and sharing a hit or two with us. Dar and I were too green to know this wasn't typical, but smart enough to think it was shitty all the same.

I always thought my neighbor John Robinson was a nice guy, but it was mostly because he was unassuming: brown hair, brown eyes, average height, whatever face. The most exciting thing about him was that he was a skater. He was a quiet ally in troublemaking, a close neighbor who was part of the resistance. But

underneath his underwhelming exterior was the moral character of a Southern politician. When I write down what he did on paper—"helping" me sneak back into my parents' home after getting too drunk, then taking turns with Mark MacMillan sticking his tongue down my throat after I passed out—he strikes me as a colossal bag of dicks. That was technically my first kiss, and I don't even know which drunk asshole it was. I woke up with a hickey. Fuck you, John Robinson.

But this was a simpler time, before anyone had put their mouths over anyone else's agape, sleeping mouths. We shook away our reluctance about the conditions under which we were about to get stoned. The important thing was that we were on the precipice of getting truly stoned for the first time, albeit with an unassuming, greedy bag-of-dicks young man from Scotch Pines.

Dar and I arrived at John's house in the afternoon. His home was a depression soup with a brown base of couches and touches of tan sunlight with dust sprinkled on top. His parents clearly weren't home. Still, I remembered feeling like it was fairly cavalier for him to be smoking weed in his parents' living room.

He said, "Hey," and nodded quietly at us. "Drop the cash on the floor," he demanded coldly of Dar. Dar did as instructed.

We kneeled in a circle on the carpet in the middle of his parents' living room, and John took the first greens, the cherry crackling as he sucked in a huge hit. He passed the pipe to Dar, who toked like she had

been doing it for years. When she passed the pipe to me, I inhaled, and my throat burned deeply. Clearly this was not oregano. I hacked until the world turned funnier. This shit was legit. Then, suddenly, before my eyes, Lightning Dar took hold.

"Lightning Dar" is a more fucked-up version of Dar, someone harnessing all of her badassery (fast forward: she is currently married to a biker and has a black belt in karate), mixing it in with high levels of humor, energy, and street smarts.

While Dar might do as instructed of her, Lightning Dar wasn't about to be taken. I knew she was up to something when she smirked at me sideways. She began talking jovially to John, "This is some good shit!" All the while inching her foot over the cash. That was all it took to make ol' Greedy Bag-of-Dicks Robinson, version 2.stoned, forget the money ever existed. When he looked away for a second, she grabbed it from underfoot.

At the same time, Dar was also getting stoned beyond this earthly realm. After she repeatedly kept running into walls, it became clear that she believed herself to be a ghost. Time fell clumsily in blurred curtains. I discovered that déjà vu is just a wormhole in space-time that allows us to feel similar experiences that happen at different times in our lives. Dar later recalled having to pee so badly, but not being able to find the bathroom through the walls she was running into.

John looked around the room, patting his pockets. "Where'd I put that money you gave me?" His eyes were as small as coin slots. He laughed at his own stupidity.

"You stupid motherfucker," began Dar, "you put it in your pocket, dumbass!" He searched his pockets and found nothing.

"You'll find it sometime soon," I said, grabbing Dar's hand and running out of yet another door, the screen door slamming. "Gotta go!"

Walking down the block, stoned for the first time with my best friend, having just reversed a karmic injustice, I felt boundless. Stoned laughter feels different from regular laughter: it's inescapable, sitting perched like a clump of koalas all over your face. After the second time smoking weed, lying upside-down on Dar and Tana's lumpy beige couch in the basement, I was convinced I'd be a stoner girl.

SOUNDTRACK "WASTED" by Black Flag

THEN, WE DISCOVERED BOOZE.

Beginning your drinking career at the age of twelve can go one of two ways: death by alcohol, or achieving career excellence in drinking.

The first several times you get drunk, you have no preconceived notion of what you're tasting; you don't have the Proustian memory of puking it up. Liquor tastes like blank chemicals. You can take a shot without grimacing. You can drink a tall glass of vodka. You feel

like a party robot[4] crafted from special alcohol-proof metal, like Wakanda's vibranium but for the sole purpose of hedonism. Why'd they make tequila shots look so hard to swallow in the movies? This is easy! Your tolerance of the taste astronomically surpasses your body's ability to process the alcohol. This is why alcohol poisoning was such a regular occurrence.

Furthermore, as a new drunk, you can get beyond-the-boundaries-of-space-and-time drunk, and not even have a hangover the next day. It's like time travel without the aging.

The first time I got drunk, we had a sleepover at the Williams' house. The three of us snuck out of their basement to the nightly cricket chirp ensemble of summer, meeting up in frenzied whispers with Micket Thompson, Rat Woozle, and John Robinson. We sat on the lawn just outside of the Williams' house with the neighborhood skaters, the grass wet, the night deliciously taut with possibility. We didn't really think about the fact that we were right outside the Williams parents' window. We took turns passing around the bottle of vodka, filling tall glasses with the straight astringent liquid, the darkness of midnight suburbia enveloping us, emboldening us. We could do whatever we wanted in this space. That's when Dar turned to

4 Borrowing the term "party robot" from my friend Virgil Dickerson's drunken alter ego, Virgilio, a party robot sent from the future who is immune to hangovers.

Rat and forced his shoulders to the ground, covering his mouth with hers. It was the first make-out session I ever remember; they rolled around passing one piece of gum back and forth between them. It was purely an experimental make-out session, not a romantic coupling, as Dar had no interest in Rat; but at least Dar was wide awake and on top.[5]

SOUNDTRACK "TRANSMISSION" by Joy Division

ONCE THE BOYS WENT HOME and we retreated to the basement, we slurringly decided to commemorate this first drunk-getting with a good bloodletting. Tana, Dar, and I took a dull knife and sliced the padding on our middle fingers, because fuck the world; we pressed them together, forever sealing our union as blood sisters. Tana and Dar even pressed theirs together, momentarily forgetting the fact that they were already related by blood. Blood burbled out of my gash like a geyser. I, in my drunken sloppiness, had cut far too deep. The blood hemorrhaged from my finger for

5 Wide Awake and On Top: A sad Lilith Fair-style all-female band that pens feminist odes that fall short of being inspiring, like "I Guess I Enjoyed It."

hours, filling up rags. I began to panic, and Tana sat on the couch with me, maternal comfort shining through her words that were thick with drink. "S'okay, baby," she cooed. "S'okay. It's totally normal to bleedthatmuch." She told me the next day that she knew nothing could've been done about it, so might as well not freak out. I agreed. I still have a scar to this day.

The next week, after sipping Boone's Farm with Dar at a playground, I somehow found myself alone, waiting for my mom to give me a ride. I recall slinging myself sloppily on the swings at the park, the world pleasantly turning in on itself, smirking into the afternoon sun even though I knew my mother was about to pick me up. In those days, the ecstasy of intoxication overpowered any single worry in the universe.

When my mother pulled up, I shrugged into the car, and it took her one look to know I was toasted. She simply stared at me, halted what she had been planning on saying, and laid her high heel into the gas pedal like there was a particularly grotesque cockroach underneath it. The outer world suddenly flew past in blurs. We sat in total silence as my mother's car careened through the streets like she was the drunk one. It's a quality I later inherited from her—we drive like lunatics when we're pissed. As the world smudged around me, from both the drink and the wild driving, I wondered if she was driving me home, or to prison, or the morgue. I wondered which would kill me first, the alcohol poisoning or the inevitable car crash.

SOUNDTRACK "BRING" by The Spits

THE NEXT DAY, MY PARENTS escorted me to the Hope Center, a place for substance abuse recovery.

"We've given it some thought, and we're not angry anymore," my mom began, tears threatening her clear blue eyes. Her black bob shook gently from some unspoken inner turmoil. "We're going to get help."

The help was as much for them as for me, as they had no compass for what to do in this situation—my parents had never misbehaved before.

My mother grew up in a family forged by war, my Belgian grandmother having escaped her country during WWII by marrying my American drill sergeant grandfather. Mom spent her childhood too anxious of her authoritarian father to do anything untoward. There was no frivolity, no stepping out of line in that house.

My father didn't get into trouble as a young adult because he was too busy pulling himself out of poverty, raised in an abandoned schoolhouse, becoming the first person in his family to go to college, let alone get a Ph.D. in physics.

My experimentation was baffling to them. Indicative of emotional turmoil.

The Hope Center was my parents' anxious over-achiever way to address the problem head-on. They didn't understand there was a spectrum of misbe-

havior, and that I was still in the "normal rite of passage" section of it. Everyone who crossed that line was in a no-man's-land they were staggeringly unfamiliar with.

The Hope Center must have offered some "scared straight" package on the menu for neurotic parents of teens. I was put in a joyless room which contained a lonely chair and a table with a questionnaire, where no doubt many real addicts dried out, twitching and vomiting. Left alone, I filled out the questionnaire. It felt like the worst kind of school test, where I might be checked into rehab depending on my answers. I was scared, yes. I wasn't precocious enough to see this at face value as a bluff. But I had summoned enough haughty teenage indignation to paint a defiant smirk on my face. My anger burned through the kindling of jitters I felt about where I would end up.

The questionnaire reported back with great authority that I was 75% likely to develop cocaine addiction, 50% likely to develop a dependence on marijuana, and that I was most definitely abusing alcohol. No matter that I hadn't even come close to trying coke yet, and that my place on the Innocence Index was "still sings all the words to *The Little Mermaid* at slumber parties with friends." So dire was my state that I would surely spiral into an addiction-fueled life on the streets if I didn't shape up. That's what my counselor told me and my parents, now in a therapy-style room with comfortable couches and dentist office smell, before letting me leave. I was granted one

more chance at freedom.

Camps for troubled teens were also common devices to scare kids straight, and more often than not they introduced normally explorative teens to next-level drug addicts. It was our degenerate education, and we became next-level degenerates ourselves. In my case, it convinced me that I was no good, so I stopped trying altogether.

SOUNDTRACK "DEMIREP" by Bikini Kill

BACK AT SCHOOL, summer was approaching, and I won my first ever "award" of popularity. In the yearbook, they gave out awards like "Most Athletic," and even the King and Queen of 7th grade. I was honored as "Most Unique." They included a picture of me wearing the striped English-style football zip-ups I was fond of wearing, garish orange streaks in my hair. Greg Keilman scrawled in that same yearbook "you dress like a freak but that's okay."

Meanwhile, life on the volleyball team for the "Most Unique" girl in school was miserable. I dodged the ball every time it came flying at my head. This was also frustrating for my peers, who inexplicably desired to win.

"Be aggressive," my parents used to coach us

after our childhood soccer games. Did they know who we were? Did they know who *they* were? We were not a family of Bulldogs. We were a family of Labrador Retrievers.

My mom is the type of person who will bend over backwards for anyone. It's our unifying familial trait: doormatishness. She's often burdened by less fortunate souls who are far too dependent on her, or administrative duties that are far outside her job description.

"They're asking you to film a nonprofit presentation, Mom? But you're a *French teacher*."

"I don't know, they just needed someone to do it."

There was the time my mom invited the King Sooper's bagger to Thanksgiving, only to find out over dinner that he was profoundly racist. The irony of being so nice, you inadvertently invite Klansmen villains into your home.

Our family's role in the community could be likened to the local high school's mascot, the Lambkin. While I didn't yet attend Fort Collins High School, I was familiar with its mascot because it was #1 on David Letterman's Top Ten list of most wussy mascots. It wasn't enough for our mascot to be, in most circles, the definition of prey—a lamb. Our mascot was an even tinier baby lamb. A lamb-*kin*.

I certainly felt like a lambkin on the volleyball court, as in life. Participating in direct competition was embarrassing to me, as foreign to me as an alien sex act. It felt desperate. *Why are these people trying so hard?* I wondered. *If you have to elbow your way to the top,*

you're probably not all that good in the first place.

When I sat my parents down to tell them I'd be quitting the volleyball team, I figured it would be a slam dunk. Or whatever you call a point scored in volleyball. After all, my weak wrists and tendency to tip over easily were clear to all. My parents must've been operating in some brand of denial that their daughter was just like everyone else. "We don't raise quitters," they told me, and I admitted to myself that I had shown perseverance where it applied to trying drugs.

But even as my parents marched me to Coach McGuire's office to tell him I'd be rejoining the team, I suspected they were holding firm not because of a devotion to sports, but from a desire to prevent a dangerous precedent from being set in other life matters. *If you let her quit this one thing,* they probably figured, *she'll quit everything for the rest of her life.*

"Yeahhh, you should let her quit," Coach McGuire said, about one sentence into their impassioned speech about commitment. Coach McGuire's acute jab to my pride was instantly absorbed by the cushiony relief of not being on the volleyball team anymore. Plus, I was right. We are each capable of determining whether something is within our realm, and when we're just going to dodge those fucking volleyballs forever.

SOUNDTRACK
"GARBAGEMAN"
by The Cramps

Summer provided immeasurable relief from both the drudgery of school and the terror of incoming volleyballs. One sunny afternoon, I rode the bus downtown to meet some friends for coffee. My nerves were abuzz with the knowledge that my family was going to be leaving within the week for Paris. My parents had saved up for years. My mother was obsessed with French culture. Mom wore French scarves while teaching French class and crammed so many Eiffel Towers into her décor, her office became a liability for poked-out eyes. The French often speak of Belgians as the unsophisticated, sheep-fucking masses; this made it especially surprising for me to find out one day we were actually Belgian. This fact wasn't exactly hidden by my French-loving mother, but she didn't really bring it forward, either.

As I climbed onto the bus, I walked past a man with weathered skin and an overgrowth of scuzz on his face, like a Slim Jim that had been left out in the 7-Eleven parking lot too long. His gaze burned my flesh as I walked past. I sat down in the back. He scooted a few seats closer. He looked rough, but it was a fairly full bus. I figured I would probably be safe.

He smiled at me crookedly. I smiled back. After all, he hadn't done anything wrong. Maybe he was just a friendly older man.

"You sure got a perty mouth," he said, before I could hold onto my neutral assumptions for much longer. *Ting.* Someone pulled the cord to be let off at a stop, right at the perfect moment to click with my

internal shock. "What a per-ty mouth. Never seen a mouth like that before."

I looked around at the people on the bus. They all just stared down at their laps or out the window.

"Thanks," I said, and nodded once. I felt vastly uncomfortable, but I was always taught to be polite. Maybe he had a daughter and I reminded him of her.

"How old are you? Are you a ... teenager?" He threw that word out casually, looking off into another direction as if he didn't care about the word's meaning. It was just a banal, Wednesday afternoon word with little consequence. His leg spread into the aisle, his body basking in the sun of a world where I knew his intentions were malicious, but here in the shadows it would be considered rude for me to say anything to protect myself. The bus stops kept ticking by as people pulled on the cord. *Ting.*

I nodded quietly.

"You look so ... young." My heartbeat began to hammer into the back of my neck. But I didn't do anything. I quietly answered his questions whenever he asked.

At any rate, I lied to myself, he's just asking about my age. It's not like he's asking about my vagina. He's certainly not exposing himself. No firm lines to vehemently guard against. Just get through this.

Ting.

I smiled a tight-lipped smile at him. Maybe I could make those perty lips disappear. *Ting.* Whenever I smiled, he smiled back. "That's nice when you smile,"

his voice oozed.

"What are you up to today?" he asked cheerfully. "Where are you headed?"

"Meeting friends," I mumbled. *Ting.*

"Where at? I just got off work. I mow lawns for a living. Could use a good time."

I was a few stops from my final destination, but I could bear no more. I didn't trust my instincts enough to tell the man to fuck off. After all, the quiet bus was half-filled with grownups who must have been listening as he oozed ill intentions. They didn't find anything wrong with how he was interacting with me. But my body took me where my mind could not. My body stood me up, and when the bus doors opened, I flew out the door and ran away.

SOUNDTRACK "IN MY EYES" by Minor Threat

I HID IN THE ALLEY, feeling as if the man's gaze continued to burn my back. Either I had successfully lost him, or I had led him to a deliciously secluded place ripe for murder. The bus pulled away and I stood there panting for a full minute until I could be sure it was gone, my heartbeat eventually returning to normal. I took the long route to the coffee shop.

If I hadn't witnessed the "perty mouth" lawn-

mower man myself, I wouldn't have believed it. It sounded so cliché, like a character from a movie. I felt the double shame of a bad thing happening to me, and of my politely standing by and letting the bad thing happen to me. It had just been so shocking for someone to step over the line like that. There was nothing in our sex education classes to cover this. But sex extends far beyond the lines of how to put on a condom. This was how far sex extended, to a haggard stranger on a bus.

Even more shamefully, I felt the slightest twinge of warmth at being wanted by anyone, even a haggard bus man. After all, it seemed like I was gaining a point towards what society wanted from me: desirability. I didn't even feel angry at the time. It made me feel separate from the people around me. Alone. Strange. Other.

SOUNDTRACK
"VIVA LA REVOLUTION"
by The Adicts

IN PARIS, WE CRAMMED in one flat and subsisted on baguettes with canned "chunky chicken" my mother had brought in her suitcase. It wasn't a glamorous French getaway by any means. But besides the ironically horrible cuisine we consumed in France, even unglamorous travel in a world-class destination was still a huge perk of having a French teacher for a mother.

I had spent my life chasing after my older siblings.

The age difference was great enough that there was never any competition in our family, only my adoration of them, with a side of little-sisterly annoyance. They were tolerant of it. I named my first doll after my sister Genevieve, four years my senior. My sister was kind in response to my devotion, although she admitted to me as an adult that she was definitely tricking me into doing her bidding. My brother Gabriel, seven years older, tortured me in the brotherly way—he shot BB guns at my Barbies in the backyard on one striking occasion—but he also ruffled my hair and gave me the occasional bear hug that embarrassed me because of how happy it made me.

At some point in the trip, my siblings and I snuck away from my parents to smoke a cigarette. My brother, being super cool and 20 years old, had bought a pack of Lucky Strikes. These particular cigarettes were nearly impossible to get where I lived in the states, because they were filthy strong. It was like comfort and safety colliding with excitement: my idols and my new thrilling habit.

I smoked all the time at home, but it wasn't nearly this nonchalant when I did it. It was a whole to-do that involved stealing a Marlboro from Dar and Tana's dad, gathering all of our friends, finding a spot in the middle of a field, tediously passing around one cigarette, and then a complex deodorizing process that included lotion, perfume, gum, and even partial removal of clothing. The attendant minutiae took much longer than the smoking and stole much from the mystery.

Lighting a cigarette without preamble was the coolest thing in the world to teenage me. I loved it in the movies when someone woke up in crumpled sheets, bedhead gone wild, and lit up like it was no big deal.

On the grey streets of Paris, it was the first time we siblings smoked, or did anything bad, together. Gabriel passed me my own cigarette. I took one drag and it hit me with a heavy buzz that ricocheted in my head. The dark cilia of the nicotine reached into my body and gripped me, left me reeling pleasantly as the world pulsed. I felt cosmopolitan, like everything was dazzling in French New Wave black and white.

"Do you get high, too?" he asked, exhaling. The question was delivered with the feigned nonchalance that masks the underlying feeling of stepping out on a high wire.

I looked down and waited a moment before answering, considering. "Yeah." I stole a glance at my siblings, wondering how they might react.

My sister Genevieve just took a drag and choked. Cigarettes weren't really her thing. She liked cloves. She recovered, shaking her brown locks out of her face, and looked at Gabe, smile-squinting. "How old were you when you first smoked up? I didn't until I was like fifteen."

I was surprised that my sister, in her oversized mustard-colored Gap windbreaker, had ever smoked weed at all. She was so responsible. She maintained good grades and hung out with band geeks. She got Glamour Shots, with her rich brown hair puffed into

mall bangs atop a head perched playfully on gloved hands. She played the goddamn flute—people who play the flute don't do drugs. But she also had a darker side that she stoked in private, in her oversized flannels, devouring the sounds of Nine Inch Nails. And she was never judgmental to anyone ever in the least. It was our rule that we had together. You cannot shock the Germaine girls. In fact, we've sometimes become instigators or enablers because of a devotion to radical acceptance.

Gabe looked down at the ground, smiling slightly, as if simultaneously surprised and amused. "Yeah, I was a bit older. Maybe sixteen, I don't remember." Gabe's brand of trouble was popular jock shenanigans, involving rich-kid parties, pranks with road signs, and dating cheerleaders. When he asked me if I got high, the only reason I felt comfortable answering honestly was because I assumed that he had done it before. We were coming out of this drug closet together.

"Well," he began, not sure what to say. He ruffled my hair with his big hand. "Just be careful, okay?" He was affecting that cheerful voice of a man lightening the mood.

Later, I perched from our Parisian flat window, which was flung open to the French night. The hum of centuries-old architecture anchored me. The air smelled like something I didn't have a vocabulary for, yeast from all the bread and fish from the open-air markets mixed with French perfume, sex, and secrets. I was wearing a plastic swan necklace that I had found

on the top tier of the Eiffel Tower earlier that week. Its shiny plastic was a bright chartreuse, hung on a yellow piece of yarn. Probably a French child's toy. But it was so different from anything I had ever seen in the States, as foreign as how the French phoneticize animal sounds, so banal and strange all the same. I went on to carry it with me everywhere I went and called it my lucky swan.[6] I believed it was magic.

I clutched the ornately black-coiled balcony that was older than time, watching Paris alight with activity even hours after it went dark. There was a stadium concert nearby whose pounding punk sounds clashed with the old beauty of Paris; I could see search lights scanning the heavens. I thought it sounded like Rancid. I imagined being one of these fashionable French nightclubbers, out devouring the thrilling world. I smiled, knowing that my siblings were silent allies in my schemes.

Years later, when I was seventeen, my sister would secure my first ever fake ID and take me out to the bars with her. At the time, I figured my siblings were just the coolest ever. And that's definitely true. What I didn't see then is they were also trying to protect me by partying with me. If I was flirting with danger, at least it'd be under their watch. My brother warned me not

6 Lucky Swan: The name of the solo project of an elder goth with apocalyptic ramblings so dark, so bleak, it makes The Birthday Party, Skinny Puppy, and Throbbing Gristle sound twee.

to get too drunk at parties or I could get "taken advantage of." My siblings couldn't save me from making stupid decisions. And they couldn't totally save me from being battered. But as we became involved in our debauchery together, they probably saved me from much worse. Add them to the long list of reasons I'm lucky to still be alive.

SOUNDTRACK
"HOWLING AT THE MOON (SHA-LA-LA)"
by Ramones

4

NATIONAL RUNAWAYS

SOUNDTRACK
"YOUTH YOUTH YOUTH"
by Generation X

YOU'VE HOVERED IN STARK SILENCE for hours, bok globules percolating your nethers as images of tonight's future-party forecast in your brain. At the stroke of eleven, you pull your bathrobe on, grab your empty glass, and head to the shower. This is your unlikely uniform as you begin tonight's journey. The giant robe is to cover your clothes, including your favorite brown suede jacket. The empty glass is to have an excuse of why you're wandering around in the middle of the night, if your parents intercept you. The shower is a TARDIS (Time And Relative Dimension In Space, a.k.a.

time machine). You're going to step inside, make your journey, and then exit into another world.

You'll pull the curtain closed while holding your breath. Then you'll turn to the tiny shower window that hovers at eye level. This window is like when you slit your TV dinner before microwaving it; it's meant as a miniscule vent to keep the room from mildewing. It's certainly not meant for human passage. But little does this tiny window know—it's a window—it goes out onto your roof. For that reason, you're going to climb onto the silver soap tray that your tall brother once pulled out of the wall when he was getting out of the bath, shattering bath tiles all over the tub. You're going to squeeze through this mini window that's the size of a bread box, its metal edges cutting into your skin on all four sides. You're going to flop forward, your nose kissing the apex of the roof, which runs perpendicular to the window making equators across your belly. All the while, you're going to keep silent through the pain. You're going to shimmy through this mini-window like a double-clothed, sinister, thrill-seeking baby being birthed, sputtering, wild into the ragged stolen air of night. Poised to blast past the suburban swath into the eternal possibility of night like a fiery rocket.

What are you running away from? The easy answer is curfews and boredom. The more difficult truth is that, sometimes, we can hurt the people we love the most simply by being ourselves. It's not just the sneaking out, the drinking, or the risky behavior your parents loathe about you, or at the very least misunderstand. It's your

naturally dark proclivities, your repulsion of the church and attraction to the weird, which emerged before all of this, *ahem*, behavior began.

Will you come back tonight? It feels better to imagine you won't.

Once you grow out of this home, you'll desperately miss it. It's never the same returning to your parents' house as an adult, because it turns out the comfort it once afforded you was the result of the lack of responsibility, rather than a stocked fridge.

But you can take it for granted now. You're a teen whose parents don't understand her, damn it!

Now, you're precariously perched on the pinnacle of the roof, looking at the stars. You feel larger than the sky.

To kill time, you light up a disgusting cherry-flavor cigar someone gave you, puffing without inhaling until you hear a "Pssst!" in the shadows. Stub the cigar out, strip off your robe. Dangle your feet off the roof, gingerly feeling in the dark with one foot for the narrow top of the fence. Hold onto the roof in a tight rope walk on the fence, then drop blindly from the fence into a pile of dead leaves.

SOUNDTRACK "STREET OF DREAMS" by The Damned

SNEAKING OUT IS A MEANS to an end: the best parties. But you've got to admit that you enjoy the means. It's a dangerous game. Then, there's the payoff: roving the ghostly streets as exultant Kings and Queens. No adults present to control this vast realm. It feels like wandering through frozen time or looking at the flat, bug-encrusted underside of your neighborhood. The stillness as compared to your vitality makes you feel uncanny, like you're a visiting supernatural being who's more sentient than this world.

You left the tiny window cracked, hoping it will not be locked when you return later to a chorus of robins. That has happened before. It's already treacherous sneaking back into your house: tiptoeing precariously atop the wooden fence; mounting the roof on your belly, your legs dangling; walking across the slanted roof, typically drunk; then slipping back into the tiny window like toothpaste going back into the tube. The night air suddenly sealed out like shrink-wrap.

This game has repeated itself every single night this summer. It began when your parents gave you a curfew that was totally unfair. Your parents took the lead by two points when they started camping at the top of the stairs, so you couldn't hurdle over them, but they didn't realize that you were willing to jump off the roof.

They began setting alarms to check on you at 2:00 a.m. You began sneaking out earlier, so you could return by 1:59 a.m. sharp. Never in your life have you been so punctual. 9:12 p.m. is early enough that your mom is

asleep and your dad is still working on his computer. A half-empty six-pack sits next to him, a practice that you'll later employ as an adult (if you have to work after-hours, at least drink while doing it). You earned style points by crouching behind house plants, dropping and rolling as you crept behind his back down the stairs, holding your breath and praying to the devil that he wouldn't turn his head while your dark figure meteored his periphery. You considered with great earnestness that you probably could be a spy.

You and your friend Shia had the nerve to call a taxicab in suburban Fort Collins at midnight. The taxi driver picked you up without question, clearly underage and clanging 40s in the backseat. He drove you to an unmarked place out by the highway, only found by mile marker. You paid the man and wandered out into the darkness, feeling around for a party in a field. Your memory of the party, out under the open stars, is just an empty cookie-cutter shape in the dough of night. Something about a rave? There was definitely techno. You have a brief memory of being out in a field dancing, wondering about life.

What is wrong with you? You feel like something is missing from your body chemistry when you don't have chemicals in your system. Your guidance counselor might suggest that being keyed up on teenage hormones and addicted to adrenaline is causing a mania in you that can only be calmed by self-medicating. You're the only one you can think of who might need a drink because she feels *too* happy. To be totally

clean, pure, feels like a white page. You just want to scribble all over it. Maybe a Sharpie here and a crayon there. Nothing too insane. You're not stupid. You're not going to rip up the page. But under the wide sky, burning brain cells like you've got too many to spare, you're definitely doodling.

Somehow, you end up on Shia's floor by morning.

THE GIRL GANG AND I had graduated from *getting into trouble* to *getting away with it*. We had successfully ditched class a number of times, small clusters of us ditching one period at a time to share a cigarette. Bolting from Boltz Junior High took some real chutzpah. Junior high was like a prison: once you were there, it was nearly impossible to escape. This is why schools are surrounded by large, flat fields with no shrubbery to hide behind. It only takes a dipshit, blind with hubris, to sprint across that human trap, particularly in groups. We did it anyway. We got away with it more times than you might imagine. Even if a teacher caught a glimpse of us, we were anonymous hoodlums at that distance.

Random absences here and there were dealt with by the dreaded attendance line autobot; just as pesky

as those automated calls from politicians, and more likely to get you busted. Whenever anyone would ditch class, or even be late, the Alexa of Ditching Past would call your home and announce it to anyone who picked up the phone.

"Gogo. Germaine. Has been listed as. Truant. To. The. Following Classes …"

The system had its flaws. It only took camping out by the phone all afternoon, grabbing it on the first ring, to evade parental discovery. There were a lot of pretend phone conversations back in those days, to the fake parents picking you up from school, to the fake friends who were really just the attendance line. Afternoon phone duty was just the price you paid for ditching class earlier; it meant not getting to do anything fun later in the day. Unless you had a younger sibling, in which case you could just bribe them to sit by the phone and answer before your parents did.

We were going to shows all the time. My first concert was The Aquabats at the Aggie, those goofy ska legends who threw an entire pizza into the crowd. It was addictive. The next step was Warped Tour, which always offered bands like Bouncing Souls, The Vandals, Guttermouth, and Pinhead Circus. Then we were seeing shows at punk party houses like the Heethens at the aptly named Heethen House. Still, I had no problem hanging out with hippies or listening to Led Zeppelin. Therefore, I never fully fit into the punk scene.

SOUNDTRACK
"TART"
by Honeychild Coleman

I CERTAINLY FELT PUNK indignation towards my authoritarian figures, however. One afternoon, my mother sat me down on the couch and held my eye contact sternly.

"Gogo," she began, "I know that you've been sexually active."

My being *sexually active* came as quite a shock to me. "Mother!" I recoiled. "Where do you even come up with this shit?"

I knew that my cursing would get me extra grounded, in this Catholic of households.

"Gogo, listen to me. When you smoke cigarettes," she went on, "and you dress like you do, and you hang out with boys, it's obvious to everyone that you're sexually active."

I'll still never know if my mother was going off of some ill-informed tip, if she was just making a point, or bluffing altogether. But I was gripped with Gandhi-levels of injustice at how wrong she was. I was still fairly innocent.

I was interested in boys, but the thought that a boy I liked even possessed a dick was dizzying to me in a way I didn't quite understand. And yet, from the boys on the block to authority figures, everyone assumed that since we smoked cigarettes, we must be fucking

the entire neighborhood. Sexual harlots hell-bent on the d. The rest of it—the drinking, sneaking out, drugs—that was all a byproduct of us wanting to get fucked, instead of good old-fashioned recreation. We were asking for it.

I might've been vaguely interested in the d, but I didn't know what to do with the d. I wanted to sign up for the d's newsletter and start collecting pamphlets on the d. Maybe a simple meet-and-greet before jumping into anything big. I wasn't ready for what was coming straight at me.

Imagine seeing a group of young men on skate-boards, huddled around a pipe and smoking weed. Is sex the first image that comes to mind? Are they asking for it? They can misbehave without being sexualized. And guess what, they probably are sluts. Actually, I'm sure of it.

I would've been a teenage degenerate no matter what. But my parents' misunderstanding of my behavior served to assuage any guilt I might've felt while I fiercely challenged myself to new depths of rebellion.

SOUNDTRACK "GOTTA GETTAWAY" by Stiff Little Fingers

A SEEDY ASSEMBLAGE of teenage degenerates met

one morning with unsavory motives. We gathered at one our haunts: outside of Toddy's, the grocery store nearby where skaters often flipped ollies in the pedestrian area. It was me, Dar, Tana, Lexi, Kylan, Bill, maybe John Robinson and Mark MacMillan.

We proceeded to use the pay phone to call the school, one by one, each affecting preposterous parental voices to tell school administrators that our son or daughter wouldn't be attending school, followed by some fairly colorful excuses. Each person took a turn doing it for another person, right in a row, while the peanut gallery of listeners laughed hysterically and silently all at once. Same number showing up on the school's caller ID each time. Nothing suspicious there.

Then, we bolted.

SOUNDTRACK
"LINOLEUM" by NOFX

WE CHARGED AS AN UNRULY gang into Tana and Dar's house, cackling with conceit at our ingenuity. Each of these stolen moments meant a greater high. Ditching with Dar and Tana had provided a freedom I had never experienced before, but this was a new level, as we were free *and* in the company of boys and drugs. We sat around in a circle in Tana and Dar's backyard, smoking a bowl. Getting very merry. The

mottled sunlight was goddamned beatific. We were all on to smoking our cigarettes when our juicy moment of satisfaction shriveled up like a raisin.

In the late morning, Tana's phone started ringing off the hook. We froze in indecision of whether to answer, whether one of us could fake being a grownup again if it were a dreaded school representative. Before we could make this decision, the answering machine picked up.

"Hello, this is Vice Principal Squires from Boltz Junior High, calling for Jack and Barbara Williams. We wanted to let you know that Tana and Dar have not shown up to school today. We suspect they are with a larger group of truant kids. Boltz has staff out in the community looking for the students, and we have already made calls to all the other parents in the group."

Already made calls to all the other parents in the group.
Already made calls to all the other parents in the group.

WHAT COULD'VE BEEN a contained situation of simply deleting one infected answering machine message had now scattered into a full-blown epidemic. An epidemic that would result in the plague of detention. Or worse.

When you're ditching school, you feel so much fucking smarter than everyone—the teachers, the students, your parents. And when you get caught, you feel like your life is literally over. We had been busted for things before, but there was something different about this time. There was a deep level of conspiracy to be answered for. Perhaps it was the inane reactivity of groupthink that fueled our overreaction.

"What the fuck are we going to do?" asked Tana, running her hand through her sand-colored hair, a cigarette clutched in the other hand.

When Tana said "fuck," it was particularly satisfying, like it had its own additional, hidden exclamation point. She was excellent at cursing. She stomped inside and I got a whiff of her hair. Tana always smelled fucking amazing. She is an Older Sister, literally and by metaphorical standards: I'll always associate girls who own an arsenal of good-smelling beauty products as Older Sisters. They have nice things I want to borrow. They're organized and generally have their shit together. Tana is a Virgo, peak of shit-togetherness. Even her cigarette organization system put mine to shame. She packed them with great panache, her baby blue nails perfectly painted; she kept a lighter in the pack and she always kept one cig upside-down. Tana wasn't going to take this out-of-control situation very well.

"Fuck this," giggled Dar. She was already vastly stoned, I could tell.

Younger sisters like Dar and me have a filtered

grasp of reality, one that's much softer and freer of consequence. It's this looser sense of consequence that allows us to face problems boldly, or stupidly, as it were. The gravity of the situation, as we looked at each other, blitzed, was so heavy as to be suddenly hilarious. We exploded into snickers.

Emotions have different facets to them. There's the psychological tie-in to an emotion. But for a feelie like me, who feels things in her body so strongly, emotions also come with tangible, sensory responses that are delightfully free of judgment. In this judgment-free zone, love and fear can feel equally pleasant. Fear feels like a million exciting little black cilia tingling my nerves; it's nearly orgasmic. It explains why adrenaline junkies and thrill-seekers exist. Our sensory enjoyment of emotion outweighs our emotional response to it, so much so that we're willing to put ourselves at risk because of it.

In this moment, buried within me was an understanding of the psychological consequences of my parents being angry or worried. It was just drowned out by the fucking delicious, hypnotic buzz of the fear of being caught.

Dar and I let some giggles escape until Lexi gave us a sharp look, and we buttoned up into pure serious again.

"Fuck this," Dar said again, rising up to her knees. "Let's just run away."

SOUNDTRACK "RUNAWAY" by Screeching Weasel

WITH THESE WORDS, that pent-up fear-buzz I had going on was positively unleashed. "Fuck yeah!" I yelled, pitching my fist into the air. We began pogoing.

"And where would you have us go, exactly?" asked Tana. She had her amused older sister face on.

I looked far into the distance, trying to pluck the answer from a place vaster and much more important than these environs.

"California," I said reverently.

California, golden land of glamour and heartbreak. Teen tragedy was beautiful in California. California's balmy weather year-round would make our certain homelessness a breeze, I reckoned. We were sick of this shit anyway. School was like hell.

"Los Angeles, Los Angeles," reads Mary Karr's teen memoir, *Cherry*. "You know almost nothing about the place, so while you're waiting for your friends to come in a blue truck to ferry you off, you stare at its spot on the map, as though peering close enough will split the small dark seed of your future and reveal whatever self you're fixing to become." Even as Mary Karr knew nothing about Los Angeles, her plan was still more solid than ours; we only had the hazy boundaries of a state to drive towards, not even a city on a map to stare at.

Lexi looked at us squarely. "How will we do that?

How will we get there?"

"Well," said Kylan, "I could steal my grandma's van."

"Yes!" Dar and I cheered.

"Can any of us drive?" Tana asked, throwing the question into the air as if not expecting it to be answered.

"I can figure it out," said Kylan. "I can pretty much drive it. My grandma never even uses her van. She won't miss it."

Lexi and Tana stared at him, then each other, unsure.

"I've stolen it a bunch of times before!" he assured them. Which was reassuring, unless you didn't trust someone who frequently steals the things of loved ones, and then it's not reassuring. We didn't suffer from this belief, of course. In Teenageland, stealing from parents or chain stores operates on its own separate plane of morality that is more acceptable than stealing from friends.

The elder girls agreed to the plan reluctantly, the younger girls joyously. Mark and John shook their heads like we were crazy. We would take that van, all of us, to the golden land of California. We just needed to run home, sneak in and grab some things, leave a note for our parents, and get the fuck out of this tired town.

Tana and Dar left a lengthy note to their parents telling them that we were running away, that we loved them, and not to worry about us. We decided that my house was too hot, so we told the Williams parents to

send my parents my regards. I would have to share clothes with Dar and Tana, but we shared everything already. I imagined a life on the road with my friends, totally free. Living out of a van, wake-and-baking on the beach every morning, no school, nothing to do. Spangeing on the streets, not having a home to go to. It was so romantic. These days, I can barely sleep in the comfort of my own bed. How would I fare sleeping in a van with several people?

It's not really the logistics that matter in Teenageland. Details are secondary. Gestures are huge, and this was a big one. We were all about bold moves. It was about reaching out as high as you possibly could to try and catch that shooting star that was sailing light years above your head. It was all in the reach.

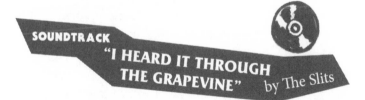

SOUNDTRACK
"I HEARD IT THROUGH THE GRAPEVINE" by The Slits

WE DIDN'T HAVE LONG until the school reached the Williams parents at work, so they'd probably be coming home soon. The next few hours were a blur of scampering around town. Some of us split up to leave our goodbye notes, some of us went to Kylan's grandma's house to steal the van. We periodically called our friends on the street to check the situation. The rumor had spread across the school that we were gone. It was

officially afternoon, and I knew my parents had to be scared shitless about the situation. Or at least, purple with rage.

All of our houses had to be hot by now. We needed to go somewhere neutral. Mark and John were friends with Stephan, who was a Super Deluxe Skater and had a house that was safe to chill at. He might not have invited us to his home on any given day; but our now infamous crisis made us novel and worthy of harbor.

Stephan was the next level hotness. He didn't talk much, and he didn't need to. He was a tall blond with long eyelashes and big blue eyes. Stephan moved with that slow masculine energy that forces you to imagine him effortlessly tossing you over his shoulder before depositing you onto his bed.

The Varsity Skater Girls were one year older than us, and they were the ones skaters like Stephan publicly courted. Cyndi, who was the hottest girl in the Varsity Skater Girls, bragged about hanging out with Stephan, moving her hair aside to reveal a hickey, joking that it happened while Stephan was "curling her hair." We all lost it with jealousy at that moment. I never got the good hickeys.

I had a thing for blonds back then, thanks to a magical blond boy who persistently emerged from my psyche like a recurring dream. When I was a child, I began the practice of drawing cathartically, a ritual which revealed murky psychological truths well into my teens; I'd sit down, turn my brain off and see what came out of my pencil. Often my pencil, seem-

ingly of its own accord, unearthed buried feelings and desires. Certain images repeated themselves—ballet slippers, when I was six—and a blond guy frequented my teenage drawings. There were no blond guys in my lineage. One stream of ancestors descended with vampire complexions from the Carpathian Mountains, and the others, brunettes from the Belgian countryside, like the farm girl on the Colette beer bottle. America's abundance of true blonds was exotic to me.

I always thought that the blond guy in my drawings was meant to be my boyfriend; I knew he would transform my life. It turns out that my blond boy is someone entirely different than I could've imagined. At the time, though, my previous blond-boy magic only made the allure of Stephan that much stronger.

Stephan lived in an apartment complex less than a mile from my house. His pad was a haven for chill activity. Random people playing video games over here, random people smoking weed in another room over there. His mom was a brown-haired woman who seemed to tolerate the activity around her. I wished my mom were as cool, but I didn't dare address Stephan's mother.

Listen to me: Never directly address an adult who is being cool to you. They might have to acknowledge their blurring of societal lines, and then kick everyone out of their home, 40s and all.

We girls huddled in a corner, watching it all unfold as Mark and John smoked weed with Stephan. It was nice being in this total babe's home, but we felt too

intimidated to talk to anyone. We wondered what was going on with our runaway buddies, if they had the van yet. We were on the verge of running out of time before dark. We weren't sure if Kylan could drive very well at night. We decided to call our girl Alexandra to get the scoop out on the front lines.

Alex told us that Jack and Barb had informed all the parents of our goodbye note, and combined, they were hysterical. Calling every parent in the community, driving around, doing everything short of grabbing strangers by the shoulders and yelling into their faces. She told us they had called the National Runaway list on us. (Three guesses whose parents did that: 1) Mine. 2) Mine. 3) Mine. I would ask them, for fact-checking's sake, but the entire topic of my adolescence is too sore a topic to broach, even to this day. I wonder why.)

I hadn't ever heard of the National Runaway list before, but I had to admit that it had a certain presti-gious ring to it. We weren't just junior high ditchers, now. We were even beyond local runaways. We were *national runaways*.

Alex told us that her mom could pick us up and we could hang out at her house. We were suspi-cious. Alex's mom, Joan, was an In-Between: a moral person, yet not a total narc, i.e., what you might call a "good person." We didn't know which way things would go with her in this hot situation, a situation too complicated for the minds of adults. She was a single mom, which meant that she was cooler than married parents. Single moms have far too much shit

to do to be policing your every move. They treat you like adults, only because they don't have the time-luxury of treating you otherwise. But Joan was also aligned with our parents' views about school attendance, morality, living with guardians, and not being danger-seeking assholes.

The cool thing about Alex's house was you could smoke there, because Joan was a chain-smoker herself. Alex assured us her mom just wanted to help. The whole smoking inside thing sold us. You could convince our crusty coven to attend a three-hour Celine Dion concert if we could chain-smoke there.

Mark and John thought the whole thing was a trap. They freaked the fuck out. "We're out of here," they said, and took to the wilderness of five-o-clock traffic outside the complex. When Alex and her mom picked us up from Stephan's, we squeezed into the back, slouching down in our seats, wondering if we might be overstating our wanted status. Then we cruised past Mark and John, flattened up against a cop car flashing with lights, being handcuffed.

Relief and fear flashed my nerves like lightning. *We are safe now*, I thought. But if we get caught, we are in big fucking trouble.

SOUNDTRACK "CAUGHT BY THE FUZZ" by Supergrass

WE WENT TO ALEX'S PAD, and Joan kept her promise

to refrain from calling our parents, or the police. We sat around chain-smoking well into the evening. The nicotine calmed our nerves.

After a number of hours, Joan began gently talking to us about the whole ordeal.

"You know, girls, I've been there before," she began in her voice, which was simultaneously both child-like and gravelly. Both she and Alex had pixie cuts, which suited their fairylike demeanors. "And now that I'm a mother, I have to tell you, your parents have got to be so worried about you."

"I know," I said, "but if we call them now, we could get arrested! We're on the *National Runaway* list," I added, and a hint of pride must've snuck through.

"Your parents aren't going to turn you into the police," she said. "Trust me. No matter how much trouble you think you're in right now, your parents will be relieved to see you. Just call them."

Finally, after this gentle prodding, and becoming the human equivalents of an ashtray, we gave up and called our parents.

I'll always remember the kindness with which Joan dealt with us. The savvy altruism that so many grownups offered us, silently protecting us. Teenagers are like wild animals, or people on PCP. You have to lie to them in order to keep them from running into oncoming traffic. These unaffiliated grownups had to step in and pretend to be cool, because we were ditching the fuck out on our own parents.

As teens, we believed we were sneaky goddesses,

genius conspiracy makers who were able to outsmart our parents; today, Tana thinks the Williams parents knew a lot more about our shenanigans than they let on. Perhaps they secretly tolerated our indiscretions so we would have our crazy parties under their roof, instead of driving drunkenly all over town. I mean, they had to know. We'd keep an entire keg in their basement, next to where Barb did laundry, only bothering to throw a hoodie over it.

My surrogate father Jack told me, soft-spoken, just the other day: "I knew that if you three were able to get through it alive, it'd make you stronger."

Joan was planning on getting us home all along. But she knew that exacerbating the situation with parental hysteria would send us scrambling further into the night.

It was true; our parents were relieved, and livid, when they picked us up from Alex's house. The punishments came later. I received two weeks' grounding and three days of suspension from school, an ironic punishment for truancy. I spent that time sunbathing and smoking in my backyard.

SOUNDTRACK "NO FUN" by The Stooges

ONE MORNING, just a year or two later, Joan's alarm wouldn't stop bleating. Alex went into her room to

discover that Joan had passed away. Alex's mother, suddenly gone, and for what? Her passing was a total mystery. It was the first time I was baffled by death. The first time I realized that people don't always die because they're a grandparent, or they had a horrific accident. Sometimes people just die in their sleep, and the people grieving them have nothing to point to for their suffering. Or maybe Alex did know, and just couldn't tell us. At any rate, this was the woman who had convinced us how strong a parent's love was, and her love was suddenly torn from her own daughter's life.

They held a funeral for Joan at a church. I didn't even know Joan was religious. I questioned my closeness to her, my deservedness to mourn. I didn't feel like I belonged there; I suffered from funeral guilt. Intruding on this tragic moment in someone else's life, not important enough to be involved in something as monumental as their death, even if they affected me profoundly. Teenage narcissism will do that to you; make everything about you and you'll always feel not enough. That's because it's not about you.

Alex vanished from my life soon after, as suddenly as her mother's departure. If more adults like Joan had continued to be in my life, would they have prevented the avalanche to come? I'll never know.

SOUNDTRACK "BRUISE VIOLET" by Babes in Toyland

5

SNOWBALLS

SOUNDTRACK
"RUBY SOHO"
by Rancid

AFTER JOAN'S DEATH, one thing was apparent: The parents I had so easily shrugged off felt a bit more necessary. Of course, I easily forgot this feeling by the next red-cup debauchery. Attention spans are short in Teenageland, and I was on to the next thing.

If anything, the sad heaviness in my gullet made me yearn for the freedom of ditching even more. Ditching is a natural antidepressant. Keep in mind that you can ditch anyone, and you can ditch anything. Ditching might be the best thing you do all day. I'm saying, ditch whatever it is you're doing right now

and prance out the door, giggling. Hop into a blue Chevy Malibu and peel out, playing Rancid's "Ruby Soho," the open windows trailing weed smoke into the parking lot. *Destination unknown! Ruby, Ruby, Ruby, Ruby Soho.*

This is how Kitty and I gleefully ditched our candy-striping volunteer shifts at Poudre Valley Hospital each week, jumping into the weed wagon with Armstrong and Jonny. We were fourteen.

Kitty had the willowy look of a manic pixie dream girl, brown curly hair cut short and blue eyes that twinkled with mischief. She had that sweet Meg Ryan vibe, if Meg had just taken a few bong rips.

Kitty was the youngest in a large and rowdy family that was half-British and half-Canadian, living in America; she pronounced things charmingly British one moment, then stunningly Canadian the next.

Her family was always fighting with one another, and often drinking. Unlike me, it wasn't conformity or a pious life that Kitty sought to escape; as the youngest of this familiar donnybrook, she was escaping the chaos. Growing up in bedlam also gave her a wicked addiction to manipulation. I was basically Kitty's bitch. I didn't mind it. Even as a teen, Kitty was one of those women who knows how to live. She taught me how to do smoky eyes for a date. By age sixteen, she hosted parties at her house where she cooked large meals for our degenerate crew and talked poetry late into the night with a glass of wine and a joint. Kitty felt very cosmopolitan to me.

Kitty possessed down-to-earth beauty, which made her raunchiness that much more of a surprise. She was the grossest person I've ever known. She regularly hocked loogies in mugs that she kept around the house, chain-smoked, and kept everyone painfully attuned to her digestive goings-on. But she sought adventure, and so did I. Kitty called the shots.

Kitty's house was great for sleepovers due to a combination of 1) great snacks, 2) loose parenting, and 3) proximity to her hot older brother, Blake. Blake was a snowboarder with curly brown hair who I'd voraciously accept into my person, given the chance. At the time of our early adolescence, this sex-fever-inducing high school boy felt so far out of my league, I had never even thought to be attracted to him for myself. I fantasized about how hot he would be with some famous model. As Kitty and I rummaged through her dELia*s clothes, I'd sneak awe-struck glances at Blake, mostly wondering what he smelled like or what his six-pack felt like when you touched it or what he looked like snowboarding or if he had a really hot snowboarder girlfriend; you know, just biding our time until night fell. When it was time to sneak out of the house, Kitty's plump and lovable Canadian mother simply grunted and nodded as we walked out the door.

I was jealous. Partying took a lot of dedication when you lived in the Germaine household. Each night when we returned home, the Germaine children were to give their mother a kiss goodnight. Mom was able to smell if any of us had a sip of beer, even hours before.

She claimed that she could smell if someone opened a beer downstairs. For that reason, we held sleepovers at Kitty's house more often than not.

But Kitty's and my friendship was first launched from our weekly candy-striping gigs, something our mothers had definitely signed us up to do. Each week, within the first few moments of our shifts, we'd meet up with trouble on the agenda. Armstrong and Jonny would pull up in Armstrong's '69 sky blue Malibu, punk rock blaring, the car snarling, smoke escaping the windows. We'd sneak out the back door of the hospital and, in my mind, cute candy cane-striped outfits went flying into the air, music video style. I don't recall what we were actually forced to wear. All I remember is they made Kitty cover up her eyebrow ring, for sterility reasons, and we thought they were total fascists because of this. So great was this injustice, in our eyes, that we didn't feel bad about ditching candy striping.

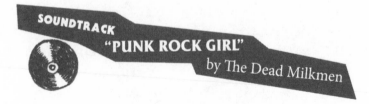

SOUNDTRACK
"PUNK ROCK GIRL"
by The Dead Milkmen

JONNY GUTPUNCH WAS the first fella I went steady with that lasted longer than a week. My previous encounters with boys had been as follows:

1. A toddler boy showing me his penis when we

were three. I still recall getting the gist that this body part was decidedly different, as an imaginary tilt shift blur of importance circled its down-tilted presence, and a funny feeling came over me.

2. My neighbor boy pinning me down in kindergarten and planting a kiss on my lips while he was wearing fake, wax toy lips. I would've considered this a joke, except that it lasted uncomfortably long, and he seemed to be earnestly into it.

3. Mark MacMillan and John Robinson's late-night experimentation for those who can't score sober.

4. Meeting Kylan by the train tracks at age thirteen, going to a movie with him the next week, experiencing the suction-y wetness of his kissing style for the duration of the movie with no escape, and breaking up with him after two weeks. We stayed friends though.

The only thing cooler than lighting a cigarette without preamble, in Teenageland, is blow jobs.

Everyone talked about blow jobs in rapt tones, despite the fact that our understanding of the mechanics of the blow job were hazy at best. Still, we had come a long way.

In the sixth grade, my classmate told me that a boner was something that happened to boys all the time. According to this classmate, the male anatomy

periodically shed its skin much like an amphibian, leaving a shell of what it once was, revealing a new layer underneath. I felt bad for guys that they regularly had to deal with this.

Later that year, after we had heard enough rumor about blow jobs, Corinne told me about snowballs. Snowballs were like blow jobs, said Corinne; but instead of blowing, like one would assume you do in a blow job situation, you actually *suck*.

Interesting, I thought. *Sucking, instead of blowing.*

In the end, such sexual knowledge was something we'd need to gain with hands-on experience. I wanted to gain that education with Jonny.

I liked Jonny. Jonny was a sarcastic skater-punk, but his humor was usually at no one else's expense. He enjoyed pastimes such as sneaking out of his mom's house in Bellevue and stealing her car, or the occasional "skitchin'" on trains—hitching a ride on the back of a train by hooking his skateboard onto the back and holding on for all hell. I liked that he couldn't keep a serious expression on his dimpled face. When he was serious for a second, I liked the way his eyes followed me just a nanosecond too long. I liked that

these lingering glances were also short enough to feel like a secret. He looked at me, and space-time melted in a rush between my legs. Jonny Gutpunch and Gogo Germaine forever—or at least for a long while in teenage time.

With his frenetic energy, Jonny became the lead singer of some punk rock bands, and eventually opened a bar and vinyl store with LET'S GET WEIRD out front on the marquis. Jonny Gutpunch, punk hero, bar owner, and skitcher of trains.

When I was dating Jonny, his energy had no outlet, so we mostly funneled it into trouble. Meeting up and making out by the Train Bridge, shrouded only partially by halfhearted shrubbery.

Jonny possessed the first penis I ever touched. It felt like it jumped up to greet me, an organism unto itself. I was taken aback by its awesome space-age consistency. When erect, penii are inexplicably hard and soft at the same time. Spongy, and yet, unyielding. When I stroked it faster, it expanded and filled up my hand like it was cast in metal. It felt like something NASA had designed. This thing was fucking magical. The great alien ship had landed.

After attempting the adolescent hand job, I made the executive decision to move up to the blow job. It wasn't a hard sell.

I wondered if I should cruise right past blowing Jonny and move straight to the snowball, to demonstrate sexual prowess. I imagined blowing on it like a candle, and that just didn't seem right to me. I

knew I would be putting it in my mouth somehow, but I wasn't sure how, exactly. I had heard to never ever, *ever*, under any circumstances, damn it, ever let it touch your teeth. Sucking on something without letting it touch your teeth sounded like a difficult game of Operation to me. I had nerves about it.

To combat these nerves, I did what any teenage degenerate would do: I decided to get shitty drunk beforehand. Jonny happily joined me. But when the time came for the proper oral sex to go down, I realized in a puddle of giggles that we had done too great a job at getting wasted. I pulled his pants down brashly and began fellating him, which was actually easier to do than it was to conceptualize; it was like a puzzle where the answer becomes clearer the less you think about it. If lack of clarity leads to good fellatio, then my drunk ass must be doing a great job, I surmised.

A few minutes into my first blow job, half with relief and half from the drink, I passed out cold.

The next day, I was humiliated that I didn't finish Jonny off; to give a teenage boy blue balls is the ultimate sin, in Teenageland. When I think about it now, it's actually kind of sweet in a stupid way. Feeling comfortable enough to curl up in his lap and go to sleep. And thankfully, Jonny was understanding enough to not make a huge deal about it. To my surprise, he continued to pick me up from candy striping, even after the botched blow job attempt.

Kitty and I loved the roomy chalk-blue seats of Armstrong's Malibu. We felt so free driving around

with the windows open. We didn't really bother to think about the thing we were ditching—which was making sick people at the hospital feel better. My guilt is slightly assuaged by the fact that candy striping is sexist bullshit. Where were all the male candy stripers? They were doctors in training, not the cheer parade.

We were fucking cheerful. We were cheerfully taking bong rips in a blue Malibu, instead of smiling for hospital patients. Cruising over a hill and catching some air. Kitty and I smiled at each other, our hair blowing in the wind, two incredibly hot skaters in the front seat driving us around the limitless world. Happiness shared with a cohort is like eating cake, but stolen happiness is like rolling around in said cake and licking it off each other. Fuck those hospital patients.

Driving around Fort Collins, we surveyed our small town, feeling above it all. We might not be the types of girls to feel welcome wherever we go. But together, we could own this town.

SOUNDTRACK "SUPERMAN" by Goldfinger

6

HAUNTS

SOUNDTRACK
"BLANK GENERATION"
by Richard Hell

BY AGE FIFTEEN, WE HAD discovered an intricate infra-
structure of debauchery across Fort Collins. Our entire
network of punks and degenerates knew its secrets. We
knew which liquor stores sold to minors: the cramped
chunk of cement on Riverside Drive with a view of
the train tracks; the more wholesome, suburban wine
shop where parents might shop, yet they surprisingly
didn't ID. We knew which cafes would let underage
people smoke inside: Max's Subsonic—an old house
turned café, with rooms to get lost in, that threw actual
parties for underage kids—plus late nights at IHOP,

and within the dingy, red-painted walls of Paris on the Poudre, the goth cafe. While I'm glad for the health of today's youth, I almost feel bad they won't ever experience the dirtbag tang of indoor smoking.

Teenage haunts are havens for illicit activity that are hidden in plain sight; they often have short names easily whispered in a pinch. The Ditch. The Dam. The Path. I knew the Path was a hard place the day one of the skaters shot a new girl at school with a duck gun as his friends erupted in laughter. I was horrified, but the fact that I didn't do anything to help still haunts me.

There was the Starlite, the downtown punk club as shitty as its glittery aspirational name suggests. It hosted many of my friends' bands, touring acts, and it even hosted an impromptu show in the parking lot featuring ALL, former members of the Descendents. Plus, the occasional party where girls wrestled in kiddie pools of Jell-O.

The memories of such parties and locations are often mysterious. I have a hazy memory of participating in Jell-O wrestling at the Starlite but can't be sure. It happened during Corinne's and my wrestling phase, a brief period when we couldn't even be together without her getting an evil glint in her eye before thrashing me on whatever PBR-soaked carpet or viscid floor we were on. I have a glimpse of a memory of the Starlite, and looking down to see my white tee soaked in syrupy red. I have another piece of a memory of making out with a skater boy, Shane, in the back of a crashing car. Kitty was backing out and

lodged the car into a pole.

NEXT TO A GAS STATION downtown, there was an abandoned house called the 608, where no-holds-barred punk rock shows took place. Circle pits, girls getting groped, throwing shit or spitting on the band and vice versa. Depending on how pop-punk the band was, local punk shows were often a contest to see who could out-asshole each other. Jonny told me about the night the gas station next door to the 608 was robbed; the assailant was wearing "black pants and a white shirt." Needless to say, when the police raided the illegal punk party next door, they were overwhelmed by punks who fit that description, hand-cuffing everyone. It wasn't until much later they found the real assailant, who was not at the party at all.

Tornado Bar was the gay club on Mulberry that was formerly called Nightingale's. Once a week they booked local punk bands, and everyone sat drinking in the parking lot until the band they were hoping to see went on. The fact that these shows occurred on Sunday nights was highly inconvenient for underage drinkers: liquor stores across the state were closed on Sundays. It made us even angrier that this law was underscored

by some dumb Christian principle of a day of rest. If you hadn't planned ahead and had your hookup buy you beer before Sunday, you had to scrounge your parents' liquor cabinet or bum off friends.

The Tornado was also a place where Matthew Shepard hung out frequently before the hate crime against him that forever altered human rights. We had gay, lesbian, and bisexual friends in our scene, but Shepard's shameful murder urgently placed the need for LGBTQ rights in front of our faces. Plus, the Tornado Bar staff were heartbroken about losing their friend.

And then, there was the Starlite: dank dungeon of underground music. They hosted national acts and locals. The Starlite was booked by a man named Scoo who was expectedly grouchy as the person expected to keep a DIY venue afloat while it was constantly filled with underage kids getting drunk. He was notorious for dicking over local bands; the common phrase was "you got Scoo'ed." Now that I understand the music industry, I recognize how hard his job must've been.

But if you really wanted to feel like you were in New York, you went to Old Town Square. It's where crusty kids, heshers, and goths sat smoking and shirt-less after buying single-rolled cigs at Paris on the Poudre. You could buy drugs at Paris, head to the skatepark to pick up friends, and then do those drugs at the train bridge. We picked up all kinds of strays at Old Town Square. Most notably, Adam Acid. Sure, he was an acid dealer, but he had sad blue eyes that

inferred a great underlying profundity. Those angelic eyes were teenage girl traps. His black hair was usually parted down the middle and he wore oversized JNCOs. Adam was charmingly smart and scrappy, and we got the gist that he came from a troubled home. He became a staple in our group, an arm draped around Tana's shoulder, arresting the svelte Lexi with his gaze and making her giggle flirtatiously.

SOUNDTRACK "ANARCHY IN THE U.K." by Sex Pistols

WHILE WE WERE BUSY using our street smarts to gain illicit knowledge of our town, an incredibly rare occurrence happened: something interesting to me. A foreign student had just transferred from the U.K. to Fort Collins. Her name was Blesh, and she was divine. Being British and also irreverent was the most punk rock thing you could do. I immediately gravitated to her because she had a cool accent; it turned out that her innards were just as cool.

Blesh didn't bat an eye at the Girl Gang's illicit behavior. Where she came from—Scarborough, like the Fair—she had been drinking for years as well, only she was able to drink at the *actual pubs*.

Blesh was mischievous and quirky. Each child-hood picture of Blesh features her crouching in bushes

wearing some homemade costume of a squirrel or an inanimate object. She once won a costume contest in her nursery school by strapping trash to her body and physically embodying a recycling PSA. She carried her trash adornment yen into adolescence, once waking up on the beaches of Greece after a night of partying, having fallen asleep in a trash bag. Carrying her love of costume into adolescence, we started our own party-bomb costume club.[7] Here's how it works:

When you have plans with someone, especially ones of the mundane sort at a benign time of the day, show up three sheets to the wind and in an extravagant costume with no explanation whatsoever. As bejeweled as you are besotted. Carpe Diamante!

Blesh and I had an arsenal of wigs and strange clothing, and the more random our appearances were, the better. This club works best when you have at least one British person who slurs drunkenly with posh charm. Meeting for coffee and homework at Starry Night Cafe? Carpe Diamante! Grabbing lunch at Big City Burrito? You'll be dining with two besotted glitter bombs!

Blesh and I also formed a club of Polite Anarchy.[8] Sometimes parties get dull, and during those moments,

7 Party Bomb Costume Club: This is the band to listen to if you like hipster party jams like the bombastic Junior/Senior.

8 Polite Anarchy: Really dark industrial band from England that writes songs that are secretly about killing women, but everyone still loves them.

Blesh and I would take to the streets. We went around neighborhoods vandalizing, only in really pleasant ways. Rearranging someone's ugly garden rocks into a smiley face. Crafting interesting scenes with their lawn furniture that might make them wonder if elves had held a party there.

In ground zero for Reagan's zero tolerance movement, Blesh and her family were like a breath of fresh air: her parents had a more tolerant attitude towards partying. As a playwright and a teacher with fancy accents, Blesh's parents were more sophisticated than anyone I'd ever met; and yet, they were also cooler, allowing Blesh to invite her friends over to drink beers. Her mum would even sit on the bench with us, smoking a fag.

SOUNDTRACK
"THE AMERICAN IN ME"
by The Avengers

OUR AMERICAN PARENTS didn't know any better than the zero tolerance lines they were fed. The War on Drugs culture made many of our parents take a puritanical approach to drinking and drugs—*Just say no!* To them, pot was on the same level as heroin. My mother truly didn't understand the hierarchy of poison.[9] Whether

9 Hierarchy of Poison: Renaissance metal band!

intentional or inadvertent, they didn't really drink in front of us, and they forbade us to touch even a drop. Which was unfortunate; people need to act out to maintain their sanity.

Because we hadn't been drinking pints with our parents like the British, or wine with dinner like ze French, we didn't know what the fuck we were doing.

That's how you arrive at the practice of pouring a glass of vodka and drinking it straight.

Alcohol's forbidden allure, combined with the fact that many parents did have liquor cabinets, was a toxic combo. My parents did not have a liquor cabinet and neither did my close friends' parents. But word of a liquor cabinet in Teenageland spreads far and wide, and I've probably helped myself to the booze in countless acquaintances' parents' cousins' babysitters' liquor cabinets.

Blesh became so quickly ingrained into our circle that, within a few months, we were working our first real after-school jobs together. We bonded over not taking anything seriously, which we did with aplomb for $7/hour at the sticker factory. In a warehouse blaring mullet rock, we made vinyl decals of trippy butterflies and band names people stuck on their cars. The Factory was run by two aging Rush-style longhairs, Josh and Dante, who hired cute girls and sexually harassed the fuck out of them. Dante once pulled me aside and told me I shouldn't talk to the guys at work, even innocently, because I was too attractive. He claimed that since we made band decals, we were in

the music biz; perhaps it was in this laissez-faire world of morals that he felt comfortable hitting on 15-year-old employees. Our nicknames for them behind their backs were "Cock and Balls." Cock for Dante, because he was a dick, and Balls for Josh, because he was inactive and lumpy.

I learned a trick to elicit sympathy from your bosses when you call in hung over. Wear a tight pair of tan corduroy pants to work the day you're going to acquire that hangover. Get shitty drunk that night and have a fabulous time. Call in sick the next day or two. When you return, wear a different pair of tan corduroy pants that are a few sizes too large. When I returned to work at the factory in pants that looked the same but hung from my hips, I instantly looked ten pounds skinnier.

"Wow, Gogo," declared Dante. "You really did get sick. Glad you're feeling better."

But when we weren't enduring Dante touching the fabric of our pants ("What IS that?" *It's pleather, you idiot.*), Blesh and I were being ridiculous together. We'd take to the random construction materials someone had left in the parking lot, and smash tiles. It was cathartic. I'll always remember Blesh transforming a batch of giant stickers that had originally said "JESUS IS LORD" to "BLESH IS LORD." I always imagine hearing the words "BLESH IS LORD" in her accent.

Blesh was once dragged onstage and whipped at a Lords of Acid concert, because she's tiny, adorable, and looks hot in pigtails. But most of the time we spent

together was pleasantly humdrum. She's the type of person you'd like to grow old with, two batty old ladies talking about vegetarian recipes.

SOUNDTRACK
"MISIRLOU" by Dick Dale

BY AGE FIFTEEN, our Girl Gang was growing tired of robbing liquor cabinets and playing Hey Mister. Hey Mister, or "shoulder tapping" in some areas of the country, is the practice of teenagers cornering an of-age person and asking them to buy booze. We'd hunker outside of Toddy's, Bum Park, or the strip club, waiting for our prey. It takes an entirely different skill set from those used in Algebra class to identify a good "Mister" for a successful round of "Hey Mister." College-age guys tend to have loose morals, as do alcoholics. We'd even ask women, if they looked like they were on the other end of the type of bender that might end in a trash can. We had scored it big with surprisingly square adults due to sheer luck, but the best way to be sure that a "Mister" is safe is to assess guilt or downtroddenness.

For that reason, we began hovering outside of the gentlemen's club downtown and cornering guilty/horny men, asking them to buy us booze. It was brilliant, if you didn't think too much about the dangers of

clandestine deals with perverts, murderers, or rapists.
Opening up illicit relations with questionable men be
damned, those men weren't statistically likely to hurt
us anyway. It was the men we knew that were more
likely to rape or murder us.

I didn't believe anyone in our lives was capable
of harm. We had our neighborhood skater boys, who
were mediocre in looks and charm and treated us as
an afterthought; but even as they inducted me into
the world of male/female relations in a fairly awful
way, they still felt harmless to me. We snatched up
a younger class of skaters—Bob, Billy, Shane, and
Mac—before anyone else could discover their majesty.
This younger skater class were the cool guys we had
been looking for, yet they weren't total dicks, because
in Teenageland, one year of age difference is immea-
surable. We were the older women in their lives, they
respected us, and we fawned over them. Dar even gave
Bob a striptease for his sixteenth birthday. Both Bob
and Shane are varying levels of famous now, a testa-
ment to our superior tastes in young men.

We had our boyfriends. I dated Jonny until that
fizzled out, and my friend Shia dated Armstrong. Dar
dated a series of good-looking dumb guys. Tana had
male friends who practically lived at her house and were
in love with her, but she was wishy-washy on what she
wanted. Lexi was now officially dating Adam, the sad
but charming drug dealer we met downtown. Blesh
was too new to know any guys yet, but she quickly
was glommed on by many, on account of the accent

and her adorable charm. Kitty was dating Jones, who was a dear friend of mine; and according to everyone, "she had his balls." Which by today's standards meant a fairly normal relationship. But in Teenageland, men who show a healthy amount of give-and-take in a relationship are an embarrassment to manhood.

Jones and his best friend Julian were responsible for carrying my faith in men through the garbage pile of adolescence. They became my best guy friends. Julian 'n' Jones came in a pair, always together in tie-dye shirts and kippahs. They remained strictly kosher through their lifestyle of bong rips, 40s, and Victor Wooten. Hell, they were so inseparable, they even shared the same birthday. J&J had beautiful, strong Jewish mothers, who regarded us with an understandable amount of suspicion. Raised by such matriarchs, treating women with respect wasn't something they even had to learn, it was in their blood. J&J never once hit on me, which is more than I could say for any of my other male friends, let alone some of my female friends. I could pass out in a bed with Julian or Jones, and nothing untoward would happen. So many of our misadventures unfolded together.

Among all of the men in our lives, it was the girls who often took the party to the next level. And in true fashion, it was the Girl Gang who took securing alcohol to a new high.

We began simply walking into liquor stores to buy our own booze. If the liquor store attendant asked for an ID, we simply patted our pockets like idiots, and

said we'd run out to the car to grab it. Then we'd make a note never to return. If they sold to us, we made sure to be memorable, so we would be able to float past that awkward ID question the next time.

Nancy Villain was a hippie goddess in our girl gang with caramel locks and natural beauty that emanated through a fierce, winking confidence reminiscent of Angelina Jolie. When she was 15, she broke into Campus West Liquors and stole a grand worth of booze.

In Teenageland, this was women's work; no one sends a punked-out teenage boy to pass that personality test. We looked older than we were, and no one suspected girls would do anything so illegal. We enjoyed surprising our guy crushes by buying them booze like it was no big deal.

I've never enjoyed small talk, but as an illegal booze patron, I was the chattiest of all Cathies. When breaking boundaries, it's always important to appear at ease. I babbled about my long day at work and, oh, I just need one bottle of wine to watch my movie tonight, thank you, and I'll just grab these 40s for my dad, he's so funny with his cheap taste in alcohol. Tana was especially good at coming across as a mature wine-drinking book fanatic who gardens, because apart from her literal age, that's who she really was. Once you knew the liquor store attendant by name, you were solid. "My ID? Bill, I came in last week!"

There was a cramped liquor store on Riverside Drive that I thought exclusively sold to my underage

friends and me; it turns out the proprietor was selling to every single teenage miscreant in town. He was a long-haired Hispanic man with kind eyes. He wasn't a bad person, just someone who draws different lines than the rest of society. Once we discovered our regular liquor store, we were swimming in all the booze that sticker money could buy.

SOUNDTRACK
"MOON OVER MARIN"
by Dead Kennedys

CRUSTY DEGENERATE TEENS aren't big on nature. However, there were a few nature areas that became teenage haunts, due to the fact that they had cement tunnels where we could smoke weed. One afternoon, Adam Acid and I snuck into the forest to get high.

Deep in the jade foliage, he passed me the pipe, locking in on me with those psychedelic whirl eyes. The thing I remember most about Adam is making intense eye contact with him. Even though he was dating my good friend Lexi, he did that intense eye contact thing with all of us. It made you feel special, living in a big moment. He was wearing a backwards baseball cap covering his slick black hair, and his face was beautiful: pale with freckles and the perfect masculine facial structure, cleft nose, like I could picture his face, removed from the rest of him, belonging to an angel.

There was something otherworldly about him.

He spun hallucination and uncertainty in the world. He hung low and uncanny like a harvest moon. He embodied a vibe.

Through the flickers of sunlight, we saw a bike cop in the distance, riding perpendicular to the forest, approaching us.

"Pretend we're making out," he suggested, and grabbed me. I supposed that making out would be far less illegal than doing drugs. But instead of pretending, his tongue was actually inside my mouth, clashing teeth, his fingers instantly inside of me, breaking my hymen. This was the more acceptable activity, in the presence of an authority, than smoking weed.

I felt raw and confused. I'd wondered for so long what it would feel like to have someone inside of me, it was hard to process how premature and surprising Adam Acid's entry had been.

Once, in the middle of the night, my black cat jumped straight into my face. I woke up to a wallop to the temple, my face newly wet. When I staggered to the bathroom, there was blood streaming down my cheek. When Adam touched me, it was like that; his sexual advance felt like a non sequitur.

Part of me wondered if we had just betrayed Lexi. But I hadn't even made the decision to accept his drive-by fingering before it was over.

SOUNDTRACK
"TEENAGE KICKS"
by The Undertones

I WAS SIXTEEN, AND while I tried to escape most rites of passage, I was uncomfortably forced to face one when a cute boy asked me to a school dance. My Homecoming date didn't go to my school, of course; that would've been humiliating for all parties involved. We were like divorced parents, my school and me. We were hostile as a bag of rats and the relationship worked best when we were kept sedated and separated. The only reason I deigned to go to the Homecoming dance at all was because it was with a boy from another school, Elan, and I could pretend it was ironic.

Elan was a skater I met downtown with a sexy jawline, tan skin, and tennis ball-yellow hair. He was gorgeous. That was something that often helped me forget that the Girl Gang and I were societal outcasts: the other degenerates were so fucking beautiful.

Before we went to the dance, Elan told me we were going to make one stop. He pulled up to Riverside Liquors, and my heart started pounding. Maybe this guy sold to Elan too!

"I hope it's okay," Elan said, getting out of the car and smiling at me with his divine facial structure that had been clearly carved by the gods. "My dad wants to see us before we go to the dance." *His dad?*

When we walked into the cramped liquor shop, there he stood behind his podium of illegality, surrounded by Bud Light bikini posters, eyes smiling. My regular booze peddler—this time beaming at his son. His eyes wandered over to mine and clicked.

"Dad," said Elan, "this is Gogo."

"Oh, I think we might've met before," he said, and waved off our introductions. Our world was so small it was ridiculous.

"It's good to … see you," I said shyly. I wasn't sure if I should summon my best parent-meeting smile or my mature, wine-drinking librarian smile. By this point, I hadn't been sure if our booze peddler kept selling to us because he believed we were of age, or he didn't care. His relaxed nature gave the impression it was the latter.

Elan and I went to the dance together. As I slow danced with him to Top 40 R&B music that made me want to puke, I felt too scared in a new environment to be my sarcastic self. While I wanted to make fun of things, I was taking cues from Elan, and he was the normal amount of serious and uncomfortable that such dances require. I began to open up and just enjoy swaying against his strong shoulders on the dark dance floor, stipples of blue light swirling around us.

We went back to Lexi's house after the dance. We had all gone to the dance together, because Lexi went to school with Elan, and she was going to Homecoming with Adam. Lexi and Adam disappeared into her room together shortly after we got to her house. She had been giving blow jobs for some time now, and who knew what level of sexual achievement she'd be attaining on this night. Maybe even a snowball.

Elan and I sat on the couch in Lexi's cold, grey basement, sipping on the same bottle of booze together. Snuggling up closer. While we drank together, I'm

not sure I ever broached the issue aloud that Elan's father was the source of my poison. He smiled at me with impish, boyish charm like Bailey from *Party of Five*, only more deliciously unwholesome. As Elan leaned in to kiss me, his lips opening into mine and his tongue exploring, I felt secure in the fact that my make-out sessions had graduated to a new level. This was quintessential making out, how making out was supposed to be done. Gone were the days of boys who placed their entire mouth on top of my mouth, wiggling their tongues around on top of mine. This was nuanced and delicate.

But after the initial thrill of kissing wore off, something unnerving began to emerge in this moment: it wasn't going anywhere. The frills of sensory delight that arched my back in dreams when I was making out with imaginary Kurt Cobain were missing.

Apparently, you can be with a guy who's incredibly attractive, making out like you're supposed to make out, and it still has no correlation to the orgasmic energy felt within. I felt like a car that was running out of gas. I didn't know what to do next because no invisible passions were compelling my body. He seemed shaky and uncommitted, too.

We had two choices: to force the next steps upon ourselves and go to legit second base, risking a deeper level of awkward, or to admit we weren't feeling it. We did neither. We didn't admit a goddamn thing, but instead sat quietly together for the rest of the night. We made one last feeble attempt at making out

the next time we saw each other, but then gave up on being an item.

SOUNDTRACK
"FUCK AUTHORITY"
by Pennywise

DATING THE SON OF MY booze peddler highlighted a strange tension that I felt in our community but could never put words to. It wafted into my nostrils like a foul smell, only to disappear and make me question whether I had smelled it at all. This feeling was present in the glares from my neighbors when I walked down the street. Our serene community always felt tense to me, a façade of peace that was built on lies.

Three years before I was born, in 1980, virtually all counties in Colorado voted for Ronald Reagan to win the Presidency. Five months before I was born, Reagan declared a "War on Drugs," a departure from the previous public health approach. Parents lived in neurotic dichotomy. They were hysterical about the dangers of drugs. They could tell some shit was going down in their neighborhoods, but they were far too naive to understand it.

The Reagan administration lathered its constituents up into a frenzy about the inner-city crack epidemic, all the while, white middle-class kids like us were flagrantly enjoying maximalist, baroque levels of

debauchery. Three out of the four boys I grew up with on my suburban block are in prison now for dealing drugs. The fourth is John Robinson, and we know what type of moral compass he has. He, too, could be in prison. He's certainly a bag of dicks.

That's how someone like me could be on an errand so innocent as checking the mail, and wind up snorting lines at my neighbor's house. Such went one unmemorable evening in Scotch Pines, in the summertime of my fifteenth year.

My mom had asked me to run outside to get the mail before bedtime, so I padded out front in my pajamas, the cold concrete sticking to my socks. My neighbor, Bryon Junk, was sitting out front of his house and nodded at me once. I wandered over to say hey.

Bryon told me with a quiet smile to come up to his room to see something. He flicked his eyebrows once. At first glance, Bryon looked like one of those gentle giant hippie types, though I knew by the associations he kept (the really fucked-up criminals) that he was tough, deep down inside. His stoic nature wasn't cloaking thoughts of Grateful Dead concerts, but something far more sinister. He also drove a hot-shit red Camaro and kept wiener dogs, which were strange accessories for his particular style. But I knew that if this silent type was going out on a limb to say anything to me at all, he was probably hiding something good.

When we got to Bryon's cluttered bedroom, I instantly spotted a line of cocaine glittering prettily from the bland wooden dresser. Bryon handed me a

rolled-up $20 bill and gestured to have at it. I bent over and snorted a line straight to my skull, throwing my head back at the moment we heard someone walking into the house downstairs. I quickly handed him the bill. Before I could even fret, my mother came storming into the room. "Oh, what on earth are you doing? I was wondering why it took you so long to get the mail."

The front door had been left ajar, and she had been worried enough about my whereabouts to break polite convention and come in unannounced.

My mother looked around the room suspiciously, and I could feel the line of coke that had been there one second previous, like a visual echo, coursing through my body.

"Nothing, just saying hi, Mother." I hurried out of the room, hoping that she'd follow without mentioning anything. As we walked back to my house, she kept glancing at me sideways, but her mouth remained closed.

I spent the next few hours in my room alone, staring at the walls, feeling out-of-this-world confident and thoroughly refreshed.

As teens, we were pretty proud of getting away with our shenanigans. I would've never been so proud of getting away with illegal activity had I envisioned the current events of police officers killing young men of color, just for selling CDs outside of a convenience store. We didn't know the inequality that existed. I wouldn't have believed today could exist, with its swastikas spray-painted on the businesses of local

immigrants. In a perfect example of teenage narcissism, I thought I was the only person in the world who felt unwelcome.

The former lead singer of the Dead Kennedys, Jello Biafra, was from Boulder, Colorado. He often popped into coffee shops to give rants that he charged five bucks for. He was a staunch Green Party supporter, political provocateur, and had a great shaky voice that carried important-sounding things further on the wind. Sitting on the floor listening to Jello felt like a cozy punk rite of passage.

Still, other punk friends of mine adopted Bad Brains' Positive Mental Attitude message. Before then, punk was all about hate, violence, and nihilism. Bad Brains brought consciousness into the dialogue. Even then, as a nihilistic teen, I didn't see the need for positive messaging. Perhaps most staggering, I didn't even care enough to see the need for feminism.

I always thought Jello and my political punk friends were exaggerating about how awful society was, even as it was slowly devouring us. I agreed with them that I wanted to break something, I just didn't know what I wanted to break. Twenty years later, writing from Trump's America, I know now that the hysterical lunatics were correct. It's even worse than they were imagining. And there is a lot that I'd like to break.

SOUNDTRACK
"OLD GLORY"
by Guttermouth

7

SNEAKING IN

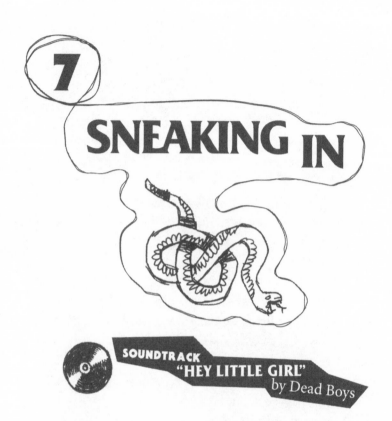

SOUNDTRACK
"HEY LITTLE GIRL"
by Dead Boys

THERE I WAS, SMOKING on the street outside the goth coffee shop, Paris on the Poudre. Downtown in the summertime among the warmed blocks of concrete that were Old Town Square, reclining punks and the black glint of their wardrobes littered the landscape like tatters of garbage bags. Colorado boasts a punk/hippie hybrid of teen runaway that some call "puppy draggers" because they always spange downtown with a puppy in tow. I secretly envied their liberated lifestyle because I was an idiot who never experienced real homelessness before.

It was the pivotal moment in my life before anything really big had gone wrong, and I felt invincible. We were in our last year of junior high, which meant that no matter how unconventional we were, we emanated a seniority that made the younger grades at least respect us. Tana was in high school, and often came to pick up Dar and me in her car. That made us feel cooler than Shirley Manson's Doc Martens. I had done cocaine already, and I was about to get my first tattoo. There was even a younger group of skater girls who looked up to us. But of course, my best moments still happened far from the halls of school.

Tana and I had a cigar club every Friday. We'd meet in her backyard and choke our way through cheap cigars, talking over our lives like mafia lords. We stuck with it for a while, even though smoking cigars is fucking disgusting.

Sometimes I wonder if we affected a certain masculinity to impress guys or fit into a male-dominated society. But we didn't invite anyone to our cigar club. We just loved being old men together. Listening to Led Zeppelin and the Moody Blues on her tinny car stereo drinking PBR like muscle-shirt dads. Sunlight and breeze catching a lock of her golden hair as we drank in a dirt parking lot in folding chairs. We wanted to transcend our roles. We wanted to do what we wanted to do. We wanted to like what we wanted to like, no matter how unlikeable it was.

SOUNDTRACK "I LOVE YOU" by Beat Happening

A GANGLY PUNK FELLOW approached me on the streets of downtown Fort Collins. He asked to bum a cigarette, then reached his hand out and introduced himself as Eddie.

Eddie was different than most of the suburban-bred skaters I had gone for. He had that perfect bouquet of edgy filth. Not literal filth, just messiness. Like Tommy Lee en route to Keith Richards, but far from reaching his final destination. He was just on the precipice, like if I waited two weeks, he'd expire. I know this to be true because I saw him, years later, with an unfortunate eyeball tattooed on the side of his neck. It wasn't even far enough to the side of his neck to make sense; it overlapped against his Adam's apple, like it was placed there by mistake, like the tattoo artist just accidentally fell against his neck and stamped it there instantly and forever, or like it was placed there specifically to give me OCD twitches.

But in this moment, he was at peak edginess, ready to pluck. Ready to …

Who do you think I am? Of *course* I tried to fuck him. Whether or not I'd succeed is another story.

SOUNDTRACK "SKATERS ANTHEM" by Guttermouth

PERHAPS IT WOULD BE a good thing to talk to someone new outside of our group of neighborhood skaters; even I knew that my love of skaters was a weakness.

Avril Lavigne had a pop song called "Sk8er Boi" in which she sang "see ya later, boy," because he wasn't good enough for her. The movie *Clueless* featured a skater shunned by his love interest, the late Brittany Murphy's character, once she started hanging with the popular kids. Both of these cultural references confounded me, because to Fort Collins '90s girls, bagging a skater was the holy grail of hotness. I didn't know anyone who would think otherwise.

Seinfeldian mythology places the female gymnast above all other potential lovers. But the female gymnast fantasy at least has some logistical reasoning (flexibility, athletic prowess, Russian accents). The origin of our devotion to skater dudes is a complete mystery.

Perhaps it was because they oozed a concentrated form of masculinity, bravery bordering on stupidity. Their hubris, on the border of unattractive, was kept in check by the fact that you can't take yourself too seriously when you eat shit every ten seconds. They were fluent in the teenage language of raunch. They walked with the ease of those who are just taking a break from more demanding physical activity. Their underwear was literally hanging out of their pants, bunched-up plaid boxers a reminder of what beckoned, chinos down to their knees. It would take just one yank.

The punk guys could be sweet. The ska guys respected women—they were the band geeks of the

scene. The skaters were fucking awful to us.

We called ourselves "skater girls" because we hung out with skaters, but it was pathetic. We couldn't skate. We sat and watched them try to do their little tricks, and they mostly ignored us, then made out with us when we were drunk. We tolerated this treatment because it was a small price to pay for making out with skaters.

And truthfully, I didn't realize there were any other types of men. I thought this small corner made up the entire world of male-female relations. Men ignore us, we have nothing to offer them, and then we have our own lives, and brains, over in another compartment. I never knew there was a greener pasture on the other side of this world, filled with intriguing men who were interested in not just putting their dicks in women's mouths, but also in hearing the words coming out of them.

The fact of the matter was, there were no suitors knocking down my door with flowers. No one stopped me in the hall to talk to me, a crush beaming behind their words. Not the way people stopped the Varsity Skater Girls, like they were proud to talk to them. These Varsity Skater Girls took us out partying and never treated us as *lesser*; but sitting longingly on the sidelines with our tube socks pulled up to our knees, watching a skater boy fuck up his ollie because he was checking out Cyndi, I felt that we were the benchwarmers of sexual sport.

The only time I remember a boy coming on to me was when I heard a rumor that a younger skater guy wanted to "eat [me] out vigorously." I held my crushes

so close to my heart, I barely admitted them to myself. When I did fantasize, it was typically about famous men I didn't know, like Kurt. Good old, dead Kurt. Romanticism was something I never even considered in the real world.

Don't get me wrong, we were as cute as the Varsity Skater Girls. Tana and Lexi, a year older than us, talked to high-caliber boys, and seemed to navigate their interactions with grace and normality.

Dar and I, on the other hand, were for the most part unwilling to pretend we were normal. Starting the party by opening bottled beers with our teeth was a bold move that either moved the crowd to ovation or frightened normal boys. Dar and I didn't desire conventional popularity anyway, so it barely mattered, but our lack of playing the game might've knocked us down a notch or two from the medium-popularity skaters we did desire.

Sure, there were other weird girls who did alright. Bri, one of the Varsity Skater Girls with a pixie cut, was confidently weird—funny, even, something no teenage girl should have the gall to be. But she made up for it by giving off the perception that she was exceptional at sex.

Dar hadn't fucked anyone yet, but I knew she would be exceptional at sex someday. Some people emerge into their sexuality like horses are born, able to immediately stand and walk gloriously into the sunset. I was swimming in sexual energy, yet I didn't know what to do with it. I was a horse drawn to galloping

but kept falling on my face.

I tolerated a lot of awful treatment from the dating pool, because I didn't know there was any other choice. Consider the type of young man who pierces his nut sack with a safety pin for leisure. I present to you, our pool of suitors. It didn't help that guys like these were the ones in control of the sexual dialogue. Consider the urban dictionary of sex acts, like the Dirty Sanchez— one more degrading than the next (and racist, in this case). Teen girls could use more femme-friendly sexual urban legends to aspire to, and with this in mind, I present to you, The Double Decker Bust:

Okay. So, you're going down on a girl, or performing whatever clitoral stimulation you choose. Clear it in advance with her, of course—and when she starts climaxing, BOOM! Penetration. It leads to a secondary, more explosive orgasm. Believe me, this is very femme-friendly. i.e. …

Roxy: "How was last night with Jonny?"

Betty: "Let me just say, I rode the double decker bust last night." WINK.

SEX JOKES ASIDE, in this cruel world of skaters, Dar and I were a bit too strange to feel confident. Our

weirdness went over just fine when we were down-
town, however. In fact, it was an asset. Downtown
by Paris on the Poudre was closer to New York City,
where anything goes. Downtown, we could be our
entire selves.

My confidence soared when I talked to downtown
boys like Punk Runaway Eddie. With his British looks,
blond hair spiking every which way, and brooding
black smear of a wardrobe, I knew I was swimming in
the deep end. And it was probably easy for him, what-
ever he said, to appear more sensitive than the skater
boys I was used to.

Eddie was a polite punk runaway. As we smoked
our cigarettes together, he told me in his quiet way that
he was kind of "surfing around town."

"What does that mean?" I asked.

"I don't really have a place to stay."

I really couldn't tell by his wrinkled clothes if
he was truly homeless, or just pretending to be so he
could ask to stay the night at my house.

He did ask. I confidently said yes, not sure how
I'd broach the issue of my parents, who were not into
hot houseguests who looked like a young Cheetah
Chrome. It would surely come to me later. He would
come to me later.

I didn't really think about the dangers of inviting
a strange boy home with me, fresh off the streets. That
was part of the appeal. If I'd wanted to date boring
guys, I'd have shown my face at school more often.

I wrote my phone number on Eddie's hand before

heading home, telling him to call me later to make sleeping arrangements.

"Meet me after dark in the green belt on Stover Street, behind all the fences right where it intersects with Strachan," I told him over the phone. It was right behind the back gate of my house. Then, I waited with fireflies dancing in my belly.

I felt like when I was a kid and we occasionally hosted college-aged kids from a touring theater troupe, young adults with cool denim jackets from places like San Francisco who were artsy enough to put on a stage. Punk Runaway Eddie was even more exciting than those theater kids, probably the most exciting house guest I'd ever eagerly awaited. The fact that he was a big spiky secret made him that much more exciting.

I honestly didn't know what would happen with Eddie. In the movies, inviting a boy to secretly sleep at your house would certainly result in sexual activity. I knew I was attracted to him. But would he even want to have sex with me? Being treated so horribly by the skaters had led me to believe I was a nice enough girl who might get laid someday if someone was drunk enough. My family's warnings about boys had fallen on deaf ears.

My tank top spaghetti straps were the first talking point that launched my father into describing, in painful detail, the world of teenage male perversion. How I was giving boys the "wrong idea" with my wardrobe choices.

"But, Dad, it's not like I'm showing them anything

they could even be attracted to," I said, thoroughly grossed-out to be having this conversation. There were no breasts on display here, no open-air vaginas.

After speaking in euphemism to no avail, Dad finally dropped his voice, his shoulders tensing with what he was about to say.

"Gogo, a teenage boy can get an erection just from seeing your bra strap," he warned. "It doesn't take much."

I went away from the conversation wondering if my dad was being hyperbolic, or if he was a pervert himself.

I did not think myself capable of giving a man an erection. There were no movie stars that looked like me, which I believed to be the bar for bonertown. The most complimentary comparisons to my naked body were classical or Renaissance statues, with their standing-at-attention B cups and unstrategically placed curves. Curves not where America says curves are supposed to be. Flesh in ungodly places like inner thighs or the breast tissue spillover near my armpits. I laughed my father's warnings off; there was no way I'd be parting the Red Sea of dicks when I walked down the halls of school.

My father and my brother both had the "guys are total assholes" talk with me. The talk that might've been more helpful was, "There are a million guys who are not total assholes," so I knew I had options. I'm guessing my dad and brother didn't even think to mention that, assuming they were examples of "not

total assholes." But they were family and, to a teen-
ager, family is a shameful abomination that shatters
all norms of coolness or sophistication, no matter how
normal they really are.

SOUNDTRACK
"SUBMISSION"
by Sex Pistols

WHEN PEAK DARKNESS FELL, after my parents finally
nudged their bedroom door closed for the night,
I wandered barefoot into the backyard to receive
my stowaway passenger. I lifted the back gate so it
wouldn't scrape the bricks loudly, stepped outside and
saw his spiky silhouette in the suburban night, looking
around uncomfortably. I grabbed his hand and pulled
him in.

Eddie and I lay in the wet grass of my backyard
for some time, staring up at the stars and whispering
about our lives. I didn't get much background on him.

"Where are you from?"

"All over." He was fairly aloof.

There weren't any romantic utterings before he
rolled over and pressed his gaunt frame into mine.
Once it happened, it became clear to me. Why was
I so stupid? We had both known all along that this
was what we were here for. Now he was kissing me,
lapping me up, sending ripples through my skin like a

buoyant kite.

We snuck inside, upstairs and past my parents' bedroom, the booming summer fan graciously concealing any creaking floorboards. In my twin bed with a pink and white striped duvet cover, he peeled off my clothes. I was fully naked, and with a boy. We were poised to make coital bliss a reality. But just as he attempted penetration, my body rejected him like a bad piercing. Between my legs was a solid forcefield of punk-proof titanium. My hymen wasn't having it.

Ah yes, the topic of my virginity. Male virginity is always discussed in fairly straightforward terms: stories about embarrassing first times, starry-eyed fumbles, mind-blowing entries into the world of pleasure. No one shames a boy for losing his virginity in just any old way. No one expects a boy to lose his virginity surrounded by candles and "Total Eclipse of the Heart," only after receiving a promise ring. He's expected to fuck whoever is going to indulge him, and that's okay.

If there was anything in the world I wanted, it was otherness. Like my lucky swan from the Eiffel Tower. I recall the first time I saw a real countercultural person in the wild, on a family trip to Haight-Ashbury. A punk standing in front of the chipped red walls of a coffee shop blaring jangly glam rock guitars. It was like someone stepped out of the Iggy Pop songs I had been listening to. I was mesmerized. Eddie had that vibe.

I had come close to losing my virginity to Jonny Gutpunch, but it never happened before we drifted

apart. I wasn't sure if Jonny was waiting for me to make the first move, which I didn't know how to do, or if he didn't want to have sex with me. After that, in this world of cynical skater dudes, having sex with someone I knew would've felt like admitting I cared. That wasn't for me. I worshipped irreverence. I abhorred the trite pressures of rites of passage.

My body was not having any of Eddie. It was like it was telling me, "Hey! Punk Smuggler!" (My hymen inexplicably has a British accent right now.) "Oy! I know you think this bloke is hot, but listen: We cannot let him in. You lit-rally found him on the street."

It's one thing to effortlessly lose your virginity to a virtual stranger. Once elbow grease is required, however, one begins to question whether this is the right thing to do. Beyond the strength of my hymen, it was also terribly painful—I winced in anticipation of the break, as if it might snap like a rubber band. It was possible my body wasn't as cavalier with my virginity as my mind had been.

I thought I heard some creaking floorboards from the hallway. Fearing my parents, who often checked on me at night after the legendary Summer of Sneak, I sent Eddie scampering to the basement with a hope-less erection,[10] at which point he probably regretted sleeping at my house.

10 Hopeless Erection: Sad bastard punk band like Lucero meets Bad Religion.

Lights out. Morning time. And we're back.

Eddie and I had planned for the morning. He was to stay put until my mother and I left for some activity I'd inexplicably complain through. Maybe some pottery class she was forcing me to take where I would secretly spend my time making pipes to sell. As Mom backed the car out, I was to pretend I forgot something, go downstairs, and tell Eddie the coast was clear to let himself out of my house.

I must've been taking too long. I got lost in the social chatter with a cute boy, and forgot I was supposed to hurry. Then, something awful happened. Something terrifying and most supremely unexpected.

Eddie had emerged from the basement and was sitting on our couch in the living room, rubbing his eyes and waking up. When you opened the front door of my home, this was the light floral couch in your direct line of sight. I stood a few feet from him when my mom charged in the door, yammering about helping me find whatever I lied about leaving behind.

My parents' home gets really good sunlight. It's a realtor's dream. It's enough to make you feel as if you're sunbathing, lying on the living room floor. If I were to guess the probability of my mom failing to see a spiky young man in aggressively black clothing on a light couch in a sunlit room, not ten feet from her in her direct line of vision, I would say with great certainty that it would be zero. And yet, there she floated by, right on past. It was a baffling mystery of the mind.

Don't think that she could've seen him and

pretended not to. The probability of that is even less than zero. If my mother spotted an errant member of the Sex Pistols, rubbing his eyes as if he had clearly just woken up in her suburban home, making himself comfortable on her floral couch after tangling with her daughter the night previous, she would've lost her fucking mind.

In that moment, I changed my tune on reverence. It was a goddamn miracle.

SOUNDTRACK "SURVIVE" by Bags

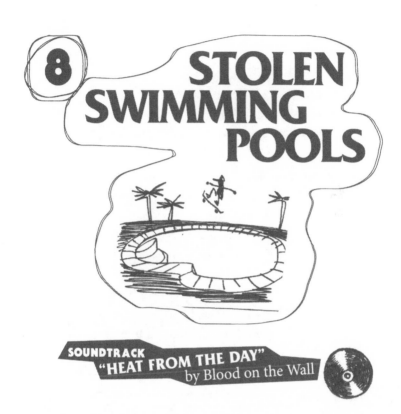

8 STOLEN SWIMMING POOLS

SOUNDTRACK
"HEAT FROM THE DAY"
by Blood on the Wall

IF MUSIC VIDEOS CAN BE trusted, jumping into a swimming pool fully clothed is the logical conclusion to a good night of revelry. It's the activity that sneaking out was invented for. In Teenageland, swimming pool gates are meant to be scaled, and a glimmering pool at night is a birthright for anyone brave enough to dive in.

Blood on the Wall's "Heat from the Day" is a perfect backdrop for any breaking and entering experience. Beginning with a darkly frenetic and ominous bass line, you know trouble's coming long before the guitar enters, repeating the same anti-note, erupting

any room into Sodom and Gomorrah. Everything flickers red, like an alarm system going off, but let's hope those alarms are in the music alone—don't want to get busted by the cops, of course.

Filled with epic danger notes, the song brings to mind the image of a male silhouette hopping over a pool fence, trailing his skateboard behind him. This was how Jonny and I fled the fancy pool in my neighborhood, soaking wet and in our skivvies, chased out of the pool by Fort Collins Police.

It took a lot for Jonny to sneak out with us, because he had to put his mom's car in neutral and push it out of the dirt driveway from his home all the way in Bellevue, then drive all the way through town to suburban Fort Collins. We wanted to make it worthwhile. We wanted to go to the fancy pool.

The fancy pool was well worth the extra bravery. It was conspicuous as hell, but also more desirable, because it had a high dive. We'd hop the tall fences, plunging into the silvery water surrounded by cricket sounds and our own stifled laughter. I'll always remember the cool feeling of the night when we had snuck out, and we weren't supposed to have it. Stolen night air feels prickly with possibility. And nothing is more exhilarating than plunging off a high dive, in the black of night, when you're drunk as fuck. Tunneling down to murky submersion. Suddenly enveloped in frigid, life-clarifying liquid.

So much of what we're seeking in adolescence is sensory. With automation and the internet, sensory

experience is the missing component of modern life. When we get our first gush of hormones, as toddlers, we need sensory regulation: pushing, pulling, working, painting, kneading, getting our hands wet. The same is true in adolescence. We're just like toddlers, sticking our hands in Play-Doh.

What I like about "Heat from the Day": how few fucks do you give to play the same note over, the entire song, and then just talk over it? The vast majority of us could attempt this mindless barrage of noise, and it would sound like a karaoke fail. But if you're from Brooklyn, it sounds cool.

In the midst of our darkened revelry, which we had believed to be quiet, we heard a loud sound coming from the other end of the pool. Then a bright light ticked on. We scrambled out of the pool in our skivvies, grabbing whatever clothing we could find. We launched ourselves back over the fence, looking to see the silhouettes of a couple of police helmets on the figures entering the pool, haloed by the bright light. Arms and legs pumping with adrenaline, our soaking wet underwear feeling a thousand pounds heavy, we roared down the quiet streets to the safety of an alley. We got away with it. For the next week, we pondered whether the pool would've had security cameras.

But it didn't stop us from coming back. We just went to other pools, for the most part. One night, we went to the trouble of hopping the fence, but the pool was already covered in a tarp for the season. We decided to jump in anyways. It was like rolling and

bouncing on a swimming pool-trampoline hybrid.

Breaking into pools is a fairly victimless crime. The biggest victims are people rich enough to pay for a pool membership or an HOA. They won't die from a little beer spill—or, on an eventful night, maybe a little jizz—in their pool.

The pool we regularly frequented but didn't belong to was nestled in the green belt behind my house. It was called the Scotch Pines Pool, and I lived in Scotch Pines, damn it. I was practically a member. Sure, there were HOA fees I wasn't paying, and the hours posted said no swimming after 9:00 p.m., but if they really wanted to enforce that rule, they'd have walls taller than hip level. Tana, Dar, Julian, Jones, and I saved skinny dipping for the neighborhood pool. Totally nude, we'd slosh our beers around in the water merrily, a new level of comfort and freedom we had never experienced before. We looked at the clubhouse with great temptation, as it was rumored to have a hot tub inside. I don't know where this rumor came from, but it was always beckoning us.

After years of using the Scotch Pines Pool after-hours, and copious amounts of liquor, we finally decided one night to break into the clubhouse. It was legitimizing years of half-hearted breaking and entering.

Jones smashed a window with a giant rock, cutting his arm in the process, sending blood trickling down his arm. When we were able to clear the shards from the periphery of the window and climb in, we got a sore surprise: a boring fluorescent-lit empty room

inside, the kind that hosts voting or bingo, with dusty speckled tile floors. No hot tub.

In Teenageland, the spread of information is strong, its origins often mysterious.

SOUNDTRACK "PROPAGANDA" by Vice Squad

9

JAIL TATS

SOUNDTRACK
"SUNGLASSES AFTER DARK"
by The Cramps

THERE COMES A TIME in a young woman's life when she realizes she needs a tattoo. The fact that this young woman is only fifteen is but a mere hurdle in her quest to acquire one. Should the young lady be lucky enough to be acquainted with an aspiring "tattoo-artist-in-training," we have our makings for a well-intentioned, badly executed milestone of exhilaration and regret.

I had been attempting, and failing, to give myself tattoos for a couple of years. I didn't care so much about what was contained in the tattoo, only that I craved the immortality of ink. There was something about the

present that I wanted to preserve for-fucking-ever. The design I attempted the most, with a sewing needle and pen ink, was a dotty peace sign on my ankle. I winced in pain, gouging as deeply into my skin as I could manage, never getting deep enough. The peace signs always faded away. Looking back, never have I been so happy to have failed at something.

My mother mistook this act for self-mutilation. She couldn't fathom being willing to stab oneself repeatedly for artistic expression. She thought that anyone needling themselves must be in a great state of emotional pain, rather than swept up in mania, stupidity, and sky-high levels of artistic self-importance.

I wasn't the only one. Teens in the punk scene often pierced eyebrows with safety pins. Kinsey Fox pierced his dick with safety pins, twice—he would readily show you. He was the one of us who burned the brightest; he once notoriously hopped onto a train, waited until it chugged along over the train bridge, then hopped off the roof and plunged into the river. He was kind and often shirtless, always had a cigarette behind his ear, always had a hug for his friends. Kinsey Fox was the spirit animal of the Fort Collins punk: experimental, manic, and boundary pushing. It was no surprise that he had more amateur piercings than anyone else.

My tattoo dreams came true one momentous afternoon when the world delivered to me a skater named Data, flipping ollies in Old Town Square. Much like Eddie, the strange boy I smuggled into my home,

Data was an unconnected stranger. Blank with possibility. It's these unconnected strangers I seem to have regarded with more trust than the boys around me. I don't think I'd recognize Data on the street today, which, as you'll see below, would probably be preferable to him. But his mark is on me forever.

When I first met Data, it was clear that he was a classic skater dude: charming, high-energy, likeable, outgoing. Hours later, as he was tattooing my breast on top of the parking garage, he looked into my eyes and said, "Just tell them you got this from a big black man named Data." (He was a short Asian guy.)

Data was just passing through town, semi-homeless in the way that can be said of young men who just want to party without the trappings of "home." He just so happened to have his tattoo portfolio with him, so I flipped through the pages while he practiced skate tricks in the square. The art was simple, that was for sure, inky doodlings immortalized in skin. Did they contain a sort of rustic charm? Or did I just really want a tattoo?

What other options did I have? I made plans to meet him later that night, at 7:00 p.m., back in the square. I gave myself a few hours to think about it.

7:00 p.m. came in an instant and I had forgotten to deliberate about my tattoo. What needed deliberation? Tattoos fucking rule.

"So, where are we doing this?" Data asked.

"You don't have somewhere to do the tattoo?" I asked him.

"I'm couch surfing," he reminded me.

I looked up at the sky. It was getting dark. We certainly didn't know any homes where the people inside would calmly accept that I was getting an illegal tattoo. We took our tattoo procession[11]—Tana, Dar, Data, and me—up to the top of the parking garage in Old Town Fort Collins. It was the only place that was both hidden from grownup eyes, but also well-lit enough for the intricacies of tattoo work. There were cameras, but getting a tattoo felt so random, we hoped any watching eyes wouldn't know how to process it.

I was certain I wanted a tattoo. The art contained therein was a matter of lesser consequence. My choice of where to put the tattoo, on my boob—far up enough that I wouldn't flash nipple if I were to show it off, but low enough that I could hide it—was 100% based on the fact that I didn't want my mom to see it. I was not thinking about the fact that I'd only be under her roof for three more years, nor that the tattoo would last forever.

Since I didn't know what I wanted, Data showed me his cobbled-together book of visual ideas. "Kanji is very popular these days," he suggested.[12] Data's Kanji vocabulary was limited, and I distinctly remember "farmhouse" being one of the words on the Kanji

11 Tattoo Procession: Hardcore band from Omaha where four guys stare fiercely into the camera whilst wearing denim.

12 In fact, the Spice Girls ruined my month by getting Kanji tattoos a month after mine.

menu. I didn't feel passionately enough about farm-houses to immortalize them on my person forever. Let's see … I pointed to the two stacked symbols for "woman." It seemed accurate.

Some people have Type A personalities. To find my personality type, keep cruising past B, all the way to F. I'm a Type F personality. In many instances where others worry, I simply don't give a fuck. I also fret neurotically over things no one else worries about. But tattoos have never been one of them.[13]

Data instructed me to sit cross-legged on the ground and take my top off. He told me I'd need to put my elbows behind my back, and Tana was to sit back-to-back with me, linking elbows so that I wouldn't twitch in pain. Then Data straddled me so my legs wouldn't kick, and he began the proceedings. I found him attractive, so I didn't mind an ounce of this.

The Cramps' "Sunglasses After Dark" cultivates an electric drone, not unlike the buzzing of a tattoo gun. The guitar riff positively flays me every time, letting loose a dark glittering city of no-good to get up to. Not to mention how indulgent it is that the song is just about being cool and wearing sunglasses at night.

In a grainy music video of a live performance of the song, lead singer Lux Interior kicks things off by reaching into his leather pants, pulling some mystery

13 This is why I have bad tattoos.

substance from therein and smearing it all over his body. When asked in a radio interview to speak on the rock and roll and psychobilly selections the station was spinning, he replied: "Rock 'n' roll has absolutely nothing to do with music. It's much more than music. Rock 'n' roll is who you are. You can't call The Cramps music. It's noise, rockin' noise." The sounds of "Sunglasses After Dark" are just a byproduct of something more deeply deviant and carefree, something immortal and untouchable.

Data's setup was actually more professional than you might imagine, this occurring on the top of the parking garage. He had packaged gloves, a sterilized gun, and a needle in a sterilized sealed baggie. I think he even sterilized it after opening it. I was satisfied. He began.

The heavy, bold, vibrating pain jerked my head back. It was fucking phenomenal. I felt secure with my friend Tana holding my arms back, and the pain never overwhelmed me. After all, it was all going down on nature's cushion. While the tattoo itself was questionable, I relished in the mere notion that I was creating a permanent memory.

The arc of regret I felt directly after the tattoo was surprising. It was instantaneous, and actually dissolved over the years. The part of the tattoo that I instantly regretted was positioning it on a part of my body I wasn't all that impressed with. In my mid-twenties, my friend Vicente told me I had "model boobs," which is gay best friend terminology for "small boobs."

As a teenager, they were a solid B cup, now a C after having kids; a far cry from the voluptuous DD curves possessed by most women I've known.

Man, I wanted big tits when I was younger. I didn't appreciate that the smaller ones are usually perky and nicely shaped. I just wanted volume. I didn't understand how much harder it is to go through life with noticeable breasts, how you need to change your entire wardrobe. When I was nursing and had giant cans, I spent a large portion of my day just desexualizing my appearance so I wouldn't feel like walking porn at the library.

I also didn't know that I'd go through many different body transformations after puberty, most notably having children, where your entire frame opens up to spit out a watermelon, and then slowly rearranges its organs back together in slightly different formation that means you suddenly have a new disease (asthma), a broken tailbone (children with large heads), and the new capacity for g-spot orgasms (a miracle). That's just childbirth. I didn't know that I'd use my whatever breasts to feed two children for years upon years. I have the most utilitarian tits in the West. Three years after my youngest was born, the milk is still flowing. I can lactate as a party trick, and I probably will. Mostly for my toddler, though. He finds it hilarious.

As a young girl, getting a tattoo on her boob, I certainly never intended to draw attention to it, nor was I choosing to give it a sacred stamp. Now, I believe

wholeheartedly in its message and placement. Breasts are miraculous. Imagine something that's part pillow, part food, and part joke. Even if a mother subsists on a diet of Cheetos and antidepressants, breasts can make a magical potion that has fat, complex proteins, probiotics, endocannabinoids—and tastes like gingerbread. That last part might be wrong, it's just what my toddler son told me it tastes like. At any rate, it's taken me 20 years and having two children to appreciate the placement of my ill-thought tattoo.

I was also, as you can tell, not super into feminism at the time, so the "woman" stamp was lost on me. I believed that women were equal to men, but I thought the way to fight sexism was to be a really fucking cool woman. Surely, if these teenage boys spend an afternoon with my level of wit, they'll roll over and readily surrender the keys to the Patriarchy. I thought that people who called themselves "feminist" were brash and irritating. The way to get across to men, I believed, did not involve nagging.

For these reasons, I experienced a period of a few years when I was humiliated to admit I had "woman" tattooed on my chest. I mean, even for a feminist, it's a little bit on the nose. One woman who spoke Japanese broke out laughing when she saw my tattoo, pointing to my boob: "It looks just like the sign on the women's bathroom in Japan!"

Sigh.

Now, I'm an outspoken feminist, not because my theories on reaching the masses have changed. The

difference is that I just don't give a fuck who thinks I'm brash or irritating.

In the midst of my tattoo sesh, a car pulled up at the parking garage. Two male figures slowly emerged from their vehicle. I don't know if it was the best luck in the world, or the worst luck; but the two people who popped into this delicate scenario were friends, Elan and Adam. They just laughed their asses off at me, cringing and in such a delicate position, in between faking out like they were going to nudge me.

SOUNDTRACK
"PRETEND WE'RE DEAD"
by L7

10
LOLITA GROUPIES

SOUNDTRACK
"THREE GIRL RHUMBA"
by Wire

LET ME TELL YOU A STORY that will confuse your sense of what's right. It begins with an epic band that plays music to rob banks to, music that's naturally playing on some spiritual plane during each and every knife fight. This music is both campy and classic, yet there's a vein of frenetic, full-throttled machismo; not the red-blooded machismo of Bruce nor aspirational douche machismo of Bono. It's foundational guitar music, darkly romantic from times past.

We'll call them the Flames. For reasons that you'll understand soon, that may be rooted in Stockholm

Syndrome, I'm keeping them anonymous.

Corinne and I enjoyed our dark proclivities. Where other girls our age went to *NSYNC concerts, Corinne and I could be found at Type O Negative concerts. We were bewitched by Peter Steele's subterranean voice and wine-swigging black romance, wind machines re-animating his long hair and goth metal bass riffs ravaging our nethers. We waited in the alley after the show among the heavily pleathered and begothed, meek souls lining up to be vampirically fucked by Peter. He waved at us with the passion of someone seeing a corporate coworker at a social event, then ducked into his tour bus. We weren't aware that he was known as a misogynist and a domestic abuser, and even considered a Nazi sympathizer in some circles. His tendency to alternately worship women ("I am your servant, may I light your cigarette?") and threaten to annihilate them in the same song ("let me love you to death … the beast inside of me is gonna get ya") was narcotic to our Baroque teenage passions.

The back-alley meeting with Peter was our standalone attempt at groupiedom. It took a lot of sex appeal on the part of the performer to convince us to put ourselves out there as groupies. This type of self-offering required more appearance-based confidence, and less innards-based confidence, than I had.

We were true music fans. I pounded a sparkly silver drum kit for years, until my mom sold it at a garage sale because not one of my sticks hit the snare

after a single teenage hormone entered my blood-stream. Boys and trouble were much more alluring. Corinne practiced Hole songs on her fuzzy-sounding electric guitar, and yet we never really got it together to form a band. Teenage laziness. Still, we went to rock shows every weekend, from our friends' shitty punk bands to giant skateboard festivals to the types of punk shows where everyone clambers over one another just to spit on the lead singer. It was just another Saturday night when we stood at the front of the crowd at the Starlite, eager to watch the guitar legends in the Flames perform before a packed house.

SOUNDTRACK
"WHIPS AND FURS"
by The Vibrators

IT'S QUITE A THING TO BEHOLD the Flames live: the band begins playing onstage without their leader, getting the crowd lathered up; then the lead singer begins playing guitar from the invisible vantage of backstage, dragging out the tension until it's barely tolerable. At the climax of chaos, he emerges like a glorious God. James Brown prima-style.

It's yet another buzzy feeling in the pit of your stomach when the Flames appear to be aiming their epic sounds directly at you and your best friend. *Are they looking at us?* I wondered. *I must be imagining*

things. There was an entire packed club of sweaty fans behind us.

And yet, after one song, the lead singer reached over a crucial, yet invisible boundary, and handed Corinne his guitar pick. The bass player winked at me.

Apart from our Peter Steele experiment, "Groupie" has always been a term I wanted to distance myself from. I worked in the music industry for over a decade, a music industry filled with musicians who are unarguably the sexiest people on earth. During that time, I never so much as touched a single one of their guitar-strumming muscled arms or errant, perfectly messy hairs on their heartbreaking beauty-filled heads. Mid-career, when I was let backstage to interview Gang of Four, I bristled at the male fan who yelled, "You'll let a groupie backstage, but not me?!" Excuse me, that's music journalist to you, fuckhead, on her way to an important band interview. It was important to me to be taken seriously, even if my job mostly consisted of things like driving Gang of Four to their hotel in my piece of shit car, which embarrassingly had trash in the back seat where Jon King sat, and occasionally calling guitars "shimmery."

(For the record, I would never call GOF's partic-ular guitars "shimmery," are you insane? I'm a serious music journalist. I would call them "squawky," "raw," "brash," or "rhythmic." I'm also not mentioning GOF in this story to associate them with these other creepy old rock stars, as they were the example of profession-alism, even though Dave Allen remembered me later

as the "trash car girl."[14] I'm only name dropping them because they rule. Ahem.)

But in this moment with the Flames, I was blissfully fifteen and had no career to be insufferable about. At fifteen, I was barely a writer. I played the drums, fairly well, even, but had never been in a real band that actually played music together. I didn't have any artistic vehicle of my own to reach this pinnacle of cool,[15] and if I did have an artistic pursuit, I'd probably never get to the Flames' level. I had no qualms capitalizing on being a girl so I could soak up their greatness. To a teenage girl, the attention of these guitar legends felt like fame itself.

Immediately after the show, while the crowd still cheered, the bass player of the Flames emerged from backstage. He had purple hair and looked like an aging punk. He grabbed my hand and pulled me backstage like a rag doll, pausing to ask, "How old are you?"

"Eighteen," I immediately answered. A silent agreement. An answer that's compliant and rebellious at the same time. He nodded, and we went backstage, my hand pulling Corinne along with me.

14 Garbage-style grunge band inevitably forced to change their name to "Trash Can Girl" because everyone's reading it wrong.

15 Pinnacle of Cool: Leather-wearing retro garage rock band that's a mixture between Jesus & Mary Chain and Shannon & the Clams. They once scored a John Waters film.

SOUNDTRACK "RED FLAG" by Fuzz

Thus began a deviant, occasional courtship that spanned three years between me, a 15-year-old girl, and Ezra, a 50-something rock star. It was a cordial and G-rated affair, considering the creepy age difference. He complimented me on my beauty, a style which was too unconventional for boys my age, but appropriately dark for the music they played. He called me whenever they were in town. He asked me for a ride from the airport and I, hiding the fact that I couldn't drive, told him my friend Ziggy Longshot was going to accompany me, just because. (It was actually because Ziggy had a car, a driver's license, and a punk band, and was frothing at the mouth at the chance to meet a guitar legend).

Corinne, Dar, Tana, and I hung out with the Flames whenever they were in town. They told us to invite our friends backstage—even our guy friends—and we always had blurry-blurry good times. I was the liaison when they came to town. The lead singer, Dean, flirted with Corinne. He invited Tana onstage to personally serenade her. But he kept it mostly PG-13 rated.

My friends and I kept waiting with great reluctance for the Flames to cash in on this fun, and kind of gross, unspoken agreement. Everyone figured they'd want us to suck some dick soon. A blow job was the

going rate for soaking in the glory of rock. After all, it's not like Baby Boomer legends enjoy hanging out with 15-year-old girls for their industry connections or their witty repartee. Even we knew that.

"Just fuck him!" said my friend Bob, fanboying out. Ironic, since he later went on to gain a similar level of fame for himself with his rap career. "I will fuck him for you. I don't care if he's old and wrinkly. He is a badass."

Guys would fuck anything. They just wanted the backstage parties to keep coming. Truth be told, I didn't know what I would do if that moment presented itself, so I tried not to think about it too much. What I didn't know then was that Tana and Dar were silently protecting me; they were always making sure Ezra didn't get alone in a room with me.

That first night we hung out, Dean gave Corinne and me a ride home to our parents. In a white minivan, he cruised the empty streets of Fort Collins at five miles an hour the entire way home. I've never ridden with someone driving so slowly. It felt cozy, more like a carpool situation with a parent, but deviant and slowed down on Sizzurp. The only reason I could fathom Dean driving so slowly was that he must get tired of being so fast 'n' loose all the time.

When I got home that first early morning, I proudly proclaimed to my parents the legend who just dropped me off. Hoping they'd at least understand being five hours past curfew because FAME FAME FAME.

They didn't.

When I had given Ezra my home phone number,

I didn't really care what would happen if he were to call my parents' home. Remember, these were the days before cell phones, and smart parents were protective over their phones, lest the Fort Collins High attendance line call.

Meanwhile at school, I was enjoying being the person who barely showed up at all, and when I did, I walked in late with my illegal titty tat peeking from my tank top. It felt good to be a slightly unnerving presence in such a place that deserved to be unnerved. I wore aviator sunglasses to class. I wasn't failing my classes, but I wasn't exactly succeeding, either.

I did show up to work at the sticker factory, on occasion, because I enjoyed the artistic sensibility of it. My sexually harassing boss, Dante, even bought one of my drawings as a sticker design to be distributed nationally. I had taken the Beastie Girl that I designed for the Riot Grrrl flier with Corinne and turned it into a vinyl decal design. It made me swell with pride to think of stoners around the country selecting my bad-girl vinyl decal to place on their car in lieu of the magic mushrooms or butterflies in our catalogue.

And I had been promoted: I graduated from sticker bitch to plotter technician, using vectorizing software, nearly a graphic design job. But Dante was still a dick.

Occasionally, Ezra would email me. It would be something very mature about producing a record for such-and-such legendary punk band at his Huntington Beach studio. I tried to answer coolly,

though my life of stickers and naivety couldn't have been more in contrast.

Corinne and I were caught between the maturity level required to entertain older gentlemen and the maturity level we were by ourselves. We made an executive decision one afternoon to prank my coworker, Bill. Most people play pranks on people they know really well, because they want to see that person fooled. But to us, the journey was the destination. We were nearly Zen in our appreciation of pranks. For that reason, the target we chose for our most involved prank was a coworker we barely knew. That was the genius of the whole thing—he'd never suspect us, and the decision was just so *arbitrary*.

Bill worked with me and Blesh at the sticker factory. He had prematurely grey hair and surprised us with his rehearsed knowledge of the full lyrics to Destiny Child's "Say My Name." That's all I knew about him, besides where he lived (because I had given him a ride home once).

Despite the fact that I didn't know Bill at all, I got a vibe from him. Bill had been struck with the funny stamp. Sitting there, he was just serious enough and just self-effacing enough that you could imagine him making an excellent prank-ee. You just wanted to mess with him. Corinne had never even met him. The fact that we barely knew him was what made it so funny to us. But the reason he made the best prank-ee was the row of perfectly manicured yard fowl that I spotted on his front porch when I dropped him off. Sitting ducks.

On a chilly evening in the fall, Corinne and I pulled up to Bill's modest home, yet another charming cottage near downtown. We wore ski masks and gripped a large trash bag. As Corinne pulled over, I snuck out the passenger door with the trash bag, ran up to his doorstep, and with fumbling hands, crammed his tacky plastic yard ducks into the bag.

We peeled out, laughing into each other's faces, surprised at our bravery and wondering what we would do with our newfound fowl.

"We could make a show of them," I suggested. "Arrange them as a centerpiece in Old Town Square."

Corinne shook her head. "That would last two seconds before someone stole them."

"Plus, it's kind of a waste," I mused. "This is hard work we're doing. We should be getting something out of it."

"True!" she said, pointing to the sky. "And that thing should be beer!"

"Beer!" we yelled. "Beer!"

We composed a ransom note, serial killer-style, with cut-out magazine letters. Our ransom? No less than one (1) six-pack of Fat Tire beer. Sure, we could get greedy and request more. But we didn't want to come out asking for the stars and the moon, lest he laugh it off. How much can plastic yard ducks be worth? Plus, there was something funny about the ratio of effort we were putting into this as compared to the meager payout.

We did have the sense to request Fat Tire, as a treat; we typically only drank Pabst Blue Ribbon. Fat

Tire was a delicacy we had rarely had the pleasure of imbibing. This luxury beer, we stated in our ransom note, was to be delivered in the alley behind the parking garage on Friday at 7:00 p.m. If and when said luxury beer was in our greedy hands, Bill would see his beloved yard candy again.

Friday at 7:00 p.m. arrived and we were nearly jumping out of our skin. We parked at the top of the garage so we could peek over the edge of the concrete and see if Bill pulled up to the alley. At 7:00 p.m. sharp, Bill's truck pulled in.

"Shut up, shut up, it's him!" Corinne yell-whispered. From our aerial view, we watched Bill's ant-sized personage get out and leave something, then drive off. Corinne and I were dancing in our flip-flops in anticipation, but attempting to stay silent, all open-cheering mouths with no sound coming out. We got our shit together, then looked at each other and nodded once. "Let's roll."

We pulled our masks down and drove to the alley in her Camry. Bill didn't even know Corinne at all, and thus wouldn't recognize her car. Sure enough, when we reached the bottom, a tasty six-pack of Fat Tire beer gleamed like a beacon. Luxury of all luxuries. I darted out to grab it, making sure to keep my face covered and slouch in case he was watching. My urge to embellish stories causes me to imagine us going on to down frothy beers, fountain-style, with great merriment. But I don't remember drinking it at all. It really is the journey that counts.

Dropping off the kidnapping victims was the hardest part. We knew that Bill would have to be watching. But we knew that it was time for his plastic bird babies to go home. We would make good on our end of the deal.

Corinne pulled recklessly up to Bill's yard and screeched to a halt. She was hamming it up, I could tell. We felt like we were criminals in a movie. I took a deep breath, my mask down around my face, and ran through his yard with high knees like I was being chased by rabid bunnies. I threw the trash bag of plastic fowl at his door, clattering the glass, and lunged back into Corinne's car as we peeled out.

We thought the best part of our prank was the prank itself. But truly, the best part of the prank was going to work every day and sitting next to Bill. Neither of us ever acknowledged the prank for the entirety of my job. I couldn't sit next to him without smiling at him sideways. He probably thought I was a psychopath. If he knew it was me, he was an even better prankster than I was at hiding it.

SOUNDTRACK
"DANCE SONG '97"
by Sleater-Kinney

ADOLESCENCE HELD a strange dichotomy for me, two worlds existing at once: the innocence of a fairly typical

youth, scored by the dark and adult world of old rock stars ringing me up. It was also a weird dichotomy of sexuality; while the teenagers surrounding us provided very little in the way of romance, sexual opportunity flowed freely.

At age sixteen, I had entered a world where the sexual landscape was rocky, chaotic, and difficult to find footing, but very interesting, all the same. Standing at a party where I didn't know anyone, I sensed two other girls who didn't know anyone either and we conglomerated in the center together. We were all very friendly, not the shy kind of loners, and as we joked around, somehow the conversation quickly turned sexual. The two girls—one blonde and the ideal of visual perfection, and the other adorable and British—decided it would be a good idea to have a lesbian threesome upstairs. We had been talking for five minutes. I knew this was definitely someone, somewhere's fantasy, but it wasn't mine; I nervously declined. From what I saw, the two of them did indeed go upstairs for their laid-back lesbian tryst.

It felt like a porn had just happened to me, and I had failed to meet the absurdity of the moment. It made me think that if life had a scriptwriter, he'd be immediately fired. They'd say he was audacious, baffling, guilty of writing crimes worse than porn plots. Little did I know, such an easy sexual world would seal itself away by the time I was mature enough to navigate it. It was only available to the young, vulnerable, or childless.

But this easy-sleazy world also made Ezra's sweet,

old-fashioned courtship feel adorable, alluring, and less threatening. He was from a totally different generation.

One afternoon, the phone rang, and I heard my mother pick up. I was walking up the stairs from my basement bedroom when I heard her panicked voice, positively shaking. "I don't know who you think you are ..."

My Catholic mother had never spoken to anyone like this in her entire life. I had told her about the Flames in the past; hell, I had practically bragged about them. There were certain things so sacred, like fame, that I believed in my soul that they transgressed laws of nature and parental rules. But hearing the rage in my mother's voice now, I had one major guess who it was that she was talking to. And although I blocked these feelings at the time, looking back I can feel how stressful it had been for her to see her teenage daughter groomed by an older man.

"I don't know you who you think you are," she continued again, "but my daughter is fifteen years old. Stay away from her ... or I'll kill you."

I've never heard my mother say anything remotely this badass, before or ever since. Of course, I couldn't appreciate it at the time—even though modern-day Gogo is cheering for Mom.

There were multiple levels of shock leveling teenage Gogo from every side, with this exchange. There was the shock of getting busted by my mother, who, despite my honesty with her about Ezra, still wouldn't be happy to know we were in contact. Most

acutely, there was the humiliation of this rock star talking to my mother on the phone and finding out I was only fifteen. There were multiple levels of shame here: the fact that I had a parent, the fact that I lived with a parent, the fact that my parent may or may not be cool in his estimation, the fact that my parent had literally threatened to murder him. It had all happened so quickly.

It reminded me of the time Kitty and I were in her backyard with her hot older brother, Blake, and his friend; both were college snowboarders. We were all soaring-drunk and smoking in the backyard when Blake's friend wandered a foot or two from us to take a leak—close enough to be impolite, but, later, we were glad for the view. I've never seen anything like it in my life.

In the span of a microsecond, blue light silently shot up from the ground and through the darkness, in an ambitious arc to his zipper. Then, the college snowboarder jiggled like a flipperty fish was caught in his neck collar. Then, he was doubled over and hollering for a very, very long time.

It took us a moment of bafflement to realize that he had unknowingly relieved himself on an electrical socket.

Blake was laughing through tears, repeating like a mantra, "You electrocuted your ween, man! You electrocuted your ween! You electrocuted your ween, man! You electrocuted your ween!" His face, seizing with laughter, and those particular words, are imprinted

into my memory like an ad slogan over a deranged Keyboard Cat remix. And I learned an important lesson that day: always look down before you pee.

Electric urination aside, this particular gotcha moment for me was just as sudden and sobering a shock to my system. Ezra understandably cooled off for a while. It was only an occasional correspondence, anyway.

After my eighteenth birthday, it was me who got back in touch with him. Since our relationship had stayed innocent for so long, I figured he was like a buddy I could just ring up for a fun party. I was like a Hollywood cool person, calling up one of my famous friends. It was no big deal.

This time, when Ezra came to town, I picked him up in my own car. Before the show, he asked if we could buy a gag gift for Dean: A Barbie Doll. Apparently, Dean was complaining that, as the head of the band, he never got to hook up with any girls because if he makes eyes at one girl during a show, all the other girls are jealous. He hadn't been laid in ages. This Barbie Doll, explained Ezra, would be his woman for the night. Oh, rock star humor.

We stopped at Thai Pepper for dinner, the restaurant with the pay phone outside where I often called my parents when I was up to no good. Lying about my whereabouts, answering their multiple pages. As we were being seated by the hostess, Ezra and I immediately came face-to-face with my parents' good friends, who were leaving. A nice, down-to-earth couple who

taught alongside my mother in the language department at the college. If they were your typical Scotch Pines squares, I wouldn't have felt so deeply ashamed. But they were worldly and down-to-earth. I liked them. Still, they were wholesome enough to be scandalized by their friend's blue-haired teen on a date with a purple-haired 50-something rock star. They were so cool, I wasn't even sure they'd tell my parents. (They did, I found out later.) But because of my discomfort, we fled without eating.

We got to the show, soundcheck, then the Starlite, packed with people as always. I was still smarting from the shame of dinner, awkward and alone. This time my friends hadn't joined me, no one was available. This backstage party felt defeated. But when the show began, I found myself alone in the room with Dean.

Alone in a room with Dean. Backstage at the Starlite can hardly be called backstage; it's practically a walk-in closet with lighting too bright for rock and roll. There are two folding chairs facing each other. Dean sits in one, in the corner, and I am in another, facing him, not too far from him because the room is so tiny. As you'll remember, each Flames show begins with the band playing on stage without him, James Brown-style, so Dean can be mic'd up from backstage and begin playing, unseen by the crowd, for full dramatic effect. Alone in a room with Dean when he begins playing those first legendary notes, the notes that make the crowd ignite, but all I can see in front of me is one man playing the guitar. Like a trick of the

eye when the moving cars around you give the illusion that you're also moving. I'm the only one in the world who is here to witness a total eclipse. They can hear it, but they can't see it. I can see it, but I can't see their cheering. I can feel the stillness, I'm afraid to breathe or this moment will slip away. My doubts about whether I should be here are shattered.

There's a saying that God doesn't give us anything we can't handle. And while I envy the people who can believe it, this couldn't be further from the truth. The truth is, if God exists, he's an uncaring dick and we are staggeringly, ridiculously out of our skill set, wandering in the wrong part of town with our wallets hanging out. We're a handful of ants lucky enough to be clinging to a rock hurtling through deep space past alien planets we'll never understand. If we ever discover the truth about our existence, it will be unfathomable, something we couldn't have ever dreamed up. Something we don't even have the vocabulary to describe.

We know more than your average mammal, but that knowledge carries zero power; we still don't know what to do with it, and we still die like everything else.

What makes us special is that we live our lives, hopefully, contentedly, and even mundanely, despite the knowledge that we are clearly out of our league. We're so fucking audacious. If we were processing the world correctly, it would be a state of constant bewilderment. Just watch a baby process the first water droplets that hit her hand. The human mind isn't

capable of constant bewilderment. We'd go mad, we'd get eaten by the tiger as we gaze up, rapt, just as it's charging us. Perhaps those who believe humans can handle all that "God" throws at us are talking about our ability to turn the miraculous into the mundane. Our brains adapt by normalizing everything. It's miraculous that we can get comfortable enough to love, have sex, and crack jokes while we're hurtling through the staggering unknowable.

Or that we can stand up, awestruck, and watch the rest of the show without falling over. Some moments, you feel lucky to be there, is all I'm saying. And despite whatever drama or mistreatment I may have experienced as a teen, moments like these transcended them. They reminded me, life was good.

SOUNDTRACK "SHADOWPLAY" by Joy Division

AFTER THE SHOW, I walked Ezra back to his hotel room, him walking behind me. Soon, I turned around and realized I was in the room with him, the door shut. I hadn't meant to be so bold as to walk into his hotel room, alone with him.

An awkward silence hovered between us as we figured out what we were going to do. After a long beat, he finally told me he'd better get to sleep. My

breath tumbled out with relief, abbreviated just as quickly as he leaned over and kissed me. Just once, a very long but PG-rated kiss. Like every other aspect of our relationship, it was innocent and sweet, but also a little bit sinister. After he kissed me, he leaned back, his eyes closed, a sweet smile spreading over his lips, and he shuddered in ecstasy. It was a long shudder, like he was savoring it.

To this day, I'm not sure how to process my relationship with the Flames. At the time, Corinne and I felt pretty proud of ourselves, gaining entry into a forbidden land without having to pay the toll that women so often have to pay. We were cohorts in our shenanigans, and we made a choice to hang out with them, even lying about our age, just because we wanted to have fun. Some might accuse us of "leading them on," but I don't believe anyone owes anyone sex, just for being there. We kept it friendly and never once gave them any indication we wanted sex.

Perhaps the band members developed a fondness for us, but had some doubts about our true age, and thus kept us at arm's length. I really want to believe that, and, on some days, I do. Maybe they just wanted to help some young crazy teenage girls have the time of their lives. Or perhaps the perpetual youth of life on the road, and getting whatever you wanted, would make anyone's tastes skew young. Perhaps Ezra was just a total creep. A creep who managed to, for the most part, control himself.

People are often quick to point out when an older

man is victimizing a younger woman, but sometimes this does injustice to the younger woman, who feels the strength of her own agency. It's easy to feel my own complicity in the matter.

And yet, can a 15-year-old truly be held accountable for her bad choices? And the fact remains that even if we were the age we said we were, we were still too young for them to be attracted to us. As a 35-year-old, I can't even look at a 21-year-old sexually.

The cycle never ends.

Ultimately, I think the truth lands somewhere in a grey area, one that many women, girls, boys, men, victims, and in-betweens are frighteningly aware of. The place where sex boundaries collide. It's a complex place with too many conflicting emotions to process. Exhilaration, excitement, sex. Shame, guilt, violation. Grossness. Greatness.[16]

SOUNDTRACK "#1 CRUSH" by Garbage

16 Grossness Greatness: A French electro-sleaze duo borrowing from the "disgusting beauty" of Yves Tumor and adding a vintage Serge Gainsbourg-ian twist.

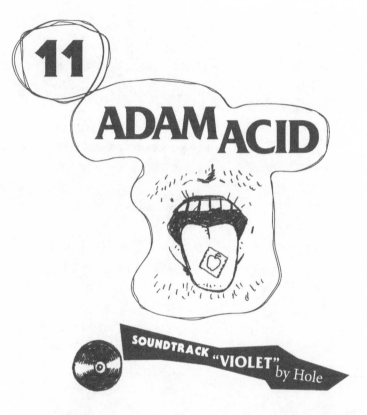

11

ADAM ACID

SOUNDTRACK "VIOLET" by Hole

I DON'T REGRET ANYTHING enough that I'd erase it from my life. But there are moments I'd choose to rewrite, just a little. Finesse it like a PR pro. Portray our protagonists in cool leather jackets, surrounded by glory guitars.[17] Pretend we were smarter, worthier, more badass and punk rock than we really are. Pretend

17 Glory Guitars: A thunderous noise-rock duo where all music videos feature the furious frontwoman flanked by flames. Just like Sleigh Bells, I guess.

the music scoring my youth was always epic, *Pitchfork*-worthy, never ska.

I might set out to write a punk rock memoir forged in badassery, frenetic and braggadocios, flanked in flames. I might instead be forced to reckon with a past that features me being the kindling that's going down in flames.

There have been far too many fires to ignore. This urge to gloss over, to rewrite, to marinate in teen nostalgia comes from the same heartbroken urge to ditch algebra class. It's rewriting my own story. Turning life into art, highlighting the good parts, and elevating the heartbreak so the pain wasn't for nothing.

If I could edit my life, I'd erase the hostile glares coming from the adults in my neighborhood; I'd replace them with secret smiles of understanding, the way I twinkle each time I see a crusty teenage punk because I have a degenerate heart. Maybe I want to blast away the toxic masculinity that ruled my community; maybe I'll just take a power drill to that one. I'll take a chainsaw to the uncaring and conservative mentality based in fear that ruled my town. Just sweep it all away and pretend that different people were welcomed and celebrated.

But there are some things so pathetic I can't seem to glorify, rectify, or spin. And that's where Adam Acid comes in.

I was a wild girl. And when you're a girl who's free, the grand old hand of the Patriarchy always reaches its hoary, shuddering finger across the ultimate divide to

scoot you back into your place. It's never the men in power who do the dirty work. It's the ruined boys.

As a young girl, I used to smile at men walking down the street. I smiled at everyone. I thought, why don't men deserve our smiles? It was never a come-hither smile. It was a curt nod, like two men would exchange as they passed one another on the street. "Morning," I'd say.

It always ended in glares, awkward avoidance, or catcalls. Maybe they were afraid to smile at me, lest someone think ill of their intentions. Maybe I'm just really bad at smiling like a normal person, I thought. Maybe I was really smiling like Harley Quinn. Maybe in their minds, I was coming on to them. Maybe they didn't think me worthy to address them at their level.

I don't often smile at men on the street anymore, even though I want to. I miss my teenage innocence. It's too good for the rest of the world.

Teenage emotions have a distinctive pretension. They're like the fear you get from watching a scary movie. At the time, they feel real; looking back now, I know that my teenage emotions occurred above the invisible safety net of my parents.

Later in life as a young mother, I'm constantly monitoring my emotional state; I desperately want to avoid postpartum depression, because I need to be at my best to care for my children. In the cold world of responsibility, depression equals danger.

When I was a teenager, however, I relished a bout of adolescent melancholia. I loved listening to The Cure

and thinking about tragic scenarios. Tears streaming down my face, I thought about what I would say at each and every one of my friends' funerals, should they have the tragic misfortune to leave this earth. I gazed wistfully out the car window, wishing I knew a love as heartrending as the Moody Blues' "Nights in White Satin." I would light candles, and simply wilt into a hot bath.

Adam Acid was tragic. He was an orphan that we took into our arms. His slicked black hair parted down the center in '90s style, he perfectly looked his part: the skeezy acid dealer with the transparent blue eyes. Despite his sadness, he had a smile that lit up from within, something magnetic.

A guidance counselor would tell me not to surround myself with such tragic creatures. I would tell that guidance counselor to fuck off—even today, after all that's happened. I was raised to show compassion for the people that I encounter, even if they're tragic. Especially because they're tragic. My mother taught me that. I cling to openness with blind pride because I want love to win. I still stubbornly wish that love had won. I wish I hadn't been the one to prove to my mother that, in this world, love loses. That doesn't mean it's my fault. And that doesn't mean I will ever stop loving.

The only thing cooler than lighting a cigarette with no pretense, in the innocent nihilism of Teenageland, is knowing someone who died. Preferably not a grandparent, nothing banal and natural like that. It has to be

a former lover, or someone really tragic.

Then, there comes a time when you actually know someone who died, and it's not cool anymore.

There comes a time in everyone's life when their emotions become real. Unprotected. Alone. Quivering in the abyss for all to see. Will anyone help?

(They never can.)

There came a time when our girl gang began speaking in hushed tones about something awful that had happened to Adam. His mother had died. I remember his reddened face, and the feeling of wanting to stand between him and the world that was collapsing in on him. We tried to be there, in our blurry teenage way. We probably just offered him vodka.

We were at a party a week after our trip to the forest. Adam had been getting everyone blitzed on margaritas. I was a pile of blurry jam.

"Let's go outside and smoke a joint," he suggested, smiling at me.

Today, if someone had Donald Trumped me a week ago, and then asked me to smoke a joint with them, alone, I would've known what was coming. At age fifteen, I could've never dreamed up what he was about to do.

We sat down, started smoking. Then his tongue was in my mouth, I was pushed down, something was spearing me, hot between my thighs. I didn't know how but it suddenly occurred to me that Adam was inside of me, searing pain parting my flesh as he sawed away. I said, "No," I said, "no," I said, "NO," he held me

down and finished anyway. My mind has protected me from memories surrounding this incident—the setting (whose house were we at?), what I wore, the courtroom where I faced my rapist on the stand—but not the incident itself. Not the suffocating rage that feels like pounding your fists against packed earth forever.

Adam Acid was quick and slick, I'll give him that. I was so confused by what was happening, not once did I ever think to kick him in the balls. On my bad days, I think, Adam isn't worth kicking into a gutter. I don't want to get my shoes dirty. On my good days, I want to hug him, like a mother. The mother he lost. Everyone is capable of everything.

A rapist hopes to commit an act of violence and separation, to lash out at the ugly world, but the truth is he's desperately reaching out for love and bonding. He thinks he's depositing his pain somewhere neat and quiet, and locking it up forever. The cruelest part isn't the act itself, but the role he's relegating his victim to—a box. Somewhere disposable to deposit his pain. But rapists never think they might be depositing their pain into a writer. A writer's words will never go away.

Adam and his clear eyes haunt me with his steady gaze, his unrelenting eye contact. Victims are only subjective; they only exist in the eyes of others. If the others don't value us, we flicker out of existence, disappear into someone else. "The original crevasse." Is that what our crevasses are? Somewhere to disappear? Somewhere to assert someone else's existence?

I saw our mutual friends at school the next day,

Kylan and Ben. I was profoundly hung over.

"I think I might've gotten too drunk and ... hooked up with Adam yesterday," I muttered. I thought this was what a drunken hookup felt like. Got fucked up and fucked someone you didn't want to fuck? Welcome to the fucking world.

Once the rape went public, my fate was sealed in the eyes of those friends as a lying accuser.

When you're an orchestrator, everything feels crystal fucking clear. When you're the recipient charged with making sense of the onslaught of timpani drum solos, trumpet bleats, and jazz notes, it's a lot harder to make sense of things. Every day, women are charged with the confounding act of interpreting the diverse array of gropes, looks, and intentions from men, gauging our desires in reaction to theirs, which are often as loud and ungraceful as they are baffling. It's hard to find my own sexuality in here, over the roar of men's.

One afternoon, Lexi and an acquaintance named Stacy came to my house with heaviness in their eyes, like they had both been crying. Since I didn't know Stacy very well, I couldn't imagine what she would feel comfortable enough to cry about in front of me. They sat me down on my bed, and then shut the door to my bedroom. Amidst posters of my dead boyfriend, they told me that Adam had raped them both. Lexi told me that they were having sex together, but that he had also raped her, on more than one occasion. I felt so sad for her, having to endure what I endured just once,

and having it done by someone she loved.

"So, I just wanted to ask you," Lexi said, as a mere formality, as tears were already streaming down my face, "was your hookup with Adam consensual?"

Sisterhood. Lexi knew me well enough to dismiss the rumors that her friend Gogo had drunkenly fucked her boyfriend.

We didn't cry for that long, sitting in my bedroom. Instead, we decided to press charges. I probably would've never had the courage to do it alone. Then, we stood up, opened the door, called my parents over, and, at the age of fifteen, I broke their hearts.

SOUNDTRACK "RAPIST" by The Exploited

THERE'S A POLISH PROVERB, "Where the devil himself can't go, he sends a woman." Adam was the devil and he sent me there. He sent Lexi and Stacy as well. To this day, we are holding his pain, and no one else—I mean, no one—wants to hear about it. If they've been raped, they can't bear to hear about it. If they love us enough to want to take our pain, it is by proxy, too painful for them to bear. If they don't love us, there's no way they want to go near it. People get all oily and avoidant whenever you talk about rape.

Rape, rape, rape. Rape, rape, rape.

The Williams sisters dealt with my talking about

it as much as they could, but they could only handle so much. The Williams parents hugged me and continued to welcome me into their home, but they regarded me with weary sadness. For some stupid reason, I always wanted my brother Gabriel to beat the shit out of Adam, or at least threaten it. He was too sad. He told me later that it was too painful for him to think about. He had failed me, and I had failed him—after all, he had warned me that this could happen to me, and that was before I started getting wasted.

As a teen, I looked around at my classmates and wondered how anyone could talk about the fucking weather. Slinking around school in my heavy eyeliner, I felt constantly on the brink of calamity, I was baffled by everyone's calm demeanor when such travesties could exist.

At night, I dreamed of my neighborhood filled with rows upon rows of dead nuns, lying in the streets with black lace over their faces. People were cheerfully carrying them on stretchers and moving them to different areas as if they were landscaping.

What's the opposite of rape? It's not chastity; it's lust. I thought I'd be riddled with STDs, I thought I'd never have an orgasm again, I thought I'd never be able to have children. Each orgasm melted every last trace of him from me. It actually feels like a miracle, but there is not a cell left of Adam Acid in my body. I wonder if he has been able to erase me from his mind.

Recently, while I was doing the dishes with my mother, I asked her about my court case against Adam.

Dr. Christine Blasey Ford had just demonstrated pure heroism in front of the entire country.

"I'm sorry, honey. I blacked out a lot of that period of our lives," she said.

I blacked it out, too. The most heroic moment of my life, a hole surrounded by the bland swiss cheese of much less important experiences.

At the end of the court trial, I was approached by my kind lawyer, Fabian, who took on the case pro bono. Through the throng of well-meaning people who didn't understand me, and hostile authorities who didn't believe me, people like Fabian carried me through.

Fabian explained to me in a whisper that the judge was sentencing Adam to only 45 days in jail because of a loophole, which allowed the DA to charge him as a minor because he had turned eighteen in the midst of his sexual assault spree. It could've gone either way. They could've charged him as an adult since the crimes were, by nature, violent. But they decided not to. It was specifically noted that the DA had considered three girls coming forward to be suspect, like we were all doing this together on a lark. Like how we gals enjoy going to the bathroom together.

I was told that we could start over and spend another year seeking a better sentence, but who knew what that outcome would be.

I ran sobbing to the back the courtroom, covering my eyes. I had mined my personal trauma in front of stoic police and detectives, doctors with speculums, lawyers and judges, over and over again for a

year. It had all been for nothing. Adam would go on to spend his meager sentence palling around in jail with a mutual friend of ours who had received more time than Adam for possessing a large quantity of mushrooms.

At the back of the courtroom, my small crowd of family and supporters enveloped me. It would've made for a dramatic TV moment; I felt more loved than I had in my entire life, and, at the very same time, thrown away.

This moment annihilated me because what I had sensed intuitively was official: to the authority figures in my community—the teachers and judges and district attorneys and anyone chosen by the people to make the important decisions—I didn't matter.

I decided I didn't want to rehash it anymore. I told the judge all I wanted was a letter of apology from Adam.

Surprise of all surprises, I never received his letter.

To this day, I don't know what I want from Adam. All I know is that it feels natural to villainize him, like stepping into a grooved mold where I've been time and time again. I know I don't want him to be able to move past this.

What is the opposite of a letter of apology from Adam Acid? This, from me.

SOUNDTRACK
"DEAD MEN DON'T RAPE"
by 7 Year Bitch

12 BATHROOM GRAFFITI BEAU

SOUNDTRACK
"LONDON DUNGEON"
by Misfits

IF YOU'RE THE WRONG KIND of guy, the best kind of marketing to attract a bad kind of girl is scrawling your name in bathroom graffiti.

I was a seasoned sixteen years old, and Adam Acid had thrown me over the precipice where the fun outlaw deviance of morning vodka turned bleak. My parents considered me to be an alcoholic, so, I figured, might as well get shit-canned on a Tuesday.

My Girl Gang's car rides looked far different than

the Mitsubishi Blondes.[18] In lieu of cruising towards some productive destination like my peers, or even *talking* about the trauma that Adam Acid bestowed upon us, my buddies and I drank in the car together. Of all places. Bleak pow-wows in the parked Camry with nothing but us, plain shots of vodka, and the eerie vapor of our breath. I've spent half a lifetime searching for that level of commiseration our little addict's circle shared. It was our warm, bland vignette against the sharp world. Hiding vodka everywhere, the plastic bottles multiplying kaleidoscopically. I was convinced we would never lead normal lives, glassy-eyed at the beginning of the school day, taking shots in the locker room, the sharp tang of vodka on our breath.

Alcohol poisoning had become a standard occurrence in our crew. We took shots for hours, writing down our toasts, called Shot Lists, each one more nonsensical as the night wore on. 10 shots. 20 shots. Fumbling through a psychic glory hole, taking a chance on finding Nirvana. It was our art piece, a transmission from that mysterious place where memory is gone but you keep existing, walking around, and saying stupid shit. Hoping to find meaning. Maybe I peered through some hole in the fabric of life when I was blacked out. Maybe there is something we can learn from this

18 Mitsubishi Blondes: A dark rock trio that sounds like a marriage of Blonde Redhead, Smashing Pumpkins, Cocteau Twins, a leaky sink faucet, and other beautiful forms of misery.

astounding new space. Or, at least, I'll say something so fucking stupid that we will laugh when we read it the next day. I am not a wastoid, I am a traveler of psychic planes.

After one bender, I found myself utterly trapped in my own bedroom. It was pitch black and the door was closed so tightly, I couldn't see a single crack of light. I was so drunk I had no idea where in the room I had passed out. I stood up and started fumbling around in the abyss, feeling for anything. It took me a few solid minutes to find a wall, any wall; from there, I kept feeling towards where I thought the door would be, but I was totally unable to orient myself. I'm not sure how long the whole ordeal took, but it felt like a hell-trap eternity. Trapped by my own damn stupidity.

Yet another night, Jones and I got annihilated at a sports bar that never IDed. We even befriended a rowdy crew of sports fans, because the magic of alcohol crosses all societal boundaries. "What am I even doing here?" I wondered into my seventh beer. I fucking hate sports. I can't even stomach sports bars. I can't even stand the color of the wood in the bar.

Cherry wood. Jack Johnson. Khaki pants. Old Navy. All the things to choose or not choose in the beginning of *Trainspotting*. These harmless but banal things fill a technicolor weirdo like me with intolerable discomfort.

At the end of the night, Jones and I passed out together in his twin bed, him totally nude for whatever reason, and I awoke to the splattering sounds of him

retching repeatedly into the pillow. I was too drunk to do anything helpful, but just climbed to the floor and passed out again.

By this point in my life, I had learned a few tricks. I learned that feelings can be subjectively altered, just like adrenaline can be exhilarating on a rollercoaster, and yet terrifying when plummeting to your death. Similarly, I found that it helped to convince yourself you're doing just fine when you're passing out drunk with a bad case of the spins. Just let go and swirl into the toilet bowl of unconsciousness, pretending it's a fun ride. Wheee.

I'd pass out and wake up in the late morning, feeling like someone was actively lancing my brain. I'd vaguely perceive my mother humming in the kitchen like a culinary songbird, creating meals and joy for loved ones, in sharp contrast with my having consumed enough booze to drown a family. My clothes and hair reeked of cigarettes. I stumbled past the reflection of the asshole in the mirror—I looked like Joan Jett had been put through a carwash—and turned on the television, its afternoon commercials for ambulance-chasers and GED programs, yet another direct reflection of the type of person in front of it.

I remember, just once, dragging a kitchen knife across my skin, my reflection stark in the large double mirrors of my bathroom in the black smudge and silver light of night. It was the type of knife you chopped garlic with, definitely not sharp enough to do any damage. It just left white indents like I was scratching

a line into dry skin. I wasn't serious. I just wanted an artistic expression for my pain. By this point, I was no stranger to the RAINN hotline; I wanted to vent about my problems more than anyone who actually knew me could bear to listen. I was putting on a dramatic play of pain for the nobody that showed up. At the same time, I'd have told you that things were going just fine.

SOUNDTRACK "MY SHADOW" by Jay Reatard

IT WAS WITHIN THIS sluzzy murk that I finally met my bathroom graffiti beau. My path towards him was set in motion years before at the goth coffee shop, Paris on the Poudre.

From the time that I first started haunting Paris, at age thirteen, this particular bathroom graffiti always stood out to me. Excusing myself from conversation over black coffee and cigarettes, I'd head to the one-person bathroom amidst the deep stench of ashtrays. This particular scrawling was in prime viewing range from the toilet.

In feminine handwriting, it said, "What makes you real?" There was even a little heart drawn next to it. Below it, someone else had scrawled, in answer: "Cameron Starling."

It could've been written by a girl who was in love with Cameron Starling. To me, it seemed like the name

was written by the possessor of the name himself. Taking a starry-eyed girl's philosophic pondering and turning it into a cheeky joke.

It was so mundanely revealing. Bathroom graffiti is the predecessor to the internet. Anonymous ranting, unsubstantiated gossip, talking shit, grasping for the divine, philosophical blathering, ridiculous pseudonyms, this is the stuff of bathroom graffiti. Not polite, plainly written full names.

I never knew whether Cameron Starling was a real person—though I suspected he was—nor did I necessarily care to meet him. Until I did. At that surreal moment, looking at Cameron Starling was like beholding a character who stood up inside of a story and walked off of the page.

Cameron rolled with the Misfits Crew. As their moniker suggested, they only listened to the Misfits. Back in those days, anyone could afford to live in cottages downtown, which is the type of charming home they trashed on the daily. They skated everywhere, wore all black, and took bong rips in the morning. Sean was the outgoing one, and Cameron, the one who intrigued me, was quieter. He didn't seem like the type of person to make self-aggrandizing jokes on bathroom walls. Maybe a snicker here and a smile there, angular jawline and a big-toothed grin. Black hair and tattoos. Not overwhelmingly handsome, but I liked the fact that he looked like someone my parents would hate.

The Misfits wrote "London Dungeon" from a U.K.

slammer in 1979, slapping the beat on the ground of their echoing jail cell. The true story behind the song isn't as epic as Glenn Danzig once claimed it to be. Danzig insisted they were arrested for fighting skinheads. He was sharpening a shard of glass in anticipation of this alleged fight. Bobby Steele maintains the skinheads weren't actually there, but that Danzig was just drunk off his ass. Danzig was arrested for making a drunken scene. Steele got himself arrested on purpose, to join Danzig, because he had no money and nowhere to stay. While the mythology of the arrest falls short, the song itself inhabits a legendary, inimitably dark and whirling soundscape. The type of danger that lures you, rather than scaring you away.

If we remove all qualifying judgments, danger is a sensation that has a bewitching buzz to it.

I listened to the Misfits in those days, but I've never been a lyrics girl. I'm in it for the sounds. If I wanted words, I'd sit down and write them. Which is why it escaped me that I was hanging out with men, eight years my senior, who worshipped the man who wrote these words:

> *Die, die, die my darling*
> *Don't utter a single word*
> *Die, die, die my darling*
> *Just shut your pretty mouth*

> *I'll be seeing you again*
> *I'll be seeing you in Hell*

Don't try to be a baby
Your future's in an oblong box

They were in their mid-twenties. We were sixteen. When you're sixteen, finding a house where you can get shitfaced is like discovering rare counterfeit jewels. It was both thrilling and a little bit scary that the owners might decide to fuck us.

For a 16-year-old, it was a compliment that men so much older were hanging out with us. We prided ourselves on our maturity. We didn't even know how to talk to our typical, school-going peers.

One of our favorite pastimes was parking randomly in the area of town near Colorado State University and party crashing: walking into any old party, typically one thrown by college kids or recent college grads, and charming our way into any conversation. We especially liked it when the party-throwers were kind of square. It was a challenge. Teenagers are sheep in wolf's clothing: they walk and talk like grownups, but they make child-like decisions at an exponential rate in an alarmingly adult world.

We didn't worry why the Misfits Crew weren't hanging out with girls their own age. Or we told ourselves something like, our lifestyle has more in common with the Misfits Crew than any girls their own age. It's a house that makes perfect sense when you're inside of it. Then, you step outside of the house and the windows are on sideways and the doors hang crooked.

So, we partied at the Misfits' house. Through the punk frills of Glenn's crooning, we embodied debauchery. "I ain't no goddamn sonofabitch!"

Corinne and I drank Pabst Blue Ribbon in the cramped Misfits house one afternoon. It was some unmemorable time in the day, a time of the day for erasing, far too early for drinking but far too late to be doing anything productive.

"Hey," Corinne said, flicking her eyebrows once. Corinne had that way of saying "hey" that just laid the groundwork for trouble. The guys were over in the kitchen making themselves drinks, and the blaring music made a curtain for our private conversation. The vibrant flames of her dyed hair emphasized what she was about to say with great, clarifying importance. "I have an idea. Let's make a sex pact."

I didn't know what a sex pact would entail, but I was pretty much in agreement before I answered because I was a teen and the word "sex" was in there.

"A sex pact. I'm intrigued. With whom?"

"So, you know I've been getting over my previous sexual encounter," she began. Corinne had an Adam Acid in her past, too. What girl didn't? "And I know you have an incident you'd like to forget as well," she went on.

I nodded.

"The only way to get over being fucked over is to take control of the dialogue. Let's fuck the Misfits guys. Tonight."

I started to laugh. "Oh, wow. You're fucking

crazy." It was one thing to hang out in this party house and see if the Misfits guys would try to fuck us. It was quite another to reach out and grab potential danger by the literal balls.

"Not crazy. It's taking control of our sexual futures," Corinne corrected me. "It's like a ..." she leaned in and whispered in my ear, so softly I almost couldn't hear it, "... rape rebound."

Rape rebound. If that wasn't already a Sleater-Kinney song, then it surely should be. Rape rebound. It did have a ring to it, in my teenage brain. What kind of women find themselves in our situation? Women who suffered misfortune but remained valiant and brave. Women who won't take punishment from the Patriarchy lying down. Women who won't retreat in failure. It sounded nice, being the ones in a position of power. Making the big-boy decisions in the room.

"Let's do it. I get Sean and you get Cameron." She gestured with her eyes towards the kitchen, and we sat there laughing nervously, looking at each other.

"Be my guest," I said, standing up, "but will you drop me off at my house before you fuck Sean? I have to be home for dinner."

Corinne groaned.

"Come on, it'll only take a second," I pleaded. "You can come back and awaken your sexual desires after you drop me off."

When I walked in the door, my mother was sitting at our round kitchen table alone, the house quiet, and it felt like the scene in the movies where the cop arrives

at the home of some 911 caller and the front door is left horrifically agape.

"Hey," I said, trying to remain casual, despite the rigid space between us. I plopped down at the table across from my mother. Her black bob was particularly perky, and her posture was stiff as a board.

"Where have you been?" my mother demanded. I opened my mouth to lie, but she immediately interrupted, "I know where you've been."

A chill rose through me as if I had stepped in water. Getting busted was not new to me. If my degenerate career reflected decades in America, my fifteenth year would be my hopeful, free-loving Sixties. Then came Adam Acid. The post-Adam period we were in, when I was sixteen, would be my personal Seventies burnout. I was no stranger to detention, grounding, and even school suspension. And yet, this moment sitting around the table with my mom had the potential to be a new low for me. These were truly dark characters I was associating with.

If she really did know where I had been partying, that is. Sometimes, my mother bluffed. Her misses were the result of her trying to glean stories through detective work, and she wasn't that great of a detective. Part of the reason for this is because she was such a good person, she simply couldn't get into the troublemaker's mindset.

I remembered the injustice I felt at being blamed for bad behavior that I hadn't even done, like when my mother told my virginal self that she knew I was

having sex with boys. For that reason, when I knew I was guilty this time, I decided to rally similar levels of indignation to match those other, more innocent times.

"Oh yeah? Tell me exactly where it is that I've been," I seethed.

"I know that you've been hanging out at some … party house," she spat out uncomfortably. It was almost as painful as hearing her curse, which she barely did before I turned eighteen, at which point she began cursing like a head chef. My mom can be a relatable human being, but she does it within the confines of rules. I understood why she clung to rules with a tight, eyes-closed grip; her father was a strict, sometimes terrifying person to live with. It was also how she chose to cope with the chaos of the world, a world which our sensitive demeanors had enhanced difficulty processing. If a crutch is necessary, rules are a better crutch than others. It was the rules themselves that often struck me as arbitrary.

"Gogo, I know that you were partying at some house belonging to older boys," she finished. I certainly didn't rush in to correct her that they were old enough to stop referring to as "boys" at all.

"Jesus, Mom. Which older boys? I'm sure there's an explanation if you just tell me who you're talking about," I began. "Older" could mean one year. I was buying time. I was revving the engine of this bullshit machine; it was about to take off. Surely, I could talk my way out of this.

"You know which boys I'm talking about. You've

been there every day this week."

A feeling the consistency of a tornado was gathering around the base of my neck. "Excuse me? How do you know where I've been every day this week?"

"I have my ways, honey," my mother said, her eyebrows raised. She often said "honey" when she was being tough. I thought it was cute when she tried to be tough. She tried to contain it, but there was a glint of pride peeking from her serious brows and flat cheeks. I sensed she had an actual hand in these cards.

"You're following me now?" The revving of the bullshit machine was now funneling its energy into the rage machine.

"I have my ways," she repeated, shaking her head. She still wasn't showing her hand. I decided she was bluffing. I'd go bold with this one.

"Well, however you're getting your information, it's false. I have no idea what you're talking about." I stared at her, self-satisfied. She shook her head again.

"I know that's not true, honey."

"How?" I pressed. "How do you know it's not true?"

"Don't be mad at me," my mother began. She had this way of saying something pleading in a commanding way. It was more that she was commanding me not to be mad at her.

"Your sister saw you go into that house."

"What? What was Genevieve doing there?" In

one emotional outburst, an admission of guilt. "What the hell is going on?" I raged. Maybe I could steal the moment with anger and confusion.

"Listen," my mother yelled over me. "You haven't exactly been a picnic to parent these days. When you're being unsafe, we have the right to do what's necessary to keep you safe."

"Did you have Genevieve follow me?" I was starting to get a sick feeling. I couldn't place it. Like the smell of the cigarette butts in nearly empty bottles of beer that we'd keep on the same table as our beers. Something strong and hideous and potentially worse, just hiding in plain sight.

"I did," she said; in that instant, it felt like the time I accidentally drank the ashtray bottle. A shock of pure repulsion.

Underneath it all, though, a reluctant appreciation. This wasn't just cute-tough. This was actually, really, impressively tough.

"… which is how I know!" she began talking more loudly, "that you've been hanging out with these older boys!"

"Are you kidding me?" I roared. "Why would Genevieve ever say yes to that?"

"She didn't have much choice because I am her mother." She enunciated *her mother*.

She might be that salt-of-the-earth Catholic, but Mama's got some tricks up her sleeve. Moments like these put in stark perspective just how batshit crazy both parties were willing to get. Mom, enlisting spies

to follow her punk daughter around suburban Fort Collins. I imagine her shoving crumpled bills into my sister Genevieve's hand. Pressing her for details in the hallway. What a gloriously seedy transaction between mother and daughter. My mother might be innocent, but she also might not die in the Zombie Apocalypse as quickly as previously thought.

My sister Genevieve, whom I thought to be my cohort in shenanigans. Following me. When I was sixteen. I was ruined by the betrayal of it all.

> *I don't want to be here in your London Dungeon*
> *I don't want to be here in your British hell*
> *Ain't no mystery why I'm in misery in Hell*
> *Here's hoping you're swell*

Passive-aggressive isn't my natural style, but it's the only thing you've got when you're out of control. And when my parents and I got into fights, I typically went the passive-aggressive route. I'd listen to their lecturing, I'd nod my head, I'd wait till they fell asleep, and then I'd sneak out.

When my mom announced the betrayal of paying my sister to spy on me, I'd had enough of that passive-aggressive bullshit. The world as I knew it was crashing down on me like an old Western set. Nothing mattered anymore.

I stood up, shoved the table away from me, and walked out the door towards Old Town. And a small part of me knew, but couldn't really think through, that

I was walking towards Fuck Night at the Misfits Pad.[19]

SOUNDTRACK
"SONIC REDUCER"
by Dead Boys

BACK IN THE TIME when there were no text messages, showing up unannounced at a party was the closest thing to feeling famous. Plunging into a sea of open arms. It was late, and Corinne welcomed me with slurry enthusiasm. She had a special glint of mischief in her eye.

I pounded beers with the intensified freedom of a lack of curfew, believing myself to be a proper runaway. The heavy voice of my parents and family removed, I indulged in the freedom of it, and all else—reason, conscience—melted away. My actions had zero consequences in this runaway realm.

SOUNDTRACK
"WHEN THE LIGHTS COME ON"
by IDLES

19 Fuck Night at the Misfits Pad: A short art film in which a naked man throws various textures of food at walls while "Last Caress" plays.

THE HOURS WERE LONG and merry, and the morning approached. We reached that point in the night where we all knew what was coming. Corinne and Sean began ambling up to Sean's room, and Corinne turned and beamed at me as she walked away. "Have a good night, guys." The way she said it, Cameron and I locked eyes like heavy magnets, knowing exactly what we were all going to do.

What makes you real? That feeling of walking into a room with someone you know you're about to fuck.

If you could bottle that feeling, what qualities would that serum possess? The air is packed heavy, holding all your breath inside your chest. The moment before the breath comes tumbling out stretches out eternally. Those qualities might change depending on the person and context. Walking into a room with my husband, overarching flecks of gold in a field of yellow, lovely purrs. When I was magnetically attracted to someone I shouldn't be, it was different: throbbing and gravitational, heavy and unrelenting. When you just recently lost your virginity in a bad way, and now you're about to fuck a 24-year-old, it's a flat level of terrifying. But the strangest part about it is that it's still beckoning, all the same.

I wasn't really attracted to Cameron; I wanted to try him like a drug. I wanted something risky. Curiosity, adventure, and the power of guerrilla marketing—his name was carved into my psyche, after all. Cameron reminded me of the yellow plastic swan necklace I found at the Eiffel Tower, my Lucky Swan. I carried it

around with me, thread on a piece of yarn, for years—
it didn't matter that it was ugly and plastic. There was
a superstitious, blind teenage importance to that swan.
If it had wanted to fuck me, I'd have fucked the plastic
swan. It didn't matter that if Cameron hadn't wanted
me, I'd have walked away.

Rule of thumb: don't have sex with anyone you're
not willing to seduce.

SOUNDTRACK
"MEN O MEAT"
by The Meatmen

IN MY MID-TWENTIES, I experienced an occurrence
so memorable that it warranted its own title: "The
Meat Handshake." Every once in a great while, some-
thing happens that's so bizarre that it lurks on in
your psyche, a Proustian wormhole between past and
present. The slick and visceral memory of it flashes
through your nerves at similarly awkward moments, a
sensory reminder of how strange life can be.

I had interviewed a Denver band, The Swayback,
for a local magazine. We met at their practice space,
which was located in the RiNo district of art studios
and warehouses, long before it became hip. Their
nearly empty warehouse was stippled with grey
twilight and spattered in white paint, a mannequin
hovering in a corner. In this sonic environment, I was a

one-woman audience while they practiced their cover of the Misfits' "London Dungeon."

I'd seen The Swayback perform their cover of "London Dungeon" at multiple shows, and it was always good. But here in their empty warehouse, it was glorious—exactly how and where the song was meant to be performed. The vibration of the bass lines cut through me, ricocheting all around me, the sensory feedback resplendently reverberant. As the sole audience member, I was rich with stimuli, at the apex of sound. Filtered through my synesthesia, the song came at me in big waves, round and sharply glinting like record grooves.

We smoked in the alley after. Night had cloaked Denver in a dusty black glow.

A man with a tattered appearance shuffled up to us in the parking lot.

"Would you like to buy any meat?" he asked, casually, as if it were a normal question to ask in an alley. Believe it or not, I had been offered meat on the street before. I lived off of East Colfax for a while, where I had also experienced the daily depravity of riding the 15 bus, and, despite my modest attire, been mistaken for a sex worker on multiple occasions. I was no stranger to the offering up of shady deals that dark Denver so easily sleazed.

On more than one occasion, some grey-complexioned man would drive up in an unmarked white van, knock on our door, and ask cheerfully if we'd like to buy any fresh meat. We always declined with a feigned

politeness that matched his. We called this vibrantly strange occurrence, "the meat wagon."

I thought maybe this was going to be that familiar old meat wagon scenario. I had no idea it could get even seedier; that was, until the mumbling Meat Man thrust his hands up in the air, clutching fistfuls of raw ground beef. There was no wagon, just meat and hands.

Most people think much higher of their outspoken nature when stories are hypothetical or being recalled. What we don't understand is just how much, in the moment, we all want to be agreeable. How, even confronted with deranged shit, we're cordial and amenable where we imagine we'd be reactionary. And in this scenario, none of us knew how to respond. We declined politely and stared at the asphalt.

"I think we're good on meat, man. Thanks, though."

But the beef peddler was lingering.

"Nice night," he began, looking around, suddenly appearing really lonely standing in the parking lot. "I've been out here a while."

I don't know about The Swayback, but I simultaneously felt sorry for Meat Man and also wanted him to go bye-bye. I was desperately looking for an out. Trying to find closure in the conversation, I said, "Well, it's been great chatting," and I absentmindedly reached out, and I shook his meaty hand.

I shook his meaty hand.

The band winced in awkward laughter; it was

like they noticed I was gripping raw meat before I did. Hot shame burned my face and I stuttered, finally managing to scare Meat Man away with good old-fashioned awkwardness. There was no soap in the practice space, so I poured vodka over my hand.

Sometimes, my tendency to go with the flow can get me in unsavory situations. On the flip side, this quality exposes me to beautifully dark places, places that people with more agency might never experience, behind a warehouse with a band I had just met. The meat handshake was as viscous as you might imagine. But it was a worthy price to pay for my exposure to "London Dungeon" earlier that night. It's a shame how much people miss out on because they're smarter than me.

SOUNDTRACK
"LUCRETIA MY REFLECTION"
by The Sisters of Mercy

THOUGH THE MEAT HANDSHAKE was ten years after Cameron, I still hadn't quite nailed the art of watching where I was stepping in the world. I often ended up splashing into the gutter. I didn't have clear sight and I hadn't discovered boundaries yet. I was still finding them at this moment, alone in a room with Cameron Starling.

Cameron made me real.

In the grey early morning light of his dust-speckled bedroom, he began to kiss me and walk me backwards to the mattress on the floor. Lying underneath him, I looked down to see a chrome ring glinting ominously from his erection. It was intimidating, but I figured cock piercings were typical for mature 24-year-olds. Before I thought too long about it, the sudden give of penetration took me.

People with synesthesia, like me, might be able to see sensation in their mind's eye in color and texture. Sex for me is always silver. Slippery catches of pleasure shimmer like the comma-shaped reflection on a cartoon candy apple. I can see the metallic taste of tongues in hues of dark pink. When I close my eyes, I can almost picture each sensation like it's on the other side of black latex, Cameron's fingerprints or mouth or tongue making indentations from the other side, like he's fucking me from a secret, guarded world that I'll never see.

With Cameron, the jagged pain of penetration bloomed within me from Velvet Elvis-navy to deep black around the edges. It felt like something was yanking inside of me. But the pain wasn't remarkable. When you're a 16-year-old girl being introduced to this world of sex, where your desires are peripheral, pain is just your tolerated companion. Cameron's breath turned ragged as serrated knives. The initial plunge of pleasure and pain that Cameron elicited inside of me became muddled and grey as he was pounding away. In the barrage of all the colors bleeding together,

I couldn't feel anything at all anymore.

Afterwards, I went to pee, and the toilet was filled with my blood. Must be from the cock piercing, I thought blandly. I couldn't look away from the wisps of red curling in the water, the realization tightening in my throat that I should feel something. I had often imagined repressed feelings to be like lumps under the sheets, something obviously obscured. In reality, nothing is there at all.

SOUNDTRACK
"PRETTY VACANT"
by Sex Pistols

A GROUP OF FRIENDS went through a delightful phase where they took roofies recreationally. Date raping their own dumb asses. Few things reach such levels of stupidity than taking a drug that has no fun effect, but only makes you forget the evening. Dar and I would camp out on the couch, sipping beers and watching it all unfold like reality TV. We witnessed embarrassing confessions, tearful moments, throwing up, and then amnesia.

At the time, I felt divinely superior over these poor souls who went to great extents simply to forget. This was me, regular caller to the RAINN hotline, pressing charges against my rapist. I thought of myself as someone who faced the world head-on. But my mind

was trickier and more secretly protective than I gave it credit for. My mind had a mind of its own.

Some unseen force from deep within my psychology emerged to blanket any feelings I might've had in fog; it was so stealthy, I didn't know it was there. It wasn't until later that I was forced to question the hazy recollection of details that I considered I might've felt numb.

I couldn't recall if Cameron used a condom. How does a condom work when you have a metal ring hanging off the front of your junk? I don't know how this accessory added or subtracted to my early sexual experience, but I cringe to think of it today. But also, I wonder if I'd enjoy it, just a little bit.

They say that youth is wasted on the young.

I wasn't sure if most people learned about sex this way, but since I was a sensory learner, that meant learning the hard way: by trying things beyond my comfort. I didn't know I didn't like something until I was embroiled in it. I was living blurry.[20] I was given too wide and vivid a sexual landscape to explore. I was shitty at figuring out where to go, and when to pack up.

I had wanted to do it. Even sex that didn't care about me was sex that I was interested in trying. People like me reach a time in their lives, usually early

20 Living Blurry: A UK-based rock quartet that makes drunken anthems like Chumbawamba, Andrew W.K., and Flogging Molly.

on, when we realize the way we think is at odds with the world. We are wired differently. We have to choose a side—to perform life the way we assume is expected of us or live by our internal guidance—and we rarely choose our own side. Some of us can even thrive by finding an acceptable outlet for the voice that whispers deep within. I found writing. Still, I've felt like a guest, writing in someone else's world, not carving out space for myself. In terms of sex, this lends itself to making a lot of decisions based on the desires of others, instead of my own.

You can have high self-esteem and no self-worth. Give me an empty room and I know I'll make it beautiful. But a beautiful room with just me in it is a whole lot of fuss over nothing.

I woke up next to Cameron the next day in a musty bed with dirty sheets and with my friend Corinne straddling me. She was grinning, half-naked, her lion's mane messy and haloed by tangerine sunrise coming through the filmy window—the picture of a satisfied woman in control of her desires. She raised an eyebrow. "So. You guys fuck?"

Did I feel more powerful, more in control after my rape rebound? Certainly. Before I was curled up in the backseat, and now I was confidently in the driver's seat, heading straight off a cliff.

SOUNDTRACK "ME GUSTA SER UNA ZORRA" by Vulpes

13

TEEN MAGIC

WHEN YOU'RE A TEEN DEGENERATE, your version of spirituality is telling ghost stories. Your congregation is your tribe of fellow misfits. Salvation, or hell, comes from hallucinogens. And miracles are any vibrant connection that transcends the everyday: a chill-inducing clue to the unknown, an arm reaching from the void to grab you. Spirituality is divine coincidence. It's the plastic swan you wear on your neck that gleams with possibility just for being from somewhere else, its otherness stamping it with luck and magic.

Sometimes, I wish I had a tool like religion to pull

me out of the muck, post-Adam Acid. But when I hear stories about traumatized ex-Evangelicals, I'm also thankful I was raised in a mediocre Catholic church that didn't know what the fuck it was doing.

The Catholic faith is old and bad at indoctrination. Never for one second did I ever believe I'd go to hell for any impure thoughts coursing through my head. Sunday morning mass was a prime time to daydream and, if anything, the church only exacerbated this desire. But to a feelie like me, the darkness, the rituals, the kneeling, the incense, the Latin drone and chant were healing on a sensory level.

Of course, that's my creative embellishment of the Catholic church. My church wasn't so sexy. We sat on folding chairs and the choir featured an opera singer, a rain stick, and a saxophone player. Imagine the sound of a band that is not morally allowed to turn anyone away. There was rarely incense and, on the whole, the place was too well-lit, as most places are for sensory vampires like me.

Church is the first place I remember experiencing autonomous sensory meridian response (ASMR): watching some churchgoer fidgeting with a candy wrapper, warm tingles spreading up my spine, euphoria nearly lulling me to sleep. It was the closest thing I ever experienced to religious ecstasy. I didn't know until decades later that not everyone experienced ASMR.

I didn't fear God's wrath when touching myself. If anything, I worried about ghosts. If our dead

loved ones are always with us in spirit, how are they supposed to know when it's an appropriate time to drop in? If they are able to avoid us in our more private moments, how would they know without some knowledge of the activity they're avoiding? Is there a cosmic scrunchie we can put on the door to this earthly realm when we're in the throes of something indelicate? Or are ghosts just so mature from crossing the void that they're totally cool about accepting masturbation, or seeing their relatives naked in the shower? "I just transcended the earthly realm to pay a very important visit to my granddaughter, and she was busy jerking off. But it's totally cool. It didn't traumatize me at all because I have seen literally everything this Universe has to offer."

I digress.

I experienced countless moments whose teenage brand of spirituality and their significance in my psyche struck a dissonant contrast from societally acceptable forms of religion. Proof evident that I didn't (and, for the record, still don't) believe in hell: I committed full-blown sacrilege[21] twice; once in a cemetery at sixteen, and once in a Benedictine monastery when I was seventeen.

The strange incidents of July 4th, 1999, served as

21 Full-Blown Sacrilege: Porno electronica band that's a mixture of Lords of Acid and Mindless Self Indulgence. They dress in sexy priest costumes.

the first mystical call from the void.

SOUNDTRACK
"AMERICAN JESUS"
by Bad Religion

EVERY FOURTH OF JULY, the whole town poured into City Park to watch the fireworks. Some holidays are overrated, and always leave something wanting because there's too much pressure applied to them. New Year's Eve, for example, which I always expected to be amazing. I also thought anything celebrating America was stupid. For those reasons, July 4th of 1999 proved an exception: it exceeded my expectations. My anti-patriotism was challenged that night by the memorable display of fireworks, running through the grass barefoot with our hippie friends, hiding our weed from the bike cops, and giggling while children with glow lights swarmed around us in the warm air.

Before dark fell, Dar, Tana, and I ducked into the neighboring cemetery to take a nip from our flask. We sat among the gravestones, drinking and talking about Important Teenage Philosophy. This was after Adam Acid. While it's still a mystery if Adam worked his evil on Tana or Dar, I know that it profoundly affected them. They saw both of their best friends embroiled in something dark with another close friend. I suspect there might even be more than what Tana told me

about her relationship with him. Whatever the cause of their trauma, they were deeply involved. We regarded each other as world-weary elders and talked about the sad parts of life, if not the specific incident.

We talked about nightmares. I told them about my dead nun dream. Tana had a recurring nightmare where the words pulsed through her body, "It. Is. Time." And she was forced to hover bodily in darkened space before a large, ominous clock ticked monstrously before her. A large dusty book shut and left her screaming, temples throbbing with searing pain.

I shared a new dream with them in which all of us were loaded into Tana's car, as usual, but instead of getting up to our usual teenage shenanigans, we drove the car off of a cliff. But as the car plummeted towards doom and I felt the pain of being torn from the life that I loved, the brakes of my entire being rebelled. With all of my strength, I willed the car to stop, and there was peace. We hovered in space for a moment, then flew back upwards to safety.

We sat in the graveyard for quite some time talking before we looked down and saw the name "G E R A L D G E R M A I N E" carved into the gravestone directly underneath me. We realized, with great astonishment, that we were partying at my Grandpa Bucky's grave.

SOUNDTRACK
"IMMIGRANT PUNK"
by Gogol Bordello

MY DAD IS ESTRANGED from his family. A mild-man-
nered computer engineer, you'd never look at him and
think "rebel." And yet, my dad is the most rebellious
of us all. He escaped the poverty of growing up in an
abandoned schoolhouse just outside of Chicago, in the
aptly named Downer's Grove. His father Gerald, nick-
named Bucky, called him stupid all the time. My dad
was taunted by Bucky because he sought an educa-
tion, so he went further and got a PhD in physics. His
liberal politics and vegetarian leanings clashed with
their meat-heavy conservative values, and their entire
garage full of lit-up beer signs. Then my dad sort of
"fell into" computer engineering, as easily as I later
"fell into" publicity. He earned dozens of patents.

Maybe my dad got his rebellious streak from
his mother, my Grandma Sally, Bucky's wife. Sally
moved from Eastern Europe as a child and aban-
doned her entire culture. Her amazing cabbage rolls
were the only hint that she was Carpatho Rusyn;[22] I
didn't know she was anything but American until she
died. We don't even know if she came from Poland,
the Ukraine, or another country with shifting borders,
just that it was somewhere near the Carpathian
Mountains. The Carpathian Mountains are four hours
from Transylvania. It sounded gypsy, vampiric, evil
spy to me. I imagined going Carpatho Rusyn on some-

22 Carpatho Rusyn: A death metal band that hails from the Carpathian
 Mountains made up of a real-life vampire coven.

one's ass would involve slamming them against a wall and fucking them for secret information. I was disappointed to find pictures of my brethren online, looking less like Dracula and more like smiling villagers in peasant dress. I also learned I share an ethnicity with Tom Selleck and Andy Warhol.

When someone assimilates and leaves their culture behind, like Sally did, we sometimes look down on it. I know, because I did it to her. Be proud of your heritage, I thought.

But wasn't that what I was doing? Trying to leave my Christian football American culture behind? My grandmother was also mild-mannered, but when you think about it, secretly rebellious.

SOUNDTRACK
"CREDIT IN THE STRAIGHT WORLD"
by Hole

MY MOTHER IS AN OUTSPOKEN, bleeding-heart liberal in a family of Republicans. She is mild-mannered, and yet, secretly rebellious. When I look at it this way, it flips my entire psychological narrative thus far. Here I've been carrying the burden of being "the rebel" of the family. The valiant rebellions of my parents—to seek an education and a better life, to care about humanity— puts my own rebellion, to be authentically myself with crazy tattoos and unconventional life choices, to

shame. I am the least of the rebels. I'm surprised they haven't seen it yet, that I'm just an extension of them. I'm surprised that I haven't seen that they're rebels until now. It's hard to notice through all of the church services and conventional living.

Perhaps some people have a gene that makes them flip a 180 from how they're raised. Perhaps I'm the first one in my family who wants the freedom to change and also keep her family.

As it was, my dad was so out of touch with his family that when an older female relative visited several years ago, I had to be told, after our visit, that she was my aunt.

I didn't know my Grandpa Bucky until I was about five, when he moved here because he was senile from alcohol-induced dementia. In essence, I didn't really know him at all. My father didn't say much about his father, but I got the impression that he was a Homer Simpson-type. Get me a beer, boy, and shut up. But he was the first person I knew who died, and that was important. I had heard about other people dying as a faraway concept before, but his death was the first that I felt entitled to grieve.

The funeral home was tacky as a conference room, dentist office smell, and I touched his cold waxy hand. Later that night, the moon was full, and I couldn't sleep because I was afraid my grandpa's ghost would haunt me. I stared out my bedroom window, seven years old, the night so bright, it was brash. Bright moonlight still leaves a trace of panic in me to this day.

Stumbling upon Bucky's grave at age sixteen when I was drinking a flask felt like magic to me, in my world of muddled superstitions. Was my grandfather trying to communicate something to me from the grave? Was it an omen from an alcoholic to a boozer-in-training? Or was it a wink from the universe? This seemed a fitting gesture from an abusive man who also had a sense of humor. Whatever the significance, we did what any teens would do in your typical horror film: we flaunted our sacrilege. Tana took a photo of me, grinning proudly, slightly buzzed, lying next to my grandfather's grave. Coincidentally, I was wearing black.

Now, when I remember drinking at my grandfather's grave, a slight chill creeps across me. But I relished in it, back then. My idea of spiritual belief at the time was more of an unjudgmental appreciation for strange connections. A shivery excitement when faced with possible evidence of the other side.

SOUNDTRACK
"GOD IS A NUMBER"
by Sleater-Kinney

MY SECOND MYSTICAL CALL from the void came when Mother sent me on a spiritual retreat after my assault. Unlike when she tried to enter me into rehab the first time I got drunk, this Catholic retreat wasn't just a

misguided attempt to control me. She really wanted me to get something enriching out of the experience.

The monastery was carved into the mountains of Snowmass, near Aspen. It was a rustic monastery, but grandiose in its serenity: large rooms that were clean and simple. The hermitage was surrounded by enchanted clumps of trees I'd escape in to smoke cigarettes and soak up the energy. I wasn't sure if the monks knew that a 17-year-old girl was roaming the grounds smoking cigarettes, but they never bothered me about it.

They were all variations of Dumbledore, crinkly eyes and robes that made them appear to float when they walked. They told great stories and even made jokes about old Brother Theophane, who was a drunk. They chanted in the dark early morning hours during Vespers, their faces cartoonish and eerily aglow. Together, their smooth voices were like a blanket you'd hold by the corners and shake, I felt buoyed up by the velvety vibration, absolutely hovering. It made me wish I was religious, I so yearned for this peaceful lifestyle. I considered being a nun. A chain-smoking, foul-mouthed teenage nun who didn't believe in God. Is that allowed?

One afternoon, I wandered far from the rustic monastery into the mountains of Snowmass to smoke my cigarettes. My retreat cohorts were incredibly nice, but with one exception, they were all grownups; I needed my occasional escape into dirtbag solitude. The only non-grownup was Renton, the son of the

church leader who was directing the retreat. Renton was three years older than me and had attended the retreat to help his dad. For a week, our conversations had shown great promise; but we had never gotten to talk without the filter of religion and adults around. On the side of the mountain, there he stood, looking like Renton from *Trainspotting,* hence the pseudonym. Surveying the land like a sexy mountain goat. I looked at him and I saw silver.

SOUNDTRACK
"WHERE EAGLES DARE"
by Misfits

A QUICK NOTE ABOUT mountain goats. In my twenties, I had a buddy named Tom who lived in a horse barn at the top of a mountain in Nederland. He was a smooth-talking salesman with a big heart and an attraction to fiery women. His favorite book was The *Dharma Bums* by Jack Kerouac. In one particular scene, Kerouac describes running down a mountain, fueled by a spiritual type of confidence borne on oneness with the mountain:

> "Then suddenly everything was just like jazz: it happened in one insane second or so: I looked up and saw Japhy running down the mountain in huge twenty-foot leaps, running, leaping, landing with a great drive of his booted heels,

bouncing five feet or so, running, then taking
another long crazy yelling yodelaying sail
down the sides of the world and in that flash
I realized *it's impossible to fall off mountains
you fool."*

Interjection: It is possible to fall off mountains.

Tom dug a pit in the side of the mountain so we
could get drunk and play guitar around the raging
flames of a bonfire. It was a fun place to party, on the
edge of something else, the view of the mountain so
blackened with darkness that we couldn't think on it
too much. On one particular evening, toasted by camp-
fire and copious amounts of booze, Tom was embold-
ened. He announced with great seriousness that he
was going to "run down the mountain like a mountain
goat." At the time, we didn't know about his literary
inspiration. It just sounded like a shit idea.

"If I have enough confidence, it'll be alright," he
intoned with the lackadaisical slur of a sun-kissed
surfer. "It's the people who don't believe in themselves
who fall."

Before we could object further, he leapt away from
the fire and into the downward darkness like Japhy.

Though they objected, the two other guys present,
Kam and Charlie, ended up running into the rocky
darkness as well, just to make sure Tom didn't kill
himself. By the time I picked my way gingerly to the
bottom, Tom was lying face to the stars, grinning in
bewilderment, bleeding profusely from his thigh. He
didn't make much of the wound at the time, drinking

the pain away; but I know he still has a wicked scar fifteen years later.

Perhaps faith was invented by a young adult, blind with hubris. Someone brave enough to learn that you can experience magic if you're willing to risk death for it.

SOUNDTRACK
"GIMMIE GIMMIE GIMMIE"
by Black Flag

As I stood on the side of my mountain in Snowmass, I was a broken girl. But I was, in my own way, trying to reclaim something for myself. My spiritual journey was much like Tom's: bold, inspirational, stupid at times. But I was trying in my own vibrant way. I had been going to one-on-one therapy and group therapy. I was in this healing place. Another miracle: I had recently acquired a killer, foolproof fake ID from my 21-year-old sister Genevieve.

Genevieve had gone into the DMV with a scarf wrapped around her long hair, so that it looked like a bob, like mine. She put more eyeliner on, like me. And she told them she lost her ID and needed a new one. Genevieve emerged from the DMV with two IDs, one for her and one for me. While I watched count-less other fake IDs get confiscated from intimidating bouncers, mine always passed the test—it was actually

real, and it actually looked like me. In fact, it looked more like me than any of my real ones ever have, or maybe Genevieve was just prettier at being me.

Ultimately, what our Girl Gang wanted to do—have a couple of drinks—wasn't all that bad, when we kept to our limits. We were getting to the age where we alcohol poisoned less. You know. We were maturing. We just wanted to be grownups and go to the bar. It was the way we had been getting the booze that was the most dangerous: playing Hey Mister outside of the strip clubs, depending on asshole punk dudes who would probably date rape us. Having an ID that was literally real and looked exactly like me was foolproof. And it was the ultimate freedom.

Beyond the newfound adulthood that my fake ID offered, I had been considering the world and trying to forgive it. Writing a lot in my diary. That was the space I was in when I saw Renton on the side of the mountain in Snowmass.

When we approached each other, it became clear that he had wandered from the monastery so he could smoke weed. Golden, I thought. I knew he was cool. Even though I didn't smoke weed much anymore—what with my weird brain and relating it emotionally to my times with Adam Acid—I appreciated having a partner in crime in this place of purity.

We both smoked the other person's substance, even though we didn't typically. Then it started to rain, frenetic darts filling every square inch of the sky, and we were forced to duck into the monastery's grand

meditation hall, cavernous and darkened by the storm.

In the meditation hall, an arched window framed a gnarled tree twisting over the precipice of a plunging mountain view. I had never seen anything so breathtaking in my life. Lightning and thunder shook the expansive sky. We lay side by side in this unreal world, slightly stoned, and as quickly as the thunder struck, we were on each other. A gravitational force moved me down to his zipper. And I gave a blow job to this son of a church leader, with all of the saints watching, and maybe even a creepy monk somewhere.

The lowliest act to a believer felt like the most divine moment to me, or at the least, a very good Madonna video. My teen heart was shook. To me, the sacrilege was the best part about it. And the lightning. What could be more transformative than coming as lightning and thunder careened through a cavernous sacred hall? Who could be more important than the person who made that happen? That was me. I had come a long way since my first botched blow job attempt. This was probably the best blow job anyone in the world could ever give.

His ejaculation spewed forth volcanically as thunder tore around us. God damn it, it was so *metal*. I swallowed, the salty serum surely making me invincible.

SOUNDTRACK "FINALE" by Bikini Kill

INSTEAD OF FEARING for my soul, the experience made me root for the relationship much longer than I probably should've. It became stamped with divinity. After all, what are the odds of finding someone hot enough to blow in a monastery? A holy place in the middle of the mountains of Snowmass? How often does the wisdom-seeker embark on their journey to the top of the mountain to meet their sage, and find fellatio on the way? Blow job beyond all blow jobs, an unknown force had electrified this particular relationship with teen magic.

Renton and I had a passionate relationship that our folks approved of, because of the whole church connection. The deep irony was that he turned out to be statistically more likely to murder me than any other man in my life. But my parents didn't know that at the time.

It was interesting that my first boyfriend, post-assault, was someone whose family was in the business of healing. I guess it was healing, in a way. He liked having sex with me when his mother was bumbling around the house, doing chores, on the verge of catching us. He was kind enough to take me to my senior prom, even though he was twenty-one. I felt kind of cool, and kind of weird, having a prom date old enough to legally buy everyone booze.

One afternoon, we were taking a pleasant drive on dirt roads out in the country. Renton told me, with happily stoned, smiling eyes, that he was going to surprise me with something.

As we puttered on the bumpy roads and the sunshine warmed my skin, Renton reached into the glove compartment and pulled out a sleek little gun. I choked on the suddenly tense air, tinged with dirt from the road. Renton waved the gun around to point it sloppily out the window, aimed at a bird that sat on a wooden fence, and fired. A birdy drive-by. My breath came gushing back into my lungs as the bird flew away; he had missed. Renton turned to me, beaming.

"Damn it!" he laughed. Then he looked at me, smiling obliviously. "I'm going to take you to shoot guns, baby!"

I wasn't sure which part about me made him think I'd be the gun type: my weak wrists, liberal upbringing, or sensitive, artistic nature. I felt an invisible line being crossed as he had reached across my lap and grabbed a loaded gun I hadn't known was there. But he was the son of a church leader, for Chrissake. Even my parents approved of him. I suddenly felt silly for being scared. I shook off the shock and recovered my sense of teenage machismo.

"Sure," I shrugged.

I spent a good twenty minutes of my life, with Renton behind me and protective ear-gear squeezing my brains, firing an assault rifle that nearly kicked me off my feet. We were in some blank wide space of dust and dirt meant to be filled by stupid young men with bullets. I was afraid the bullets would kick up and turn around and lodge themselves into my chest.

If there was anything Renton was into more than

guns, it was hallucinogens. They were his soul-juice. He had been tripping on them for years. I suppose it makes sense that someone raised by a spiritual leader, who had a chip on his shoulder, would try to speed up the process of spiritual transformation by frying his brain with acid.

Hallucinogens wage war on my strange brain, and they simply don't work on Dar. She tried ecstasy, LSD, and mushrooms, but never once felt a thing. This landed her as designated driver one night at Red Rocks, when Tana and I were positively laughing rainbows on ecstasy. Tana kept reaching out and touching strangers. I rubbed a condom between my palms all night long, the whirlpool of lube sending velvety sonar pulses throughout my body. I met a strange girl in the parking lot when we were leaving and found myself rubbing up against her, clinging to her as Dar pried me away. I thought she was magnetic. I theorize she might've also been on ecstasy and I sensed it, like we were the same Utopian species. When Dar dropped my rolling ass off at home, I sat in my bedroom and continued to rub a condom between my palms in the dark all night.

Instinctively, I regarded psychedelics with a shallowly buried fear. It was confusing to me. People on acid felt familiar and comfortable to me, and yet I regarded the drug itself with intense fear. Maybe it was forecasting that an acid dealer would ruin my life. I know now that I feared hallucinogens might amplify these qualities I already possessed into insanity: mania,

bewilderment with the world, abstract connectedness, this was my brain already. The connections tripping people made in drug-fueled epiphanies made perfect sense to me.

But I couldn't escape psychedelics forever; I was forced to reckon with them at age seventeen. Both my boyfriend and my best friend Kitty had been acid heads for years, and I was a broken woman. The perfect recipe for psychedelic healing.

"You'll be fine!" Kitty said from her couch, her legs crossed, breaking up shwag to put in her pipe. "I trip my ass off all the time. I can't believe you've never tripped with me before. Come on! It will be so much fun. We'll do mushrooms. They're natural and they don't last as long."

In the half-dark of Kitty's apartment, the overhead kitchen light illuminating our ritual, I plucked shriveled brown fungi from a Ziploc baggie, gnawed them up and stared at the walls, waiting for them to melt like candle wax. I didn't think much about the fact that Renton and Kitty gave me the same dose that they took.

SOUNDTRACK "PROGRESS" by IDLES

As we sat on Kitty's couch, the room darkened, at least in my memory. I felt my brain loosely cracking into

different compartments. Time jumped. Here sat Kitty, clutching her knees, rocking, laughing with panic-tears streaming down her face. Laugh-crying and rocking, rocking and laugh-crying. Her facial expression was like someone who had wandered the streets screaming of the apocalypse. She was probably just laughing really hard, as she got incredibly giggly on all manner of drugs; in my tripping brain, that moment was extended to eternity and was entirely sinister.

Renton and Kitty were always cordial to each other when they were forced to hang out, but they regarded each other with the insidious mistrust of those fighting over territory. Under the warp of psilocybin, their strained relationship hung tangibly in the air, a thick mud ready to suffocate me.

"I don't like it in here," I said in a rushed tone to both of them. "I don't like this."

"Let's go outside and see the fairies," Kitty said to me, her blue eyes arcing into rainbow shapes. "They live in the trees outside of my house."

The night was black and the suburban trees next to pathetic streetlights weren't the fucking fairy forest that this bad trip was demanding of. We halfheartedly wandered from one tree to the next, looking for fairies that, despite the hallucinogens, never materialized. I couldn't even hallucinate correctly. I felt something mounting within me.

"Take me home," I demanded. I had never been demanding in my life. I was demanding at this moment.

"Are you sure, baby?" Renton asked. "It's going

to be hard to drive right now." He was a black faceless smear to me at the moment.

"I have to go home," I repeated, staring forward.

"Gogo, you will be so much better off here with your friends!" Kitty pleaded.

I wasn't having it.

When Renton dropped me off, I bid him adieu, then plunged into an hours-long hell-cartoon à la Rob Zombie's *Haunted World of El Superbeasto*.

SOUNDTRACK "SUPERBEAST" by Rob Zombie

LOLLIPOP SWIRLS OF FORKED cartoon tongues, campy naked girls with dead doll eyes, the carnal convergence of sex and death squishing together in a despicable bouillabaisse. Ever-moving.

I felt exactly like my goddessly friend, Nancy Villain, when someone had allegedly dosed her with 100 hits of acid while she was passed out drunk. Down by the Train Bridge, Nancy was draped over Kinsey's shoulder, squirming and ululating word salad. It was the first time I learned that acid can't kill you.

The only thing that made me feel better was running. Sprinting from the bowels of my basement up two flights of stairs, past my parents' room to the highest corner of the hallway, looking in the mirror at

the end of the line, a reminder I was real, then turning around to descend the two flights of stairs. Running to escape the thoughts in my own head, as pathetically as a dog chases its own tail.

With my low level of fitness, this could only last so long. I soon found myself in the basement, cordless phone in hand, trying to decide whether to call 9-1-1 or my friends. Thankfully, I chose the latter. Tana and Dar came over late at night, filthy-drunk. The hilarity of their drunkenness was a salve to my terror. Dar passed out on top of me, snoring, and I was convinced she was a cute monster. After I started to come down, I sat outside on the back deck with Tana, smoking a cigarette. The sky was cool and blue-black, and the perspective on my cigarette was warped, like the cherry was on the end of a cartoon cigar.

Later in the relationship, I went to Renton's apartment. I felt so grown-up, driving to Denver, almost dying in traffic to arrive at his pad in a Mexican neighborhood in the center of Denver.

"What an afternoon," he said, shaking his head and smiling. He put a hand over my shoulder and led me to his bedroom window, peeking out conspiratorially. "Okay, they're gone. These neighbors of mine, they're a couple ... they were fighting out in their front yard like nutcases. I was worried for a while," he said. "It was getting pretty hairy."

"Oh no," I replied, concerned. "Is everyone okay? Did you call the cops?"

"Nope," he said proudly. "I just sat here with my

gun like this, and I kept it aimed at their heads the whole time," he bragged. "In case anything got too real." He took a rifle that was on his bed and threw it into a steel closet that was filled with eight other guns.

When Renton and I first met, I had associated him so strongly with Renton from *Trainspotting* that his camo pants had only reminded me of the "Do you see the beast?" scene in the film. I hadn't considered what else they might indicate, like gun nuttiness. I had tolerated the unexpected bird drive-by shooting because I was taken by surprise. I had tolerated the fact that he enjoyed his UPS supervisor position too much for my tastes. I had tolerated the blind jackhammering kind of sex that young gun-toting men are so eager to provide, because it's fun every once in a while. But this sniper-style moral superiority that placed him in any position to judge or deliver death to another human being was a disgusting turn-off. It was that coupled with his loaded gun collection, which made me feel like I was doing delicate things amidst a minefield. I was done, and for someone who wasn't used to drawing boundaries, walking away was like an interplanetary leap.

But of course, I was going to deal with this departure as a teenager does. For the moment, I smiled, had halfhearted sex with him, shared a meal, and then answered my phone less often until we drifted apart.

SOUNDTRACK "BULLET" by Misfits

14

STRIP CLUB REGULAR

SOUNDTRACK
"HOW LOW"
by Against Me!

DON'T SLOUCH THE HIP STRINGS on your G-string. Pull them up as far as you can, because it makes your legs look longer, and holds the money tighter. If you're lying on your back giving your customer that peachy front-to-back peek of your foldy bits, cross your legs and push your bottom knee into the top knee-pit towards your chest; it'll make you look more flexible. Make eye contact and really connect to your customers. It doesn't matter if you have perfect tits or ace aerial moves; the girls who make the most money are good at convincing their customers they're just like

a girlfriend. Except for the club elder, Diamond, who has to pull out the pyrotechnics to compete with the 18-year-olds. She always rakes it in when she lights her nipples on fire and has the customer blow them out like birthday candles. Most importantly, regularly use apricot scrub on your ass. There is a lot of dirt on the stage, which can cause breakouts.

That last one was the only Rule of Stripper[23] that I regularly follow, and no, I don't roll around on dirty stages for a living. It makes my ass as smooth as yacht rock on Sunday, and I happen to know this because I used to be a regular at a strip club. I was seventeen years old.

James Brown's tortured soul was steeped in a whorehouse. This tragic upbringing motivated him to be the biggest, baddest Godfather of Soul. My love affair with strippers was less about tragedy and more about the gaping hole of suburban boredom, and a proclivity for immersing myself in late nights and immorality.

SOUNDTRACK "ORGASM ADDICT" by Buzzcocks

23 Rule of Stripper: Much like Barenaked Ladies, Rule of Stripper is a band full of schlubby dudes that lures fans with titillating false advertising.

ON TANA'S EIGHTEENTH BIRTHDAY, we rented porn. It was the only rite of passage left in our bleak adolescence. We considered ourselves to be well-seasoned teenage girls, like a well-loved cast iron pan. We had smoked cigarettes for years; hell, we were regulars at a liquor store. The only thing left for us to try, besides the harder drugs that speckled our experiences, was porn.

Before the internet, the price of titillation was showing your sorry face at the Adult Book Ranch. It was so conspicuous, just off the main drag of College Avenue, that teenagers laughed at its decrepit architecture and the lowlifes who slunk in. It was rumored to contain a glory hole in a sketchy back room and that, sometimes, even females were behind the glory hole. Naturally, it became a rite of passage for anyone turning eighteen. Let's reach out and grab the shame like a black dildo.

Tana, Dar, and I parked just down the street from the Adult Book Ranch. Dar stayed in the car because she had not yet turned eighteen. I hadn't either, but I possessed a high-quality fake ID. Tana and I decided to walk in like two teachers shooting the shit on a fall afternoon, making jovial conversation as though we did this kind of thing all the time.

It was small, jam-packed, and pulsing with shapes that made me feel strange. The seasoned Book Ranch merchant took a glance at us over his magazine and went back to not caring. Our casual conversation halted as the truth of the place began to seep into our bones.

Our eyes glazed the moldy curtain to the back room, the only thing between us and the fated glory hole. We started to panic. In silent agreement, we chose the first DVD we could find and got the fuck out of that place.

We grabbed a DVD called *Backdoor Betties* because it had the hottest dude on the cover; he had green hair and looked punk rock to us. We made cheerful conversation with the merchant as we rented the film, and he just stared blankly at us. Tana presented her ID with great pride, and I tried to affect the same smiling pride presenting my fake one. If I were to get my amazing fake ID taken away at the Adult Book Ranch, it would be a deep shame. Thankfully, our porn peddler could not give less of a fuck.

Then, we drove home and slunk into Tana's room, drinking way too much coffee and getting all spazzed out on porn.

Scene after scene unfolded of pure anal sex, not even a lick of vaginal penetration; quite truly, I lost a little desire for sex altogether. Maybe, had I been introduced to anal in smaller quantities, it could've appeared more intriguing. We were such novices that we had missed the playful reference to "Backdoor" in the title that would've informed a veteran Adult Book Ranch patron that they were renting an entire DVD of anal. It wasn't sexy in the least. In fact, it had the opposite of its intended effect.

Dar's eighteenth birthday was next. For years, we knew how we'd celebrate her birthday, as she had been pledging to become a stripper with the passion of the

bereaved vowing revenge. We had all been stripping unprofessionally for years at this point. But Dar was doing it right this time. At the legal age, the time had come for Dar to embark upon her professional exotic dance career. We weren't going to try to talk her out of it. We were attending the audition and cheering her on.

Dar knew how to move. She had a sunny disposition. She was not easily shocked. She was up for anything. She was a blonde with big tits. And she was hellbent on trouble. Most of these traits inform her current career, caring for the elderly. And all of these traits translated well to caring for horny men.

We worried about her a little, sure. But we trusted her to handle it. You could fill a stadium with the adolescent hubris we emitted like radioactive sunshine. We were fucking unbreakable, until we were broken, and then we just laughed about it and kept going.

Today, my female friends and I are maternal. We look out for each other. It's nice, but sometimes I miss the iron trust of teenage friendship. It's not that we didn't care; we just held each other in unquestioning, prideful respect. Fear was never a factor.

SOUNDTRACK "INSIDE OUT" by 999

THE FRENCH HAVE AN EXPRESSION to describe an orgasm: la petite mort. It means "little death" because,

for a brief moment, you go somewhere else. I first discovered orgasms by mistake as a tween. I was lounging in the bath, absentmindedly pouring water from the pitcher I rinsed my hair with. Something made me linger the stream over my clit a little bit longer, even though I didn't even know what a clit was. Within mere moments, I was panting on the other side of a new world. Watergasm. The first time a man made me orgasm, my entire being opened up and back around itself. An explosion implosion. Sex is like that. It turns everything inside out. Inviting another human inside of your body is the most vulgar and divine thing you can do. The way that some of these auditioning strippers undulated was reminiscent of a world hypnotically turning inside out. Exposed. The precious meat of the world on display.

SOUNDTRACK
"EX-BOYFRIEND BEAT"
by Skinned Teen

DAR DAZZLED US. She nailed the audition. I know, because I was there. Apparently, it's cool at the Hunt Club for your best friends to watch your audition, cheering you on while you disrobe in the blue light. It didn't feel at all like our amateur strip parties. There was no hokey twirling of shirts above heads. It was scarier. There was Dar on a platform, lit from

below, and orbiting around a pole. We gazed up at her breasts from our lowly perspective: high-up, holy[24] and moon-kissed, serene blue mountain ranges circling the sky.

I liked strip clubs because I saw through the degradation and straight to the female power. I needed to put myself in the place of the male gaze to understand what had tried to destroy me. Plus, the twirling ladies were just so pretty. It was a complicated mix. While I admired the dancers, the entire charade was a deranged novelty. You like breasts? I'll fill mine with silicone until they're giant cartoon cans. A parody. What a strange cage is misogyny. If we weren't raised with it, men's fear would be glaringly apparent. Putting beauty on a pedestal, then filling it with silicone and throwing money at it. Trying so desperately to control it so they can lie to themselves that it doesn't control them.

Men are at the whim of random erections since before their memory even forms. They must feel so out of control. We're all so out of control.

Dar was hired on the spot. At the Hunt Club, it's totally kosher for the friends of new hires to stick around for stripper training. Dar's training was delivered backstage by a bubbly, leggy blonde with clear heels. This is where I learned the Rules of Stripper.

24 High-Up Holy: Former Dead Heads who started a thrash-grass band.

Our teacher of the exotic arts also told Dar that she'd get a lot of gifts from customers—and she did, of the Cubic Zirconia variety—and she warned Dar not to go with men who asked her to do extra stuff on the side. This is a warning at every strip club that is obeyed only by some.

A quick note about vocabulary. When I first moved to Denver at 19, one of my best friends was Vicente, a gay boy who grew less body hair than I did. Vicente, with his gorgeous awe-inspiring beauty, was plucked from his home of Mexico City by a vacationing older man who brought him back to Denver. Vicente soon became a stripper on South Broadway, painting his sugar daddy's walls a festive dandelion yellow to remind him of home. He danced to Kylie Minogue and Britney Spears in a way I could only describe as "liquid," his Aughts-style pinstripe hat shielding his brow in mystery. It was impressive how he could confound my sexuality, attractive to me despite being the two things I don't tangle with: cock-seeking and effeminate. It was even more impressive he could make me tolerate Britney Spears.

Whenever anyone introduced Vicente as a "dancer," he quickly interrupted in his luscious Latinx lisp, "Excuse me. I'm a stripper." It's in Vicente's honor that I use the word "stripper" so proudly, instead of the tamer word, "dancer," which is what you might call it if you were ashamed. There's not all that much dancing involved; stripping involves circus acrobatics,

really good customer service, and fucking the air.[25] That would be good on a business card: "Air Fucker."

My ears recall the sound of clear heels clacking together, a stripper opening herself up and helicoptering her clear heels around a patron's head, nearly decapitating him. Who is more vulnerable here?

The meaty bouncers at strip clubs might be strict about IDing dudes, but they're a little more lenient when it comes to younger girls. After all, we represented potential recruits. It was for this reason that I got away with drinking at the Hunt Club while Dar was working. I even got to blow out Diamond's birthday nipples. She proceeded to patiently teach me how to arrange the matches, should I find the opportunity to perform such a trick. I took her lesson in with great reverence, hoping to save this trick up for the very perfect moment.

The Hunt Club was a topless bar, which is really the only way to go. I remember going to Saturday's, that all-nude pit of despair, with my friend Vicente. We were meeting some friends.

"It smells like pussy in here," he sneered as we walked in.

The waitress came to take our drink orders.

"Vodka," Vicente answered before she even

25 Fucking the Air: A techno act reminiscent of Aphex Twin featured on CD compilations like Trance Global Nation 2 or soundtracks to films like Hackers or Run Lola Run.

finished asking.

"We don't serve alcohol here," she answered. He fell into histrionics. Can you blame him? Vagina in your face is far too intimate without a hearty buzz, especially for a gay man and a girl clearly questioning her sexuality.

Topless meant less intimacy and an alcohol license. Whenever the Hunt Club girls needed to loosen the male patrons' wallets, they'd strip for me. They'd take my hands and put them on their asses, which was a big no-no for the men. Their asses looked so soft in the glowing light, but they were often rough, nearly callused. Their soft veneer an illusion. A balding man saw this transaction once, placing his own hands on the stripper's ass right after I had. He was promptly removed from the club.

Sometimes, the club was dead. Nothing is more depressing than weak turnout at a strip club. Especially since the Hunt Club was no top shelf affair. It's gotta be champagne showers for everyone or nothing at all. I'll always remember the image of a stripper swaying list-lessly for one patron to Bon Jovi, bored out of her mind. Of all the jobs to be bored at. But even on the boring days, I'd look at Dar with her work gear (lingerie, ciga-rettes, clear heels, and shots of liquor) and think about my work gear (X-ACTO knives, vinyl stickers, and temperamental printers) and get slightly jealous.

There were plenty of regulars who came at the same time every day, as early as 11:00 a.m., actually eating from the sad little buffet. Men with little to offer the

world and suspicious holes in their pockets. Men who approached the strippers after work and asked them to do weird stuff, like smoke an entire cigar while ashing on their cocks. An entirely new kind of cigar club.

I sat there with my beer, looking at women, thinking about men. Trying to figure it all out.

Was Dar in a position of power, her sexuality elevated like a goddess? Or was she lured by money into victimization?

Was I the ringleader in our mischief, a fiery force in our endless search for trouble? Or was I seduced by the risky behavior that resulted from my addiction to feeling?

Did we use our desirability to gain entry into the fun party world of rock stars, or were they using their fame to lure vulnerable young girls?

Was I a traumatized victim bent on self-destruction, or was I, from the start, just living bold and free like a man in a sexist world?

None of it. All of it. You can turn it around in your mind endlessly and never know the answer.

When I got a fake ID, the Hunt Club became a less interesting place for me to drink. There are only so many tits you can handle. It's still a lot, but the limit does exist.

SOUNDTRACK "THEE MOST EXALTED POTENTATE OF LOVE" by The Cramps

IT WASN'T UNTIL FIVE years later, when Vicente and his clan blasted into my life like a confetti cannon, that I found myself once again in the harem of naked skin and cheap perfume. I spent many late nights sitting among them as they burned through cocaine cigarettes—strippers love coke—and drank 3.2 beer. They didn't realize the beer at the grocery stores was weak and, for some reason, I never had the heart to tell them. I figured they were on enough drugs that it didn't matter. They took me to all the gay bars in town, from the more collegiate JR's to the cowboy bar, the Wrangler. It was refreshing for beautiful men to tell me I was beautiful without them trying to fuck me. When Vicente and Co. snapped, their sugar daddies bought me drinks.

But before I benefitted from the sugar daddies of South Broadway male strippers, I was my best friend's biggest strip club cheerleader, hanging out during her shifts and pondering sex. How important is the manner in which one is introduced to the world of sex? I thought about Lexi, Adam Acid's former girlfriend who was also assaulted by him. She and I were never close before, but after we were both assaulted by Adam, we took to hanging out more often at her spacious grey house with nice views that was out in the boonies. We could talk freely about rape stuff—the trial proceedings, our therapists, group therapy—without freaking anyone out. She was the only person who could relate to such horror stories such as how my group therapy leader just happened to also be my French teacher at

school. Such a connection was comforting—on some days, it was nice to find an ally at school. It was also a daily reminder of my trauma and what I felt set me apart from the other kids.

During one of our conversations, I talked about losing my virginity in a violent way. "Why don't we rewrite the story of your virginity, right now?" she asked. She encouraged me to envision my ideal deflowering scenario. I chose Jonny Gutpunch as my devirginator. I surprised myself by making it happen after a dance. How cliché. My first sexual experience, no doubt, had an ideal soundtrack. It was "I Only Have Eyes for You" by The Flamingos.[26] That echoing, sparkly blue kind of innocence. *Sha-bop-sha-bop.*

I recalled this recent deflowering fantasy as I sipped my beer and watched my best friend spreading her legs for a customer, and I knew that this romantic ideal was laughable. A hamster in the wild.

Ah, hell. The Flamingos were probably assholes, too. Another Pabst Blue Ribbon, please, barkeep.

To this day, when I hear The Flamingos, the echoing three-four time is tinged with sadness, and my eyes well with tears—like how I heard Skeeter Davis' "End of the World" differently after I saw *Girl, Interrupted.*

26 Insufferable adult-me would say The Flamingos song is too expected and would choose the cozy Belgian band Amatorsky's "Come Home," but that's just me.

I'm sure anyone from the outside would see me at the strip club and feel sad for me. But to someone who wanted to be in the most indecent corner of the suburban sprawl, the Hunt Club was an immoral naked circus, with beer. I sometimes brought my guy friends there, and they instantly fell in love with me. If you want to impress an 18-year-old dude, bring him to a strip club without warning. That was Nico, the sweet Latinx pop-punk guy I brought on a first date. He thought I was super cool for a minute. PSA: These relationships don't last long.

I wasn't a stripper because I'd be hella awkward fucking the air. But, in my heart, I was one of them. The strip club is a place for a certain kind of woman; we are often the ones in abusive relationships, too. We're women with a very benign-sounding, but lethally self-destructive combination: We are nice, and we are tough. Too nice and too tough for our own good.

SOUNDTRACK
"BARBED WIRE LOVE"
by Stiff Little Fingers

DID DAR FIND DANGER in her profession? Quite the opposite. She found love. Dar stripped for a few years before she fell in love with one of her customers, a punk biker named Kizz. They got married in two seconds. No one expected that marriage to last.

As organized by 19-year-old degenerates, the events of Dar's bachelorette party were so salacious they cannot be mentioned, even anonymously, in this book. The most shareable part is that I hired a male stripper by pricing them out in the Yellow Pages and hiring the cheapest one. I noted over the phone that Dar had a thing for Batman. The auspicious entry of Batman's buff female bodyguard was followed by his meek entrance, barely taller than five feet and wearing a cloth Batman costume from the kids' Halloween section of King Soopers. We threw money at him and, in Lightning Dar style, stealthily scooped it back and kept recycling the same bills. The fact that we were stiffing one of Dar's stripper brethren was totally lost on us.

Today, Dar and Kizz have two beautiful boys together. Kizz works for Harley, skateboards like an old man, and has a giant fuzzy beard. They still share that sarcastic, uber-honest kind of love where they can fight openly about their sex lives in front of everyone and it's charming. That's the honest kind of love forged in a strip club, where the relationship begins naked.

SOUNDTRACK "SEX BEAT" by The Gun Club

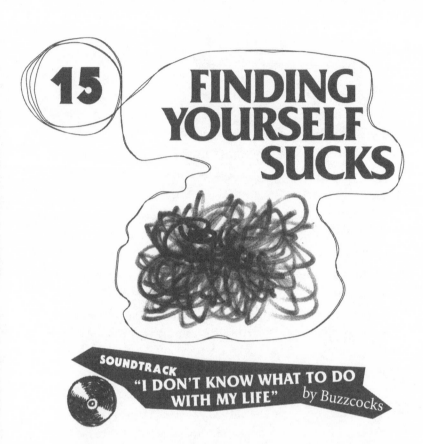

15

FINDING YOURSELF SUCKS

SOUNDTRACK
"I DON'T KNOW WHAT TO DO WITH MY LIFE" *by Buzzcocks*

HALFWAY HOME FROM ARBY'S, I experienced a gaping crevice in the space-time continuum that parted the suburban neighborhood's tree-lined streets. It began with a scent on the wind. It was the summer after high school, where I had graduated with a measly C average, before I was to move out on my own.

Kitty, a stoner who loved her creature comforts, had driven us to get curly fries and a Jamocha shake after some hearty bong rips. I hadn't taken any drugs at all but was always up for curly fries.

Kitty was the driver. Someone else was always the

driver.

Even in my friendships, I was most comfortable being carted around and told what to do. This was partially due to my being the third child, accustomed to going with the flow, and it was partially due to the small debilitations that come with my sensory processing issue. I couldn't even change lanes in a car while wearing sunglasses. I couldn't carry on a conversation with a passenger while driving without getting lost.

As I stuck my hand out of Kitty's open car window, wind cooling my fingertips, I considered the summer air and everything it grazed, my body included, could be a cruel illusion. The summer air seemed to stipple with static, as if my discovery of reality's facade had caused the machinery of it to falter. Flakes of atoms crumbled before me. How was I to know this wasn't all a dream? The dream of some twisted godlike creature, a devil, or some greater truth we humans couldn't even fathom? Reality as I knew it cracked open for a second, hung limp on rusty hinges. My thoughts plunged into terror, the back of my neck burning, my heart banga-ranging out of my chest like a captured frog. I swallowed. I said nothing to Kitty about it.

It would happen like that each time.

At the Italian restaurant with my parents and their boring friends, feeling for an instant, almost too quickly to admit, that the restaurant looked fake. Like a theater set, eerily uncanny. *Is this moment real?* I wondered. *What is a moment?* Pounding heart. *What is real?* Echoing skull. Something sickening solidifying

the makeup of my chest.

Lying in bed, suddenly gripped with the absurdity of being horizontal buried in soft things, suddenly foreign to the human species and all of its customs. *What are we? What is this?* I feel a crack in my soul's casing planting alien doubts. Are these moments linked to anxiety because they're a symptom of it, or do I feel anxious because I'm truly peering beyond what's humanly understandable?

SOUNDTRACK "NERVOUS BREAKDOWN" by Black Flag

MY PLANS AFTER SUMMER were murky and changed often, but I certainly wasn't enrolled in any college. I had experienced the trauma of rape on my own already. Sure, there was support, but there was no way to outsource all of that pain. And yet, the thing that gave me panic attacks was dealing with life on my own. Paying bills, having a job, buying food and then preparing it to eat instead of starving to death in the gutter with one outstretched hand reaching skyward. In a nutshell, I didn't have much faith in my creative snowflake of a self.

Finally, I had a full-on heart attack. Or so I thought. At home with my mother, I announced it to her: I couldn't breathe. I couldn't manage a normal,

human heartbeat. I couldn't live. I couldn't human.

"Maybe you have E. coli," was her first response. E. coli must have been the new parental craze of the month, circulated by stressed-out mothers trying to keep their asshole teenagers alive. She threw me into the car and drove me straight to the emergency room.

The books we want to read are about how something beautiful and inspiring made us better. But sometimes it's simply fear. Animalistic fear.

Hospitals and doctors' offices are greatly comforting to me. They're the only exception to my boycott on mundane comforts and khaki. The people who work at hospitals have glowing souls that burn brightly in the dark. They need the beige furniture to absorb their extra magic. They have some secret understanding that lets them tell the dying that everything is going to be okay. Forget the hundreds of thousands of medical-based errors that result in death each year. Doctors are the types of science-based authority that I desperately want to believe in.

I sat in the bustling emergency room of the Poudre Valley Hospital, the hospital where I was born, currently dying. After waiting a full hour like this, finally, a kind doctor shuffled in. He asked me to explain my symptoms, he examined me, looking me in my wild eyes with his mild ones, and then he assured me that I was simply having a panic attack. And with his words, the spaghetti explosion of my panic politely tucked itself back in.

Anxiety had never threatened me on my risky

adventures, not even as I played Hey Mister outside of the strip club. I was fearless, even as I was being raped. But this was new: life was arranging me in one corner and everyone else in another. Being scared with others is like watching a scary movie; it's thrilling. Being scared alone provides no cushion between you and your imagined dangers. I was surrounded by people who cared about me, even if they didn't always know how to help me. But I felt totally separate. There's a reason sensitive people feel alienated by those around them. The typical person might observe that they're sitting one foot away from their closest family member. To someone who feels every atom in the room, the next person is billions of units away.

One afternoon when I was sixteen, I was pouring my heart out to the RAINN sex abuse hotline once more. In an argument with my mother, she said that the sexual assault was my fault. This is the Number One No-No in sexual abuse therapy. Today, I can imagine feeling the way she did; if my risk-seeking daughter got raped, then continued to seek risk, I would be furious. At the time, I broke out my note-book, having understood loneliness but never to this scope. I wrote down: "We are all alone in life. No one else in the world, not even our parents, can be expected to understand us or take care of us anymore."

No one could understand my specific pain imprint, not even other rape survivors from my support group. Even in my good times, I was different. My pain only served to illustrate the isola-

tion of being a unique individual in our spectrum of ways, suddenly revealing this truth underneath a page like the texture hiding under a crayon rubbing. My neurodivergence, though I didn't know what it was at the time, was a more obvious and radical illustration of how different we each are, the special fucking snowflakes we've been taught we are. My crystallized edges might be more jagged, but everyone's are sloped differently, and there's a loneliness in that. There's also a beauty in it.

Instead of this being a moment of desolation, it was a moment of neutral and resolute determination for me. It was getting to the bottom of the dumpster, wading through all the rotten food and grey clothes to stare around at the emptiness, noting that this is indeed a trash receptacle. And that I should probably get out of it.

We are alone. If we're lucky, we're loved. If we're truly lucky, we can be understood. No one will ever fill our crevices exactly as we need. We need to do that for ourselves.

SOUNDTRACK "THE END" by IDLES

THAT WAS THE BEGINNING of Gogo the writer. After that day, writing replaced the RAINN hotline. I filled

notebook after notebook with emotional catharsis, unloading in scrawled pencil what I had once confessed to strangers, then cringing to read it later. When I began to write, I still didn't recognize or listen to the voice inside of me. But that voice couldn't contain itself, it erupted out of me like that abomination in the *Alien* chestburster scene.

Of course, that epiphany was at the age of sixteen. The panic attacks started around eighteen. I continued to treat my body like a New Orleans gutter during Mardi Gras for some time. The untidy truth is that people are capable of hemorrhaging fire for years, and then easily folding themselves back into a normal life, a mystery to those around them. It wasn't until I was poised to move out on my own that I stepped onto the high wire, ready to walk alone across the sky. I finally felt my own weight.

I hadn't ever felt sorry for how I had treated my mother. We're capable of causing the most harm to the people we love the most, because they are such a vital part of our foundation that we can't even see them anymore. I didn't think to apologize to her as much as I didn't think to apologize to my own body. But there was a heartbreak in our organic parting of the ways when I moved out, a loss. It haunts me like the song-bird voices of the women in my family: my Belgian grandmother, singing rounds in Walloon; my mother's soprano lilting in the golden light of the kitchen window when she's at the sink.

I finally felt the dark crash of emotions that came

with my teenage nightmares of dead nuns, with being forced out of innocence at age fifteen.

SOUNDTRACK "WHAT KIND OF MONSTER ARE YOU?" by Slant 6

16

CHARLIE & GOGO

SOUNDTRACK
"I NEED YOUR LOVE"
by Ramones

MY SISTER GENEVIEVE and I walked past a Vet Center one evening and, with very little deliberation, nonchalantly walked off with half of the establishment's twenty-foot sign. The half we stole was a hunk of solid wood that said "ENTER," leaving behind a first half that said "VET C." In thievery, it's important to act casual, even if you're sweating profusely with a ten-foot "ENTER" sign cutting into your palms. The senselessness was delicious. The joke behind most of our pranks was, *"Why would* we do something like that?"

Genevieve and I moved into an apartment together

in Boulder when I turned eighteen. ENTER became the art that greeted our visitors the second they walked in our door, like a homemaker's embroidered saying, or a really intense door mat. ENTER.

Being young means that you have so much to laugh about, you can waste it on pointless shit. Like pranks. And for all we had been through in my family, it seemed like maybe our turmoil had brought us siblings together. I didn't know any other sisters who were allowing their lame younger sisters to intrude upon their vibrant college years like Genevieve did with me.

I was between ideas of what the fuck to do with my life, and so I was living hers with her. It was nearly official that I was her shadow; I even had that fake ID—Genevieve's real ID, technically—and we went to the bars together.

CU Boulder was a pristine tree-filled campus rich with frat parties, wealthy international students, and Trustafarians. Certainly not the place for a scruggy girl degenerate to reside, but there I was, smoking cigs in the alley while Gen went to college. Guys who looked like Pearl Jam fans leaned on the porches of quaint houses while drinking out of red plastic cups. A Tribe Called Quest beamed from the stereos and tapestries hung on the walls.

We were fairly bad at living in our cluttered apartment. Dishes stacked so high in our sink that our friends—college guys—were compelled to do our dishes for us when they came over. We hadn't quite

nailed shopping for food yet, buying enough butter at Costco to last us a year, yet running out of real food and subsisting on toast with barbecue sauce. Not cooking the chicken fingers enough, pink in the middle, nuking our microwaveable mac 'n' cheese so long it became dough. Going to parties where we'd get so wasted off Goldschläger, we found ourselves inexplicably taking out the host's trash, laugh-yelling in each other's faces, not sure how we had gotten there. Bringing random homeless people to our house to party. Waking up from a night of debauchery and finding stolen lanterns from Pearl Street restaurants in our apartment, brambles in our clothes. Placing some of our plates and bowls in the parking lot as a karmic offering for our stealing habit. Getting ordained as ministers off the internet so we could marry people to plastic geese. In short, we were ridiculous.

My failure at being a grownup, however, hadn't resulted in the imminent death I had envisioned. Just a few bounced checks and the borrowing of a couple hundred bucks from my parents.

I was 19, a fact that was very bland to me, but was incredibly erotic to my sister's college friends. I was chain-smoking while halfheartedly "working" on the CU campus, handing out fliers for $8/hr. I've had some shit jobs, but this one carried a particular shame for me. It was embarrassing to perform this lowly function for peers enrolled in a better college than I would ever attend.

I saw a ghost for the first time in our beige Section

8 apartment. I had seen apparitions before; after taking Ambien, I woke to a wizard floating parallel above my body, his ethereal white hair and beard hovering in imaginary waves. (When I told my mother about it, she asked, "Was it Jesus?") Another dark figure was climbing on the inside of my window. I knocked over my lamp to prove to myself it had all happened. It was on the floor when I woke up.

Here in Boulder, dead asleep, a sharp dream forced me gasping into the cold of the waking world. As I blinked my eyes open, a young man sat in the corner of my bedroom where there was no chair. He crossed one leg casually across his knee and wore a bandana wrapped around his head, hippie-style. When you see a ghost, the double take thing is real—seeing the vision, then the deep retaliation of your entire body as you truly see it, reeling, a second time. Once that shock wave moved through my body, he disappeared. The air in the room felt sucked-in, grotesque.

I was struck by how modern he looked. He looked like someone I'd see playing pool at the Sundown Saloon dive bar (affectionately called the "Scumdowner"). No old white pantaloons of yesteryear.

Beyond ghost sightings, nothing earth shattering had happened to me until I met *him*. During one of my flyering gigs on campus. He was handing out fliers too, standing across the path from me. He was stacked with clothing, layers of shirts and basketball jerseys, John Lennon sunglasses, and a free schwag baseball cap. A piecemeal, eccentric sense of style I've grown to adore.

This guy was quirky and intriguing.

The guy—his name was Charlie—came over to me to bum a cigarette. We ended up talking so long, it marked me with an embarrassing farmer's tan across my forehead for a month. The curse of bangs.[27]

"Do you like movies?" he asked. It was cute, and safe. Who doesn't like movies?

"Sure," I said.

"Let's see a movie together sometime." He smiled at the ground shyly.

A week later, he left a message on my answering machine. It took a lot to get through to me in those days. Genevieve and I had a thing against any kind of phone communication. We wanted to discourage it. I harnessed my previous experience from working tele-marketing jobs to perfect a female robotic voice. Here's how our outgoing message went:

"Thanks for calling M + E Incorporated. Your call is important to us. Please stay on the line, and someone will be available shortly to answer your call." We piped in hold music for a hearty three minutes. Then, without warning, it beeped, throwing the caller off the cliff.

Most people left a message of confused air. It was so convincing it even fooled people who knew my voice into thinking they had the wrong number.

Charlie stayed till the confusing end and proceeded to leave the longest message in human history. It

27 The Curse of Bangs: Witchy garage rock band from Los Angeles.

wasn't so much that he had a lot to say as that he got lost in the details. An indication of his measured, thorough personality. Dwelling in the world of information, yet not quite sensing the appropriate time to hang up. Literally, my opposite.

This potential suitor's foreign nature made me unsure of how I'd respond to this long-winded request. Kitty and Genevieve were listening to the message with me and encouraged me to go on the date. Maybe they understood that I desperately needed a dose of opposite. Kitty herself was in a bad place, romantically. Her relationship with Jones had recently ended and she was on a self-destructive sex bender. When I was out at the bars with her—she had an ID of her own—she often bragged to strange men about how good she was in bed, then took them home and fucked them, then was heartbroken when they left her on her front porch in a kimono, calling her Katherine on the way out the door.

While I outwardly tried to show compassion in these low moments, rubbing her back or listening on the phone when Kitty was crying alone in the morning, I was also exasperated with her. I was a danger-seeking asshole, sure, but not to this level of fucking complete strangers. I was really worried about her. This was a line, for me, and I wanted it to stop. At the same time, I felt unqualified to outwardly condemn her actions because I was just as crazy as her.

Kitty didn't know what she was desperately reaching out for. I didn't know what I was missing

either, but we were both missing it. It was the love of a partner that happens between all the fucking. The gentle teasing from someone who secretly loves the ridiculous quirk they're teasing you for. Maybe they don't even like the quirk, but they still love you in spite of it. The bringing you coffee in the morning, then brushing it off when your face lights up. The silent love of a partner that's hovering in the background doing quiet actions for you that he thinks no one will see. It's foundational love, with a backbone, it's so subtle you learn to take it for granted when you have it, but when it's gone, you're riding a ramshackle car with no chassis, holding all the pieces together with sweaty hands and sheer will. Kitty had that with Jones and lost it, so she was gutted. I had a glimpse of it with Renton, but it was new enough that the small parts I had seen still made me slightly uncomfortable.

SOUNDTRACK "OH!" by Sleater-Kinney

THE SECOND TIME I SAW Charlie was our first date, walking around Pearl Street without going inside anywhere because we were too broke. He told me his family was from New York, but his parents ran away to Taos, New Mexico, to build their own home and live in the stark beauty of the desert. Just a couple of years

into their Taos adventure, his parents split up. He was raised barefoot as a wild Taos boy by a strong single mother, but he has New York culture in his DNA. Warm crinkly brown eyes, big gentle hands.

On our second date, we drank beers at Kitty's house and smoked at the picnic table in her backyard. We were a little drunk and decided to crash on Kitty's couch. After she went to bed, Charlie and I sat on the couch together. He pulled a blanket over our heads like we were in a fort, found me in the folds, and kissed me for the first time.

We fell asleep together and he kept planting kisses on my neck, absentmindedly, in his sleep. He struck me as someone who was taught, or inherently knew, how to respect the things and people around him, to treat them like they were precious. It's why dogs and children flocked to him, he had a divine and gentle respect for the world. We were inseparable shortly thereafter.

I got a new job at the mall record store, and while Charlie never officially moved in, he was always just there in my bed, sleeping as I left for work. I'd spend the days listening to The White Stripes and feeling my depths stir at the thought of who was currently in my bed. I'd come home from work to find him in our messy apartment, shirtless and smoking a joint. Brown hair, brown eyes, caramel skin, he radiated warmth. He gave me live ASMR in the way he turned pages slowly, he fueled my future career as a writer by being a voracious reader. He absentmindedly stroked my

hair whenever he was reading, his measured presence an anchor to my anxieties and mania. He stood casually in a doorway with beer in hand, squinting into some far-off place that handsome men must all see.

SOUNDTRACK
"MAN NEXT DOOR"
by The Slits

ONE AFTERNOON, CHARLIE and I shared a joint in the parking lot outside of my apartment. I smoked weed, like a couple of hits when the pipe was passed around. Charlie was a next-level stoner, with Jamaican heritage, who took down entire joints to the dome. My neighbor, Schizophrenic Bob, had wandered over to talk weather and conspiracies. Bob was the beloved mascot of our Section 8 housing, always sitting out front and ready to say a kind word. His schizophrenia was typically relegated to paranoid-lite banter—property management companies not accepting his rent in cash, injustices of the bureaucratic variety. But today was a new day.

"I saw them outside of the building today," he said quietly as he leaned in towards us.

I inhaled a hit, watching the cherry swiftly devour the joint. This joint was going quickly. "Saw who?" Plumes of smoke.

"The property management people."

"Oh, PSI?" I asked. Our property management

company was particularly horrendous in a boring bureaucratic way. Looking back on it now, that's probably because it was Section 8—for the poor and insane. Two demographics that rarely receive good service.

"They were coming for me," he was shaking his head, his white hair and beard catching wind.

"Coming for you?" I began to choke on the fumes.

"They're gunning for me," he said. "They don't like it when I bring cash in. They're after me."

"Guns? Gunning? What?" The afternoon sun went behind a cloud and the world's color dropped a few shades. It felt like Bob was getting more paranoid with every drag I took. It was like there was a direct channel from my mouth to the paranoid shit firehosing from his mouth. Nameless government operatives in the bushes, his proximity to orchestrated annihilation imminent.

The sunlight came out from behind the clouds again, now too bright, searing and singeing the paper-thin delusions unfolding like cheesecloth from Bob's wrinkly mouth.

I excused myself and promptly darted inside my apartment, where I locked myself in the bathroom for an indeterminate amount of time.

Sitting on the ground in front of the toilet, mouth agape, I was convinced I was about to vomit, but nothing came out. I still didn't feel comfortable leaving the toilet. *It could happen at any moment,* I thought. *What if I puke on the floor? What then?*

I heard Charlie's words through the muffled

echo of the bathroom. "Yes, just half an hour ago." It sounded like he was talking to someone on the phone, conspiratorially, I might add. I watched my puckered reflection in the glint of the toilet water. "She's in the bathroom right now." Somehow, I just knew that Charlie was talking to my family. I didn't know how he had gotten their phone numbers, because we had only met a month ago. Maybe he was talking to my sister. Maybe even my parents. "No, I don't think she's okay. I think she has to go to the hospital right now."

Something must be truly wrong for Charlie to be calling my family like this, I thought. *Maybe I'm dying.* I tried to breathe, put my head on my hands on the toilet seat, and waited patiently for someone to come and rescue me. It would either be Charlie, or maybe some EMTs blasting through the bathroom door like a save-the-day parade. They would take me to some doctor who knew, with great assurance, what was going on with my fucking head. One of those glowing savior types. They'd clear it all up and everything would be fine again, and I would know such things as how best to proceed in life and what was my calling. It wouldn't do any harm to stay put. I waited for what felt like hours, until my muscles were shaking from crouching in a strange, stupid position. Finally, I creakily stood up, shook out my limbs, and opened the bathroom door with the levity of someone leaving the wild to discover advanced civilization.

Charlie sat on the couch, his eyes red slits, a heavy-lidded smile crinkling his eyes as he guffawed at what-

ever movie he was watching. "Hey, you feeling okay?"

"I thought the hospital was coming," I said. Out of my mouth, the words felt childish and strangely British. The hos-pital was coming?

"The what?"

"Weren't you calling some people?" I asked timidly. I was starting to feel a bit crisper, clearer. I started to question the past couple of hours. "Were you on the phone with my family or something?"

Charlie smirked.

I started to feel embarrassment inching in from the peripheries of my emotional world. This wasn't the first time Charlie had witnessed the dazzling strangeness of my brain. Recently, I had fallen asleep while we were watching TV. When a particularly loud commercial came on, I rustled awake grouchily, my brain grasping for a way to describe my discomfort. "Too expensive!" I pronounced, gesturing at the screen, half asleep; inexplicably, the phrase came out of my Colorado mouth with a slightly Southern twang, like I was a guest on Jerry Springer. "Too 'spansive." It was something we laughed about often, but I was beginning to settle into a bad stereotype here: the crazy girl.

"I've been sitting here watching movies for hours," Charlie said. "I tried to come into the bathroom, and you told me to go away. I thought maybe you were sick and needed some space," he said.

As if it needed to be uttered: "You must've gotten really stoned," he added.

Even in my deranged ability to hallucinate from

something as benign as marijuana, I recognized some emotional truths here. As my world faux-crumbled, I waited for someone to come and rescue me. I knew now that I was going to have to be the one to stop hugging the toilet like an idiot, stand up, and open the door.

SOUNDTRACK "NEVER SAY NEVER" by Romeo Void

"Have fun," Charlie told me as he dropped me off at Denver International Airport. It was spring break and Kitty was spending it with her drunk and disorderly siblings at their family home in North Carolina. Perhaps for mental support, she offered to fly me out to be with her. Compared to my polite and Catholic family, drunk and dramatic siblings were thrilling to me.

The first night, Kitty and I got shit-housed in their basement. Partway through the night we were joined by Blake, Kitty's sexy snowboarder brother who had rendered me speechless for five years with his casually gorgeous appearance. Blake had rarely hung out with us on his own. He had always been a little too good for us, which had in turn made me lust after him more. After four beers, I was a charming showoff, shooting with the pool cue behind my back and making it in.

At the end of the night, we all fell asleep in the basement, slumber party-style—Kitty over on the couch,

and Blake and I crashing out on the floor. After Kitty's snores sawed the air, I heard rustling next to me, then I felt a sudden warm rush of nerves ignite throughout my body as Blake began kissing the space on my neck by my ear. *This cannot be happening,* I thought to myself. Blake was famous-person hot. He was so out of my league. He was my best friend's brother. Plus, Charlie. *Charlie, Charlie, Charlie.* I loved Charlie.

"I shouldn't," I whispered, my breath catching and my chest heaving, disconnected to my protesting mind. "I have a boyfriend." *Charlie,* I repeated in my head.

"He doesn't have to know," Blake whispered into my ear, unrelenting in his seduction. His wet tongue and warm breath raised shivery goosebumps across my body, which was responding, despite my mind. Each moment I lay there writhing under the blanket threatened to pin me deeper to the floor in ecstasy.

I bolted upright and ran out to the garage, where Kitty's parents let their children smoke. It was about 2:00 a.m. I lit a cigarette up against the wall to slow my heart from its pounding.

Across the garage, the door into the house opened slowly, and I knew whose silhouette would be there. But I thought of the name of the man I loved. *Charlie,* I thought to myself. I knew I had to resist.

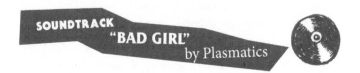

SOUNDTRACK
"BAD GIRL"
by Plasmatics

THE SECOND BLAKE'S SCULPTED shoulders under his plain white tee were illuminated by the glaring light of the garage, I knew I wasn't going to resist. He approached me, looking me in the eye, grabbing my cigarette out of my hand, dropping it, and stubbing it out on the floor. Then, he kissed me, so deeply, backing me up against the wall with one hand behind my neck, his hands in my hair. I melted into him. He grabbed under my knee, spreading my legs and, in one hoist, wrapped my legs around his hips, pressing me into the wall. After that, it was over. I wanted him inside of me, where he came again and again during the course of the week. I didn't know how to stop it. I couldn't stop it. I fucked him in his bedroom, and I fucked him in the family living room. On the living room couch, I unzipped his jeans and took his hardness into my mouth, his hands in my hair. I don't remember where his family even was, especially since there were so many of them. I remember him saying something when his cock was deep down my throat, his hands covering my ears, muffling his words unintelligibly. "Oh Gogo, flim flam flom." I'll always be curious what he said.

A couple of days into her family spring break, sitting in their backyard and after a few beers, I told Kitty that I was fucking her brother. She laughed it off because that's the kind of friendship we had.

"Blake really needed to get laid," she said. That's what kind of family she had—they were honest and open with each other. I was envious. I was relieved

that my best friend wasn't mad at me. But I had no idea what I'd do about Charlie. We had never discussed exclusivity, so I could get off on a technicality. But we were saying "I love you." That's commitment. My heart felt like I had done a terrible, terrible wrong.

The least hurtful thing, it seemed, would be to lie.

SOUNDTRACK "BETRAYAL TAKES TWO" by Richard Hell

I WAS SO NERVOUS for the entire flight back to Denver, I was shaking. After walking barefoot through the fire of destructive teenage boys that was Fort Collins, I had finally found someone who respected me, cherished me, and understood me. Charlie, my love. I was sure he was my life partner from the start. He was every bit as darkly gorgeous as Blake, and he cared deeply for me. And within months of meeting him, I had forever fucked it up. I formulated a plan to shut the fuck up about it for the rest of my life. After all, he wouldn't suspect me of meeting anyone exciting at Kitty's family's house in North Carolina. Was I capable of such a lie?

The plane landed. I marched to my doom, Charlie's car was waiting for me in the pickup area. I got into the car, head down. Going to kiss him, I immediately burst into tears, the expectant smile draining from his face.

I proceeded to tell him everything. I did not spare any detail. Was I capable of lying to my love? No, I was incapable of stopping the wave of vulgar truths spewing from my mouth. Charlie was visibly saddened as I told him, stiffened his shoulders, and stared at the road ahead. What did the road ahead bring us?

The next day, Charlie drove to a field with a forty and drank the whole thing alone. He came back, hugged me, told me it was okay, and we never spoke of it again. Despite the fact that I never betrayed him again, I branded myself a cheater.

SOUNDTRACK "DANNY SAYS" by Ramones

THAT SUMMER, MY PARENTS went on vacation, naïve enough to think I wouldn't party at their house the entire time because I was grown up and my apartment was forty minutes away.

As it turned out, I would.

Charlie and I slept in my parents' bed with the coiled metal bedframe in the master bedroom, feeling like fucking royalty at the top of the stairs. We looked down upon the open and spacious home I grew up in. It was so dazzling, you wouldn't even know it was built upon thrift store finds—the kind of authentic sophistication and beauty not bought but crafted from

garage sales and good taste and careful tending by my beautiful mother. She put such pride in all the minutiae that raising a family involves, even as she had a career. She had given me such a good home. As I admired her homemaking, appreciating her, the irony wasn't lost on me that I was currently squatting in her home.

Sunlight and dust slatted the air across the open balconies that lined the foyer and a grandiose, if old, chandelier. Even though it was purchased for next to nothing by today's standards, this home was a level of luxury that Charlie and I would never know again, soon to be spit out into a poor economy with creative careers underway. Decades of life lived on internship pay, in a vibrantly creative music industry whose actual economy was crumbling, without adequate health care, pushing thin budgets, creating mountains of debt, and sweating through a constant state of financial crisis. Finally breaking even just in time for a pandemic to hit. Charlie would even try his hand at stripping with Vicente and Co. in Denver for a short while.

Of course, we didn't know that at the time. It was a comfort I'll likely never feel again in my entire life. That short-lived moment was the safety of home with the freedom to be who we wanted. It's hard to get both at the same time.

SOUNDTRACK
"HARMONY IN MY HEAD"
by Buzzcocks

Kitty, Dar, Tana, Julian, and Jones stayed in the other bedrooms throughout the week, and we converged as an eccentric little family. We cooked meals together, dressed up for a fancy party, played Shenanigans on the back deck while the sun hung low, and figured this was what adult life held in store for us. We were playing pretend grownup and it only contained the fun familial dinners without the bills or responsibility. It was the sunset of our time together, and we knew that things were about to change.

Corinne and I both wanted to leave Fort Collins, but after her car was hit by another driver, she now had the means ($5,000) to do it. She informed me that she was going to travel over the summer, and she eventually moved to California. Julian and Jones were going off to college in Greeley. UNM had a renowned music program, which Julian plugged into as he played the electric and stand-up bass.

Tana and Dar had no plans to leave Fort Collins. Their family was solid, Dar was still enjoying stripping, and Tana was a creature of comfort. She was a cozy person, she was a settling person, she worked hard doing administrative work (as Virgos are often pulled into), and even bought a condo shortly after.

The Williams sisters visited me at my Boulder apartment often; sometimes, Dar would knock back four shots of vodka before hitting the road, driving like a demon to beat her buzz so she got to my house before the booze kicked in. Tana would always clean my entire apartment when she visited.

I didn't know at the time that I was wading through the final waters of my friendship with Kitty. I couldn't believe the end came so quickly. One minute, we were inseparable, talking several times a day on the phone. Despite having a large family to feed, Kitty's father was a world-famous welder, and made enough money to support her financially. She never really had to have a job. She was always halfheartedly starting career tracks, making excuses, and quitting. She was meant to be a lady of leisure, an indoor cat. I was working at an indie record store on Colfax Avenue and going to commuter college when our lifestyles began to clash. I didn't have the time to indulge her several calls a day, and when I didn't answer, she'd keep calling or leave manipulative teasers on my answering machine. Finally, I told her over the phone that I couldn't talk so much on the phone anymore because I had to work and study. She curtly told me to drop her house keys off, and we never saw each other again.

But before she rocketed out of my life, Kitty helped to transition a new life partner into it; she was the one who urged me to go on a date with Charlie after hearing his rambling answering machine message. She gave that to me. She left an imprint on me that only a best friend can. Her exotic Canadian food, like mushy peas, her books of poetry, her cat scampering through the smoke-filled, sunlight slatted French doors of her apartment, and her wispy art school fashion.

But even friendships can be codependent when you're young, and it was time to step out on my

own. And my relationship with Charlie, rather than a constraint, was the rich soil that helped me grow.

SOUNDTRACK "DREAM BABY DREAM" by Suicide

17

MODERNWORLD

SOUNDTRACK "COOL MOM"
by Childbirth

A FEW YEARS AGO, I was walking through grassy fields with my blond-magic boy. The towheaded male who had been gracing my drawings as a teen was my son, Henry, now just a year old—the blond boy I had assumed to be my soul mate. The connection feels too strong to be a coincidence considering that I know very few blond men, and Henry's blondness is a total mystery. Looking at Charlie, with his dark brown hair and caramel skin, and me, with my stark black hair, you'd never expect us to create a blond.

I'm old now. Not actually old, but old enough

for teenagers to think I'm old. Old enough to get mad in a mosh pit when someone bumps into me. The show was the Hi-Dive's sixteenth anniversary party, featuring Zebroids and Wobbles, Denver's only skate-punk band ... like, they actually skate (badly) onstage while playing, ollying gloriously into the crowd. Someone stepped on my ankle, and I experienced levels of rage one might feel if someone walked up to you at the library and stomped on your ankle. "What the fuck, motherfucker?!" I guess that means I'm too old for mosh pits.

I survived through two bouts of childbirth. I suffered through contractions that made my bulging belly turn square. I broke my tailbone without an epidural while pushing out my first child. I could only describe the pain as shuddering, shaking my bones. I had a vision of walking through a desert at night, with nowhere left to go but death and coyotes. I learned that the most hardcore thing to be is a mother.

I was forced through the boot camp of parent-hood, which teaches you that the removal of entitle-ment can only happen through experiential learning; I'm sad to say there wasn't a single book that could've taught me to cherish family, health, sleep, leisure, sunsets. Being a parent is the antidote to nihilism. I only learned to treasure these things once parenthood spit me out on the other side of the void, having so much taken away. Without this shift in perspective, I had been continuously disappointed by life's refusal to bend to my needs.

Never again did I get truly stoned after the Great Unraveling of Schizophrenic Bob. I occasionally microdose, though.

If God existed, she would design my eldest daughter Colette specifically for me. She has my good traits. She's bewilderingly creative, she already has her own elven language, and I'm convinced she's more fairy than human. She also possesses myriad talents I don't have, ones that I really could have used growing up: leadership, piercing intelligence, and frank outspokenness (all gifts from Charlie).

These days, there is abundant knowledge to help sensory sensitives like me. And for that reason, we recognized sensory difficulties in our children early on, treated them with occupational therapy, and they haven't shown signs of trouble since.

During one trip to an occupational therapist, Colette sat in a large gym with the lights dimmed, floating in a spaceship while wearing large headphones. It felt less like an exercise concocted by medical professionals and more like something my friends would get up to on mushrooms, and yet there we were in the Children's Hospital's official Occupational Therapy department. The headphones she wore were to reset her brain with binaural, high-caliber recordings of sounds from different distances that would orient her body three-dimensionally. The dimmed lights were because sensory vampires like us are so bothered by brightness, it actually impacts our cognition. And the spaceship was just a glorified swing, shaped like a boat,

because swinging is calming for your brain. The occupational therapist (OT) grabbed one end of the spaceship, then swung Colette hard into a wall, bumping the entire apparatus and causing Colette to jump. I looked sharply at the OT.

"A heavy jolt is calming for her brain. It gives her perspective, it tells her where her body is in space," explained the occupational therapist, adjusting her thick black spectacles. And in one instant, so much of my adolescent rebellion made sense to me. Maybe I was metaphorically crashing into things to find perspective.

Both of my kids have already repaid a fair share of rebellious karma. They challenge me at every stance.

So, how does Modern Gogo refrain from disrobing and scaling pool fences at every turn? What keeps me from indulging in those urges now?

I was a tactile learner, and I learned.

My desire for adventure was quenched, but it wasn't from some epiphany that I deserved better. I found new, healthier vices. I funneled my wild spirit into ambition. My sensory addiction was transferred to sex and writing. Though most writers might not relate, writing is a sensory activity for me. It feels like I'm scooping something out of my brain and molding it into space-time for immortality. I could just as easily be a painter or a musician.

I didn't so much leave my lifestyle behind as Charlie and I merged our craziness: working together at a record label, starting a secret society and writerly collective in Denver called the Donnybrook Writing

Academy, and frequenting Charlie Brown's piano bar, where Jack Kerouac used to hang out long ago. I became a music journalist, publicist, and Burrito Fairy for Illegal Pete's, the countercultural burrito restaurants. My job, in addition to writing, was giving touring bands free burritos and beer when they came through town. I also did publicity for a haunted bordello called the Black Monarch. It's in a ghost town called Victor, Colorado, and the owners have themed the rooms after serial killers. The owner and his girlfriend are goth geniuses, and I made them super famous. I guess it's all to say that we didn't lose the weirdness, we just funneled it into ways to feed ourselves.

Even though we had kids, we never grew up. This results in some forgotten homework assignments, keeping the kids out too late at parties, and the occasional spontaneous trip to Lakeside Amusement Park at bedtime. It's the type of parenting style where we start secret rave clubs with the other dance parents from Colette's ballet class, sweating together on the dance floor mere hours after we politely clapped at the holiday recital. We put wine in our thermoses when we take our kids on a walk in the stroller. We still like a little trouble. But we are good parents.

SOUNDTRACK
"FAIRYTALE IN THE SUPERMARKET"
by The Raincoats

IN THIS MOMENT IN THE FOLIAGE with Henry, the sun was kissing us while I held his chubby hand. He had recently turned one and had just learned to walk. The breeze moved through the tall grass like fingers over sun-warmed skin.

We turned down a path that cut through the neighborhood with tall shrubs on either side of the sidewalk. Hidden from sight. I should've sensed instantly that this was a Teenage Place. The Path. The Dam. The Ditch.

As I turned down the path with my blond cherub, wearing yoga pants and definitely not looking like anyone who has ever gotten an illegal titty tat, I came up against a huddle of grubby teenagers. They sported black hoodies with angry white lettering and safety pins and janky haircuts. A cloud of pot smoke issued from the center of their gathering like a volcano. They turned and saw me with my precious baby, panic freezing us all in place. We stared at each other, at an impasse. After a beat, I picked up Henry and walked through the center of the group nonchalantly. "It's okay," I said. "I've been there before," and I winked.

"Shiiiiiiit," they declared in my wake, the hazy clan erupting in celebration. It felt like walking away from an explosion in the movies; only instead of destruction, I had tossed a grenade of relief. In Teenageland, the most story-worthy moment is when you get away with it. This will be a moment of teenage lore for them, when that totally square mom was cool with us smoking weed.

I reveled in the moment. Seeing those crusty punks was like seeing how far I'd come. I was so norm-core,[28] so sane that my friends and family surrounding me wouldn't even believe the life I had once lived. And it made me glad I had lived that crazy, risky life. Since everyone turned out relatively okay, with a little baggage of course, I was glad I had been raised to live with an open and accepting heart and taken that lesson to the strange corners of life.

My cool moment was short-lived, however, when Henry and I were on our way back home and the teens still commanded the narrow path. I highly doubted I could maintain that level of cool for a second time. There has to be a Scandinavian word for the feeling when your initial social exchange sets the bar so high that you hope to never see that person again in your lifetime. *How could I top it?* I considered, for a moment, lighting my nipples on fire like Diamond. But that might scare the baby. Instead, Henry and I went to excruciating lengths to avoid the stoners by taking another route, doubling our walk time.

SOUNDTRACK "TOO OLD TO DIE YOUNG"
by Ed Gein's Car

28 Normcore: A movement of film, music, and fashion elevating an ironic caricature of "normal" life—shows like The Office, pumpkin spice lattes, Dave Matthews Band, Old Navy, khaki, etc.

I MAY NOT BE COOL anymore, but one thing hasn't changed. There comes a time in one's life when you grow up and leave your sordid past behind; for some of us, that moment never comes. Instead, there is a realization that you will never, ever lead a normal life. You keep waiting to enjoy talking about real estate or being on the PTA, but it just never happens. Not after having two children, which you somehow thought would magically make you enjoy Top-40 pop music and suburban parties. Not after proving to yourself that you can make a living in the real world. At no point in any bland corporate copywriting gig did I think to myself, *This is me, now.* Nothing can rescue me from my weirdness; nothing will wash my strange away.

Maybe it wasn't a rebellion all along. That was me then and it's still me now. This is not a story about finding oneself, but keeping oneself.

My parents are still lovingly in my life and are the best grandparents ever. They've relaxed in their older ages: they quit the Catholic church for a Unitarian one with a lesbian minister, and they even compliment me on my dyed green hair and new tattoos.

My children, ages six and three, already know how babies are made. They know what a gun looks like, and what to do when you see one; what racism is, and how to stand up to it. They know what booze is, and I know I'll be hosting their friends for shindigs when they're teens. I'll be honest with them about alcohol: I can honestly report interplanetary levels of self-esteem, zero inhibitions, and unbreakable bonding

between 2 – 4 drinks. After that point, it's all puking and getting lost in your own bedroom. My kids are more familiar with "Sports" by the Viagra Boys than actual sports. They practice consent, even in their tickle fights, and scream loudly when their boundaries are being crossed. Henry wears pink and Colette is super into math and engineering. They're already phenomenal at making sure their voices are the loudest in the room, but I also try to teach them to say yes to life. I'm absolutely terrified, and preemptively honored in anticipation, to hang out with them as teenagers.

SOUNDTRACK
"BIG BANG BABY"
by Stone Temple Pilots

AS RESEARCH FOR THIS MEMOIR, I went to Jonny Gutpunch's bar on South Broadway in Denver, where it all turns to antique shops. We drank a few IPAs and made valiant attempts at remembering a time when we had actively been trying as hard as we could to kill brain cells. Over the years, he had been the lead singer of a punk band and living in the Highlands in Denver back when it was the ungentrified Northside.

Surrounded by vinyl, posters, and red, black, and white punk paraphernalia, Jonny Gutpunch told me about his daughter and his fiancée, about his upcoming wedding in Mexico. His bar was filled with

electric energy and his incredible playlist was made up of authentic music from our youth: mostly NOFX, Buzzcocks, Jesus and Mary Chain, even some grunge and Bell Biv DeVoe. It was really good to see him again, but part of me wondered what had drawn me back here, of all places. Of all the ex-boyfriends, the guy friends, why him?

After I gave Jonny a goodbye hug and I was walking out the door, a song halted me in my tracks. I recognized the deep cut; it certainly wasn't very punk rock, but this Stone Temple Pilots song was in heavy rotation during the nineties.

Across the bar, I made eye contact with Jonny and pointed to the heavens, "STP?"

He knew exactly what I meant, despite the fact that the speakers were all around us. All of the people I associate with would know that "up" means "what's playing?" (Translation: music is God.) He nodded, "Big Bang Baby."

Big Bang fucking Baby. What a perfect song for an epiphany.

"Big Bang Baby," coincidentally, is a song rumored to be about my dead boyfriend, Kurt Cobain, and his fame-induced demise. People criticized Stone Temple Pilots' Scott Weiland for the song's cynicism, as he seems to taunt Kurt, "there's a hole in your head, there's a hole in your head." Some people think Scott was relating to Kurt, too. How he got used up. How no one really cared, they didn't know his real story, how they all just hummed along. In this world we've created, by the way,

even the cool guys we worship, the ones the girls want to fuck, they're all dead. Kurt is dead. Scott, who sang cynical songs about Kurt's death, is now dead. Even the ones who seemed fucking invincible—Peter Steele's inhuman machismo, David Bowie's unbreakable star power, Prince's infinitesimal sex appeal—they're all dead. Men suffer from how we lay out the world, even as they lay it out. But back to my teenage epiphany.

How had I not seen it until now, this moment, walking out of my first real boyfriend's bar?

It's no surprise my biggest teen crush was a famous person with the added unattainability of being dead. Because my notion of romantic love was dead from a very young age. It was slain with my first kiss at age thirteen, when two punks practiced on me after I passed out drunk. It would've been embarrassing to have a single feeling in that post-apocalyptic emotional wasteland. I chose a dead man to love because my love was already long gone. I chose a dead man to love because a dead boyfriend had no way of actually breaking my heart.

Even though I liked him, I don't remember how Jonny and I met. I don't remember how we broke up. We drifted apart and I didn't think about him all that often. After him, there was the strange punk runaway I tried to lose my virginity to; then rape; followed by four years of men who were too old or too uncaring for me, with few exceptions.

There is a lot that I chose not to notice as I floated through the teenage world of sex. It would've been too

painful to navigate with an open heart. I only collected the gritty parts for my story: the teen legends, the hilarious stories, the glory. It didn't even occur to me to have feelings in the most emotional time of my life.

Sex affects much more than just the physical body. It imbues our self-worth. It subconsciously tells us how to feel about ourselves. It opens or closes us up. It inspires the actions we seek, and the good, or bad, decisions that we make. It colors our confidence when we tell potential business clients our hourly rate. It affects everything. Maybe this is why, even years later, I had failed to find self-worth, despite seeking it.

For the first time ever, at this very moment, I recalled Teenage Gogo in her tube socks and baby barrettes, and I wanted better for her. I had allowed myself to be angry about having my virginity stolen, but I had never had the heart to think about what it is that I actually wanted. I wished I had lost my virginity to Jonny. Not some punk runaway stranger. Certainly not a rapist. If not Jonny, just someone I knew who was also nice. Someone who could be patient and tender instead of uncaring or violent. Someone who liked me as a person. Dare I say, someone who understood the fucking majesty of my mind.

Anything less than this is walking across the most important threshold of the living, totally alone.

Take it away, boys

ACKNOWLEDGMENTS

I WANT TO THANK MY PARENTS for accepting their forever-wild daughter. To Charlie, for helping me heal. To my agent Nat Kimber at the Rights Factory, for having the biggest heart I've ever had the pleasure of knowing, and for actually using it in this industry. You get 10,000 punk points.

To my publisher, Greg Gerding at University of Hell, for devouring *Glory Guitars* and absolutely getting it on a cellular level—and for all the bad-ass music recommendations. To my editor, Amy Chadwick, Editrix from Hell; to say you were pleasant to work with falls ridiculously short; you're kind and brimming with enthusiasm, and you made my book better.

Thanks to our teenage girl gang—Dar, Tana, Corinne, Blesh, Lexi, EC, Nancy Villain, Alex—for living these turbulent times with me, especially those of you who helped me with photos, memories, and words of encouragement. Special thanks to Bea the scene queen for helping me with the soundtrack, reconnecting people in the Facebook community, and

for being you. You're incredible. Thanks to Karin Partin Wells for being a party mom with me and working together on the screenplay; I actually cried when I read how you exploded my story into a multi-dimensional thrill ride. Thank you to Leah Charney who has read and edited all of my books, who is the best kind of friend, who understands you when no one else does, and who is a stealth Gogo content tipster.

Thanks to Glenn Ross for all of our inside jokes, our multitudes of fake music, and for my favorite photo shoot experience. Thanks to Gisele, Brandi, and Patrick for smashing televisions with me like Wendy O—we nearly broke our hands (that shit is harder than you might think). Thanks to Jason Heller for your brilliant writing that gives me something to aspire to, and for always encouraging me. To Amanda EK for being my mirror twin and confidante.

Thanks to the greater Grrrl Gang—everyone who "grew up young and female-identified in the '90s" and who recognizes themselves in this story, to paraphrase Alex DiFrancesco. Thanks to my siblings, who looked out for me when I was a rebellious teen ... and hooked me up with fake IDs, and such.

Thanks to my children for being the planets that I orbit around. I want to work to make the world a better place for you. Thanks to all my early readers. Thanks to anyone else who helped me with this memoir that I didn't name; I didn't want to drag you into this depravity. Thanks to that special person who helped me write that sentence.

BIO

A NEURODIVERSE GIRL in a '90s suburban world, Gogo Germaine was born with a lollipop-swirl brain, goth-kitty heart, and lightning-bolt soul. She won the Spelling Bee and the D.A.R.E. essay contest in the 6th grade. She was voted "Most Unique" in the 7th grade.

It was all downhill from there.

The rest was the stuff of hysterical after-school specials: stealing cigs, shotgunning PBRs, snorting cocaine, sneaking punk boys into her pink bedroom, and listening to tinny car stereo tunes while glaring into the sun like a muscle-shirt dad. She snuck away every night for a summer; fled to California, but only made it past Fort Collins; paid $12 for a tattoo she got on top of a parking garage; banged a dude whose name was bathroom graffiti in a coffee shop; was courted by an aging rockstar; and spent her adolescence running through every door.

And then, one day, she finally escaped.

Gogo became a band publicist, music journalist, and writer devoted to exploring rebellion and the grey

areas of life. She helped launch what was rumored to be a sex cult in a haunted bordello in a ghost town, gave birth to two love children, and wrote such subversive things that she was estranged from half of her family and friends in a single year.

Gogo currently spends her days working in a phantasmagorical wonderland. She wrote *Glory Guitars* for the singular goal of capturing the feeling of the air as she ran across a field ditching school, totally free from responsibility. It became a hopeful platform for her to reclaim her agency and make sense of all the heartbreak she was running from: the heartbreak of being a differently-wired girl in a predatory world. She is no longer a danger-seeking asshole.

THIS BOOK IS ONE OF THE
MANY AVAILABLE FROM
UNIVERSITY OF HELL PRESS.
DO YOU HAVE THEM ALL?

by **Jason Arment**
Musalaheen

by **Tyler Atwood**
an electric sheep jumps to greener pasture

by **John W Barrios**
Here Comes the New Joy

by **Eirean Bradley**
the I in team
the little BIG book of go kill yourself

by **Suzanne Burns**
Boys

by **Calvero**
someday i'm going to marry Katy Perry
i want love so great it makes Nicholas Sparks cream in his pants

by **Nikia Chaney**
us mouth

by **Leah Noble Davidson**
Poetic Scientifica
DOOR

by **Rory Douglas**
The Most Fun You'll Have at a Cage Fight

by **Brian S. Ellis**
American Dust Revisited
Often Go Awry

by **Greg Gerding**
The Burning Album of Lame
Venue Voyeurisms: Bars of San Diego
Loser Makes Good: Selected Poems 1994
Piss Artist: Selected Poems 1995-1999
The Idiot Parade: Selected Poems 2000-2005

by **Lauren Gilmore**
Outdancing the Universe

by **Rob Gray**
The Immaculate Collection / The Rhododendron and Camellia Year Book (1966)

by **Joseph Edwin Haeger**
Learn to Swim

by **Lindsey Kugler**
HERE.

by **Shawn Levy**
A Year in the Life of Death

by **Wryly T. McCutchen**
My Ugly & Other Love Snarls

by **Michael McLaughlin**
Countless Cinemas

by **Isobel O'Hare**
all this can be yours (hardcover & paperback)

by **A.M. O'Malley**
Expecting Something Else

by **Stephen M. Park**
High & Dry
The Grass Is Greener

by **Christine Rice**
Swarm Theory

by **Thomas Lucky Richards**
Thirst for Beginners: Poems, Prose, and Quizzes

by **Liz Scott**
This Never Happened

by **Michael N. Thompson**
A Murder of Crows

by **Ellyn Touchette**
The Great Right-Here

by **Ran Walker**
Most of My Heroes Don't Appear on No Stamps

by **Sarah Xerta**
Nothing to Do with Me

edited by **Cam Awkward-Rich & Sam Sax**
The Dead Animal Handbook: An Anthology of Contemporary Poetry

edited by **Isobel O'Hare**
Erase the Patriarchy: An Anthology of Erasure Poetry

edited by **Greg Gerding**
2020 The Year of the Asterisk: An Anthology of American Essays*

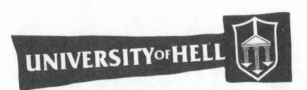